HALS

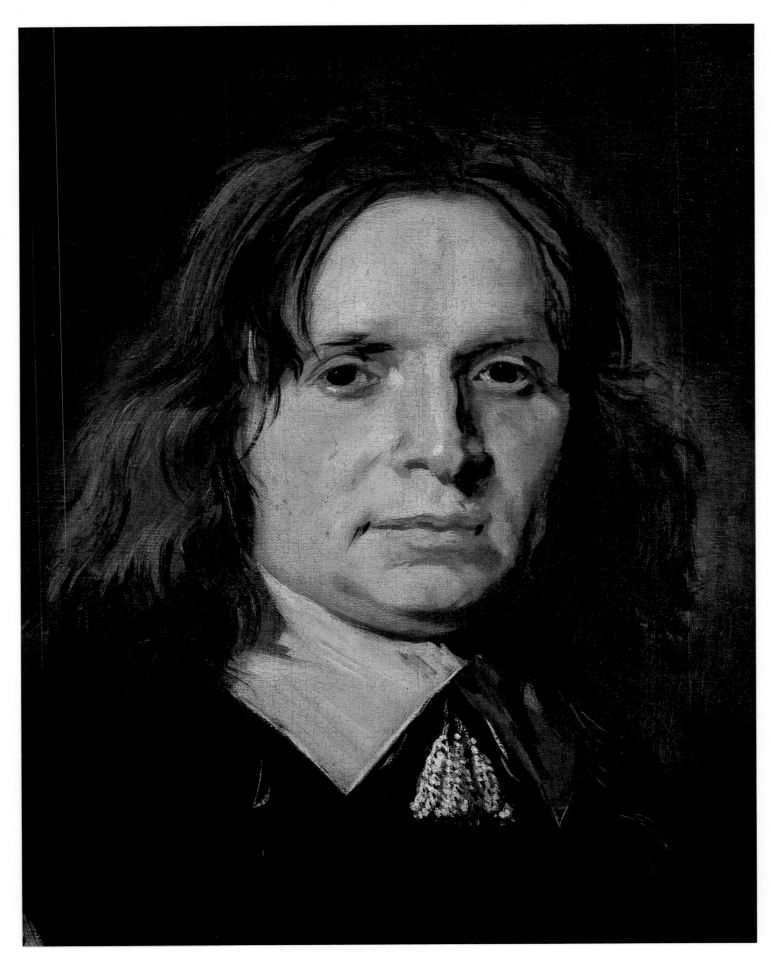

Lift colorplate for title and commentary

FRANS
HALS

TEXT BY

H. P. BAARD

Former Director, Frans Hals Museum, Haarlem, The Netherlands

Translated from the Dutch by George Stuyck

THE LIBRARY OF GREAT PAINTERS

HARRY N. ABRAMS, INC., *Publishers*, NEW YORK

TO SEYMOUR SLIVE

Editor: Joanne Greenspun
Designer: Judith Michael

LIBRARY OF CONGRESS CATALOGING IN PUBLICATION DATA
Baard, Henricus Petrus
 Frans Hals.

 (The Library of great painters)
 Bibliography: p. 164
 Includes index.
 1. Hals, Frans, 1581/1585–1666. I. Baard, Henricus
Petrus, 1906–
ND653. H2A4 1980 759.9492 79–18048
ISBN 0–8109–1055–1

Library of Congress Catalog Card Number: 79–18048

Illustrations © 1981 Harry N. Abrams, Inc.

Printed and bound in Japan

CONTENTS

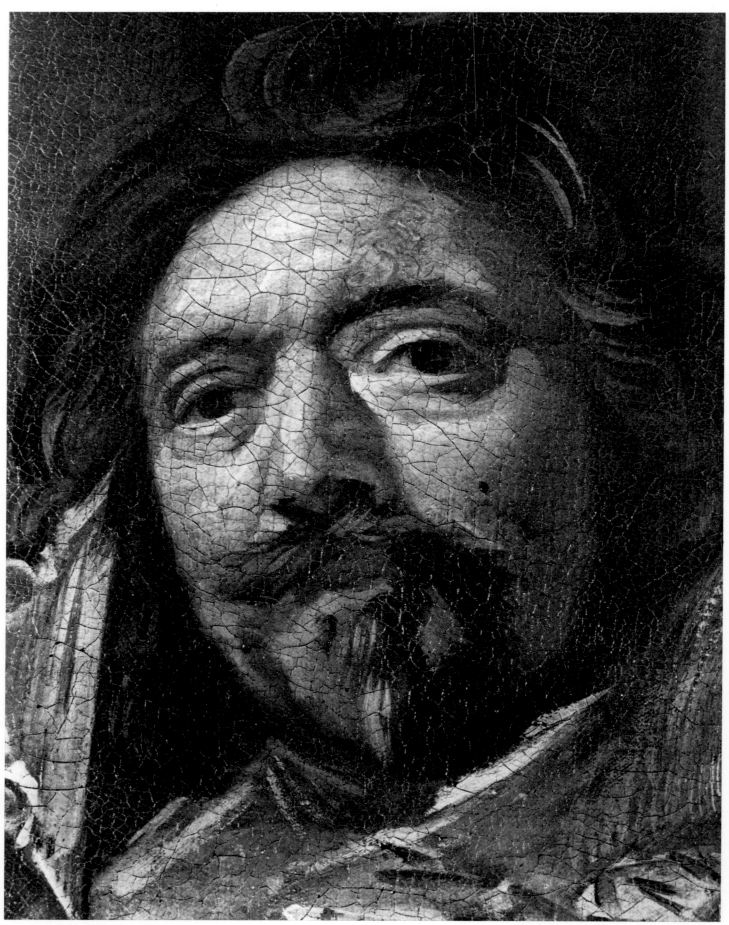

1. Self-Portrait. Detail of *Officers and Sergeants of the St. George Civic Guard Company* (see fig. 38)

F. Hals

IN HIS *Journal* for November, 1852, Eugène Delacroix noted: "Opinions change out of necessity; not enough is ever known about a master to discuss him from an absolute and final standpoint." This statement suggests that each new publication about an artist is an incomplete addition to the total image composed of the inevitably subjective views of various authors, as expressed by them within the limits of their own time and place. The same applies to the present author's treatment of his subject, the portraiture of Frans Hals. He, too, is aware that he must accept these bounds; in fact, he has restricted himself by basing the approach to his subject on the conviction that, within the framework of this publication, the reader is best served by placing the emphasis on Hals's phenomenal artistry.

Experience during a long period of activity in museums has shown that the extent of this artistry remains, on the whole, unrecognized. For, generally speaking, the eye is perceptive of the elements of time and place present in all portrait paintings, but it usually overlooks the ability of the painter of genius who, behind the "trappings of the time"—which to him are of only secondary importance—can bring out the essence of a portrait, revealing how this has been accomplished.

The name Frans Hals still erroneously evokes the gayer side of seventeenth-century Dutch society. Closer familiarity with his work, however, provides a different picture of the artist and contradicts the tradition that has persisted of depicting a happy-go-lucky Hals as the "painter of laughter." The author will try to approach Hals through the mastery of his craft and, above all, through the breadth and scope of his artistic greatness, to rid him of the cramping anecdotal image he has acquired and give him the due place time has ensured for him among the very greatest portrait painters in the evolution of pictorial art.

To familiarize oneself with the world of Frans Hals is an exciting adventure on many fronts. First and foremost we meet the people of his time as they appear in his work from about 1610 to near the time of his death in 1666. Contemporaries of the provincial society of the small but lively and prosperous town of Haarlem during Holland's Golden Age include men, women, and children from all walks of life: clergymen, merchants, a tramp, fishergirls, scholars and topers, wanton women and the mayor's wife, the herring vendor and the brewer, the mayor and the professor, the rich child and the urchin bent on mischief, the haughty squire and the minstrel, young and old couples and family groups, regents and regentesses, officers and sergeants of the civic guard, and those striking Haarlem citizens who served Hals as models for his paintings of the Four Evangelists, two of which, those of St. Luke and St. Matthew, were rediscovered in the State Museum in Odessa in 1959. Only two of these are self-portraits, one of which can be regarded as authentic (fig. 1). Meeting Frans Hals's contemporaries, as depicted by him, gives us not only reliable information on the appearance, dress, and life-style of the time, but opens up wider perspectives. Hals could do more than perpetuate the status of his models: without neglecting even the slightest detail characterizing their social position, he could penetrate to the core, the very essence of his models. He increasingly underplayed the outward appearance of his sitters, thereby bringing out their spiritual aspects—a development which reached its climax in the work of his later years. Inherent in this development is his phenomenal and inimitable brushwork, which can be compared to the orchestration of a musical composition.

Once we have become acquainted with the contemporaries he has immortalized, we are pleased to see them again because, as in the case of classical music, we are captivated anew by his "orchestration," so that those portrayed reemerge before the perceptive eye. Furthermore, what makes the orchestration so exciting to the "listening eye" is the great variation in keys, for each time Hals came across a new model he was inspired, both as artist and *metteur-en-scène*, to create yet another striking variant on his subject: man. Like a psychometric instrument, his brush reacted to the personality of his model, and the "recording" he made produced an abstract radiation from the canvas or panel on which he had projected the character and the essence of the sitter. Pose and gesture, face and hands revealed this essence to Hals, and he depicted it in

a surprising variety of tones with a thin *alla-prima* technique. A striking example of how he distilled the essence from the outward appearance may be found in the regents painting of 1641. Here we see how, in one portrait group, the hands are depicted by varying brushstrokes according to whether they are strong or weak (figs. 2, 3).

We are tempted by these fascinating "recordings" we have just mentioned to take a first quick glimpse at Hals's world: the sparkling orchestration which caught the ostentatious posing of the squire Jasper Schade van Westrum (colorplate 37), the cacophonous leitmotiv of Malle Babbe's shrieks (colorplate 28), the *adagio* lending a weighty mien to the very learned Johannes Hoornbeek (colorplate 39), or the revolutionary *presto* with which Frans Hals immortalized the carefree gentleman who, as the "Man in a Slouch Hat," defies the solemnity of a museum (colorplate 48). In the brio of his brushstrokes lies the secret that makes us recognize him as "the most painterly painter in the world," the greatest craftsman of his art, who captured life as it was lived and effortlessly made his contemporaries reach out to ensuing generations.

The surprising aspects of Frans Hals's work which we shall observe in this survey will determine the course we shall take when we examine it more closely. However, to arrive at a true evaluation of this masterly portrait painter, we must be warned against the dangerous misconception mentioned above, which, in the "appreciations" of his genre and group paintings, reduces him to the level of a storyteller whom the superficial onlooker identifies with the simple bons vivants whom he portrayed. This danger stemmed from the pens of romantic and overenthusiastic authors who failed to realize that not all was fun and games in Hals's world. If we look into this world seriously we shall see that the characters rarely laugh, and that, for example, the popular painting in the Wallace Collection in London, inappropriately titled *The Laughing Cavalier*, portrays no more than a latent laugh, a smile which indicates self-satisfaction rather than exuberant joy of life (colorplate 13).

Once we realize this, Hals's image will gain in dimension. He was not the artist whom we are compelled to identify with merry cavaliers and lusty drinking companions. He was the seventeenth-century "vitalist" who, inspired by human life, gave it form without a trace of ponderousness. Undeniably, there is in Hals a tendency toward melancholy, which can be detected in his self-portrait (fig. 1). It would probably be unjustified to suggest

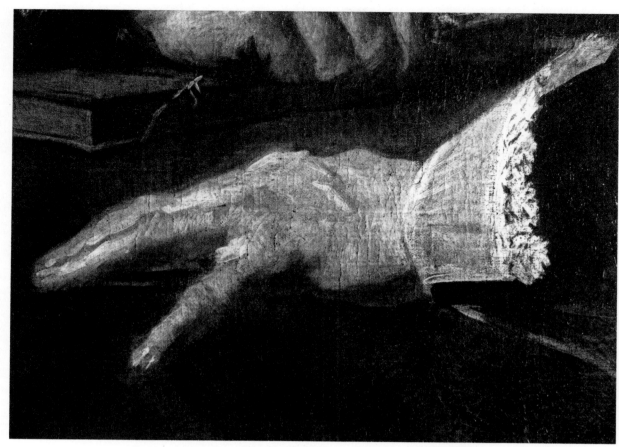

2. Hand of Dirk Dirksz. Del. Detail of *Regents of the St. Elizabeth Hospital of Haarlem* (see colorplate 33)

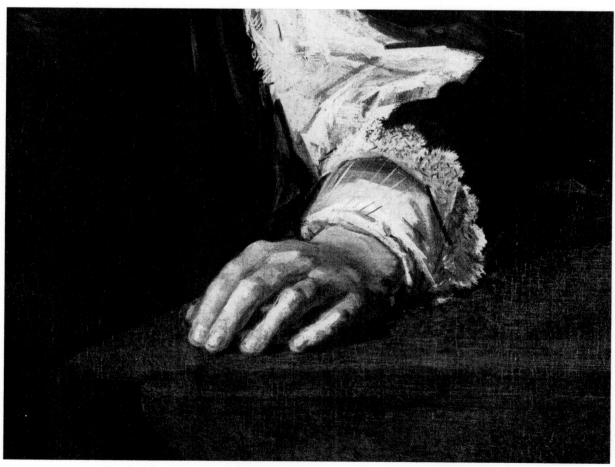

3. Hand of Sivert Sem Warmond. Detail of *Regents of the St. Elizabeth Hospital of Haarlem* (see colorplate 33)

that the melancholy expression of gifted artists like Hals, who gives the impression of having had few, if any, material worries, can be ascribed to the *melancholia ingenii* which we also see in the self-portraits of Rembrandt and Goya. But it is more difficult to fathom the genius with his deeply hidden impulses than the gifted artist, and it is evident that, in spite of Hals's apparently carefree nature, his models, after his "colorful" period, are characterized by a trace of melancholy which can be seen in the portraits of his younger models and even in the mood of the otherwise uncomplicated figure in the Kassel museum (colorplate 48). Hals's work is not dominated by laughter and joy, but by spirit, strength of mind, and an infinite interest in life in all its manifestations. Thus we salute him not merely as a painter of laughter, but above all as a painter of man.

FRANS HALS, the son of a clothworker, Franchoys Hals, and Adriaentgen van Geertenrijck, was born between 1581 and 1585 in Flanders in the southern Netherlands. As his parents were from Malines (Mechelen) it was sometimes assumed, in accordance with old sources, that this was his city of birth, but as he is often referred to in records as Frans Hals of Antwerp, it was probably there that he was born.

Like many others during that period, the Hals family migrated northward to Haarlem for religious reasons, as it is known that Frans's younger brother Dirck, who was also a painter, was baptized there on March 19, 1591. It is possible that from 1600 to 1603 Frans Hals was a pupil of Karel van Mander (Meulenbeke 1548–Amsterdam 1606), who was also a refugee and who settled in Haarlem in 1583 (fig. 4). Van Mander was a co-founder of the Haarlem Academy with Hendrick Goltzius and Cornelis Cornelisz. van Haarlem and distinguished himself as the author of the well-known *Schilderboeck* (Book of Painters) published in 1604. This encyclopedic handbook was modeled after Giorgio Vasari's *Vite de' più eccellenti architetti, pittori, scultori e italiani*. In his work, Van Mander collected a wealth of information about many old and contemporary painters.

In 1610 Hals became a member of the Guild of St. Luke, which, among other functions, monitored the rights and duties of the Haarlem painters. In the same year Hals married Annetje Harmansdr. She died five years later, leaving two children. One of them, Harmen (1611–1669),

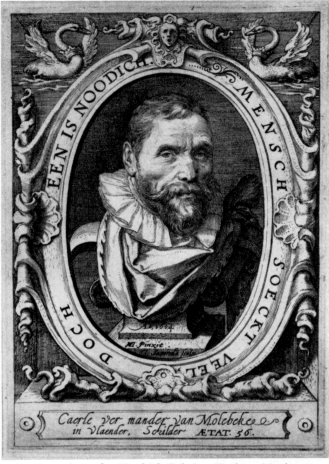

4. Jan Saenredam, after Hendrick Goltzius. *Karel van Mander.* 1604. Engraving. Print Room, Rijksmuseum, Amsterdam

was also to become a painter. The fact that Annetje had a potter's field burial is indicative of Hals's financial status at that time.

In 1616, at the time of the first civic guards painting (colorplate 6), the records show that Frans Hals stayed a short while in Antwerp, where he may well have become acquainted with the art of his great fellow countryman Rubens.

On February 12, 1617, Hals married Lysbeth Reyniers in Spaarndam, a hamlet near Haarlem (fig. 5). Nine days later their daughter Sara was baptized. Lysbeth bore him eight children, three of whom became painters: Frans Fransz. Hals the Younger (1618–1669), Reynier Fransz. Hals (1627–1672), and Nicolaes (Claes) Fransz. Hals (1628–1686). Jan Fransz. Hals, who was active from about 1635 to 1674, was probably also a son from the second marriage. Their daughter Adriaentgen married the still-life painter Pieter Roestraten (Haarlem 1630–London 1700), who was his father-in-law's pupil.

It has often been noted that in seventeenth-century Dutch painting two painters would work together on one painting. To mention two examples: Adriaen van Ostade "peopled" the *Church of Assendelft*, the magnificent panel by Pieter Jansz. Saenredam, dated 1649 (Rijksmuseum, Amsterdam), and Willem van de Velde the Younger completed the official portrait of Admiral de Ruyter by Ferdinand Bol in 1667 by adding the admiral's ship *De Zeven Provinciën* to the background (Rijksmuseum, Amsterdam). Hals also collaborated with his fellow artists, although very rarely. For example, he added the female figure to a still life (1630) by Nicolaes van Heussen (born c. 1600), now in the collection of Viscount Boyne of Bridgnorth, Shropshire, England. It appears from old archives that he collaborated with Willem Buytewech, who worked in Haarlem for some time after 1612. Pieter Molyn (London 1595–Haarlem 1661), who worked in Haarlem from 1616 on, painted rural backgrounds, including the landscape in Hals's portrait of Isaac Massa in the Art Gallery of Ontario (colorplate 16).

Some biographers have mentioned "irregularities" in the course of the artist's life. However, these legends are too unreliable to give a responsible account of his circumstances. We can rely on certain archives which give us casual information about the difficult financial circumstances in which Hals was caught up during his entire lifetime, circumstances which forced him to move many times, whenever he could not pay his rent. During these "wanderings" through Haarlem he lived in the Groot Heiligland, the street where the Frans Hals Museum is situated today.

We may be reminded in connection with his financial difficulties of a debt of two hundred guilders to the baker Jan Ykesz., who confiscated Hals's furniture and five paintings. Incidents like these indicate that the Hals household was not an example of well-ordered family life, although this would hardly be surprising in a milieu where a father and his five sons were all painters.

Frans Hals and his brother Dirck were guards and associates of the well-known chamber of rhetoricians called

5. Hendrik Keun. *Spaarndam.* c. 1770. India ink, 10 1/4 × 16 1/8″. Municipal Archives, Haarlem

the Vine Tendril (*De Wijngaertranken*), whose motto was "Love Above Everything" (*Liefde Boven Al*). In 1644 he was appointed an officer of the Guild of St. Luke of which he had been a member since 1610. It may be noted here that the board of the Guild of St. Luke consisted of a deacon and deans, whose functions may be compared with those of a chairman and board members today.

In 1662, owing to increasing financial difficulties, Hals was forced to ask the burgomasters of Haarlem for support. They agreed to give him a grant of fifty guilders, which was increased to one hundred and fifty guilders annually. A year later the support was finally settled at two hundred guilders a year for life. This amount was, according to monetary values at that time, a very reasonable allowance if compared, for example, with a minister's annual salary during the seventeenth century, which was about three hundred Carolus guilders.

The fact that Hals did get financial support points unequivocally to his straitened financial circumstances. However, a year before his death, he stood as surety in the amount of 458 guilders for his son-in-law Abraham Hendricksz. Hulst. Possibly the fees for the group portraits of the regents and regentesses of the Old Men's Almshouse, which he painted in 1664, enabled him to guarantee this surety. In any case, shortly before his death his financial position must have improved slightly.

Hals died at the end of August, 1666, more than three years before Rembrandt, in the town where his entire oeuvre was created. On the first of September his body was laid to rest beneath a simple tombstone in the choir of St. Bavo's Church (fig. 6).

Even though there may exist some uncertainty about the extent of Hals's financial distress during the last years of his life, the destitution of his widow, who survived him by eight years, was as evident as it was heartrending. Witness the information provided in the archives of 1675: "... having reached a ripe old age and being reduced to poverty, she will receive an allowance of fourteen stuivers a week." And to think that the lifesize portrait of Willem van Heythuyzen was sold in 1969 by the Prince of Liechtenstein to the Alte Pinakothek in Munich for twelve million German marks!

HALS's inspiring influence can be seen in varying degrees among his pupils. Arnold Houbraken in his *De Groote Schouburgh* (a compendium of the lives of Dutch artists) mentions that, in addition to his younger brother Dirck, his sons, and his son-in-law Pieter Roestraten, Adriaen van Ostade, Philips Wouwerman, and Vincent van der Vinne were also pupils of Hals. Judith Leyster and her husband Jan Miense Molenaer were also influenced by him. Hals's influence is less noticeable in the work of the Haarlem portraitists Johannes Verspronck, Bartholomeus van der Helst, and Jan de Bray.

Only one artist, Hals's compatriot Adriaen Brouwer, who between 1623 and 1626 worked in Haarlem as well as in Amsterdam, can be regarded as achieving the level of genius. There are in parts of his work suggestions of Hals's flowing brushwork, and if Brouwer was his pupil, as has been assumed, it is by no means impossible that pupil and teacher influenced one another.

The reason for the relatively slight impact of Hals's work on the Haarlem school of painters becomes clear when we realize that his great artistry was not merely due to his professional ability and skill, but rather to the extent of his originality, imagination, vitality, and spiritual depth, which transcends the concept of talent and is the mark of genius. The differences between Hals and his successors and imitators show the gap between genius and talent in general: "Genius does what it must, talent does what it can." This also applies to the more universal Rembrandt and his school. But his subjects, with their wealth of nuance, however difficult to emulate, inspired imitation more than did Hals's revolutionary touch. Just as Rembrandt is inimitable as a master of the pencil and etching needle, so is Hals in his complex expressiveness and gossamer light quality—features that are of essential significance and to which we shall return later in greater detail.

What we have just said about drawing and etching reminds us of Rembrandt's triple versatility as an artist, draftsman, and etcher. Frans Hals, on the other hand, was universal in scope within the limits of portraiture, but left no prints or drawings. The few drawings that are ascribed to him—erroneously, in our opinion—lack the power of Hals's sure hand. And the engravings connected with Hals's work are copies of existing or lost oils (figs. 8, 9). Take, for example, the portrait of a man in the Print Room of the British Museum (fig. 7). It was copied from a painting done about 1650–52 which now hangs in the Hermitage in Leningrad (colorplate 43). The drawing is interesting as a document since it shows that the man originally wore a hat, subsequently painted over by an unskilled hand.

It would be somewhat risky to suggest what Hals's drawings would have looked like, and we may ask ourselves whether his pencil strokes would not have had a

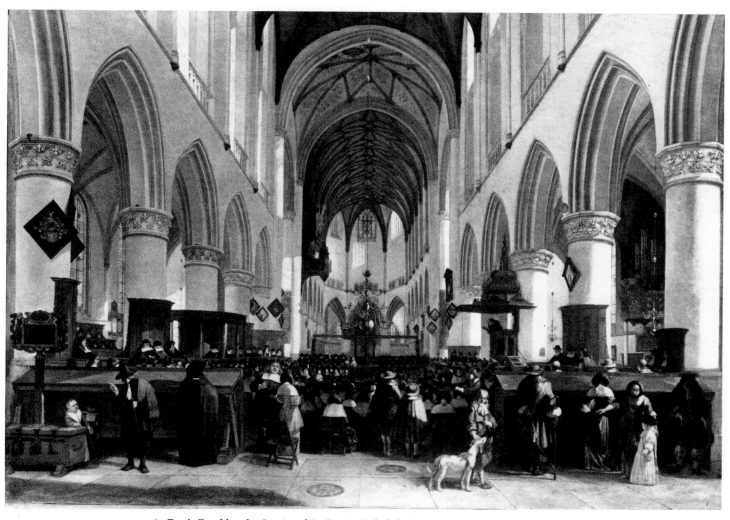

6. Gerrit Berckheyde. *Interior of St. Bavo's Cathedral, Haarlem.* 1673. Oil on panel, 24 × 33″. National Gallery, London

more pictorial character, such as the "snapshot" style of Adriaen Brouwer. They certainly would not have had the "cerebral" touch of the drawings attributed to him.

If Hals made no drawings, probably not even preliminary sketches for his group portraits (which nonetheless seem to be based on well-thought-out compositions), it may be due to the manner in which he wielded his brush. For Hals's way of painting increasingly involved the descriptive element, inherent in sketching and drawing. An illustration of this is the brilliantly painted limp hand of the *Man in a Slouch Hat* in the museum at Kassel (fig. 10). Moreover, it would seem that a system of preliminary study did not suit Hals's *alla-prima* technique, which shows great spontaneity and always gives the impression of an eyewitness account. In this connection we might quote Hals's Italian contemporary Bernini who, when asked why he did not make preliminary sketches for his commissioned portraits, replied: "I do not want to copy myself, but to create an original."

The most authoritative author on Frans Hals, Seymour Slive, who quotes Bernini in his work on Hals, estimates the number of Hals's authentic paintings at 220, a comparatively modest figure, but we have to remember that a large number of portraits, including all the work of his youth before 1610, have been lost. Many of his portraits are known only in part from copies, engravings, drawings, and photographs.

Our inventory of Hals's work shows that there are many group portraits and that in the five paintings of civic guards and the three of regents and regentesses in the Frans Hals Museum in Haarlem seventy-nine men and five women are portrayed. These eight group paintings, together with three individual portraits, all in the Haarlem museum, constitute the largest collection of Hals's work in the world.

Hals should not be regarded as the leader of the Haarlem art world, or as the inspiring master of a flourishing studio community such as those created by Rembrandt and, in

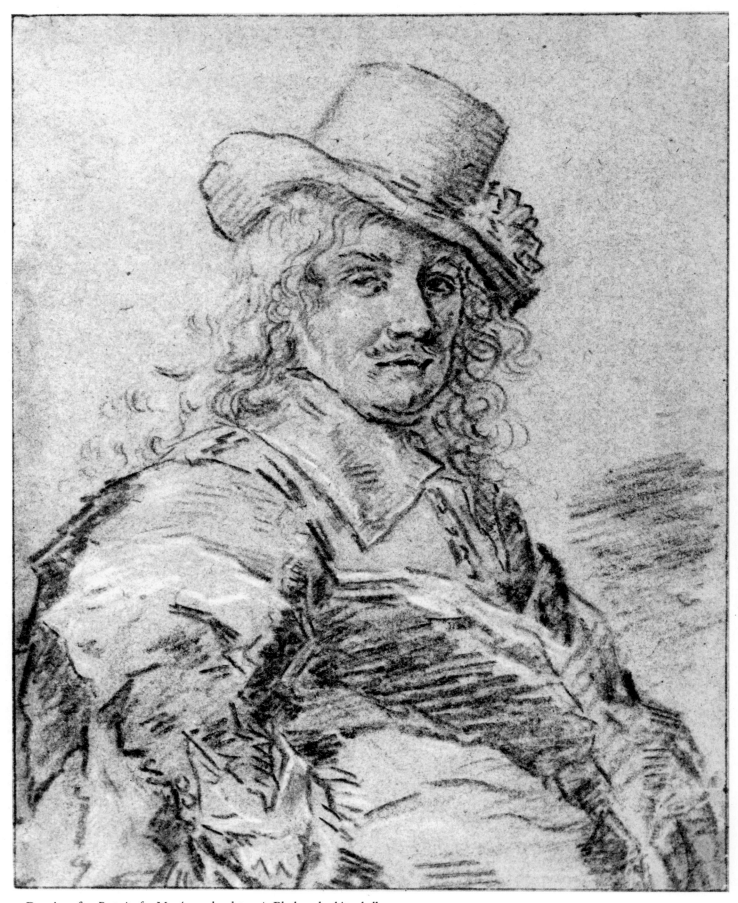

7. Drawing after *Portrait of a Man* (see colorplate 43). Black-and-white chalk.
Reproduced by courtesy of the Trustees of the British Museum, London

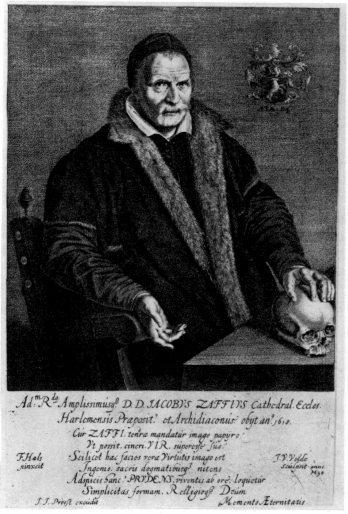

8. Jan van de Velde, after Frans Hals. *Jacobus Zaffius*. 1630. Engraving.
Print Room, Rijksmuseum, Amsterdam

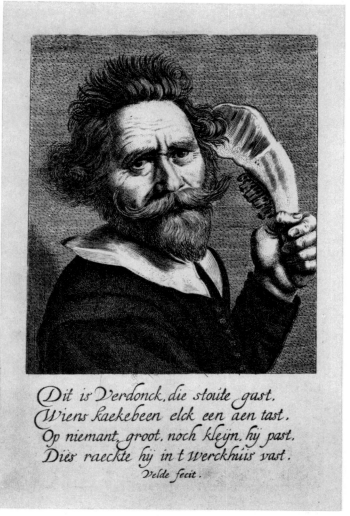

9. Jan van de Velde II. *Verdonck*. Engraving. Print Room,
Rijksmuseum, Amsterdam

particular, Rubens. For Hals was at the opposite pole to all things academic, but he injected stimuli which made the Haarlem school world famous. The fact that until the end of his life he continued to receive commissions shows a considerable degree of recognition, even though the decline in their number during his last years indicates a falling off of public interest in him. He continued to show a sureness of touch, despite the loose brushwork characteristic of his last paintings, and the reduction in the number of commissions was in no way due to any decline in his artistic powers resulting from the burden of his advancing years. In dealing with the portraits he painted at a very advanced age, we shall see that it is understandable why his contemporaries could not appreciate his revolutionary way of painting.

At an earlier stage there was no lack of individual appreciation of his paintings, as we may see from the opinion of the Haarlem author Theodorus Schrevelius, who, in 1648, said of Hals that "by his extraordinary manner of painting, which is uniquely his, he virtually surpasses everyone. His paintings are imbued with such force and vitality that he seems to defy nature herself with his brush. This can be seen in all his portraits—and he has made unbelievably many. They are painted in such a way that they seem to breathe and live." It may be noted here in passing that Schrevelius's reference to Hals's output as "unbelievably many" is in itself evidence that many portraits must since have been lost.

In 1661 Cornelis de Bie, in his *Gulden Cabinet van de edele vry Schilder-Const* (a collection of biographical notices on seventeenth-century painters, architects, sculptors, and printmakers), praised Frans Hals, "who is still active and living in Haarlem and miraculously excellent at painting portraits or counterfeits which are very rough and

17

bold, nimbly touched, and well ordered. They are pleasing and ingenious and seen from afar they seem alive and appear to lack nothing."

In his *Journal* of 1663 kept by the Frenchman Balthasar de Monconys during a journey through the Low Countries, he recalled, in connection with a visit to a militia company in Haarlem (to which company he is referring, we do not know): "There is also a building called *le Doul*, where the officers and magistrates of the city assemble to shoot with harquebuses and practice with the pike, which is called *butte* in France. There are very large portraits of the assembled men, and among them one by Hals, who is with reason admired by the greatest painters." This evidence of appreciation was no doubt an exception in view of the fact that the nonconformist Hals, particularly in his later years, was unacceptable to his contemporaries, as his vision did not conform to the conventional conception of art of the time.

In this respect Frans Hals shared the same fate as all great artists who, like him, overcame the transitoriness of their time. A comparison between the early works of Titian, Rembrandt, or Van Gogh, for example, with those of their later years shows that with them a similar process developed, though along different lines, culminating in the inevitable isolation which Goethe had in mind when he said, "Where it is high, it must also be desolate." In the case of Hals we may, for example, compare the supposed portrait of Bartout van Assendelft, dating from about 1610 (colorplate 2), with that of Herman Langelius, painted half a century later (colorplate 44). The criticism by Hals's contemporaries of the latter portrait shows that the man of the time was incapable of grasping the scope of the achievement we have just mentioned. "The man has to die before the artist lives," said the Dutch poet Willem Kloos (1859–1938). Greatness requires distance. It may be characteristic of Hals's brilliant artistry that a long interval was required for his "rebirth," when, at the time of the Impressionist generation after 1870, he became acknowledged and recognized.

Just as the name Shakespeare is closely associated with Stratford-on-Avon, so is Frans Hals's with Haarlem, despite the fact that he was not born there and that since the Late Middle Ages many personalities prominent in various fields, including painting, gave substance to the fascinating history of the town on the Spaarne. Hals's identification with the town in which he developed can be regarded as an indisputable confirmation of his genius.

Haarlem, the capital of the province of North Holland, now has a population of 165,000 inhabitants. In Hals's time (1622) the population numbered about 40,000 (fig. 11). This seven-hundred-year-old town lies twenty kilometers west of Amsterdam, the country's capital, and about nine kilometers east of the North Sea. The small river Spaarne runs through the town and forms the national waterway between the IJ of Amsterdam and the Haarlemmer meer, a lake which was reclaimed between 1848 and 1852 (fig. 12).

The town developed around the lordly mansion of Count Willem II, king of Germany, who, in 1245, granted a town charter to his place of birth. Between 1350 and 1388 the count's hall became the town hall, which remains to this day the center of the town hall building. This partly medieval town hall lies in the heart of Haarlem, which is surrounded by a natural opulence of woods, dunes, lakes, and sea. The town's network of small streets and alleys is still reminiscent of its medieval layout, with the Grote Kerk, or St. Bavo's Church, built between 1455 and 1490, at the center (fig. 13).

While Amsterdam became a trading center, Haarlem developed into an important industrial city. One of the mainstays of Haarlem's prosperity was the breweries, whose beer had a great reputation. About 1430 Haarlem had a hundred breweries, most of them on the Spaarne. The water they used was filtered through the sand dunes and enhanced the taste of the barley water, which was also exported in large quantities. Representatives of this great source of prosperity were painted by Hals, such as Johan Claesz. Loo, owner of the Three Lilies Brewery and colonel of the St. Hadrian Civic Guard Company, who also served as burgomaster for twenty years (colorplates 24, 25). Michiel de Wael, owner of the Sun and the Red Hart breweries, is portrayed in the *Banquet of the Officers of the St. George Civic Guard Company* of 1627, in which he has ostentatiously drained his glass *ad fundum* (fig. 14). A vivid representation of the impressive girth that can result from beer consumption may be seen in the robust picture of Claes Duyst van Voorhout, owner of the Swan Brewery (colorplate 30).

How closely the reputation of Haarlem beer was associated with the fame of Frans Hals, as late as the nineteenth century, may be seen from the popular genre paint-

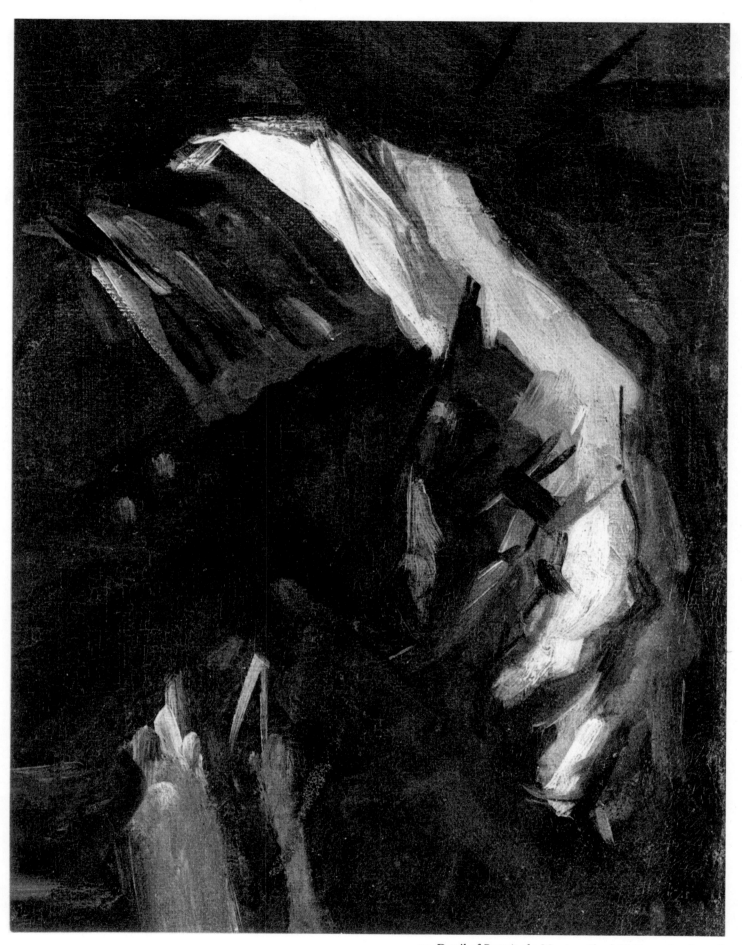

10. Detail of *Portrait of a Man in a Slouch Hat* (see colorplate 48)

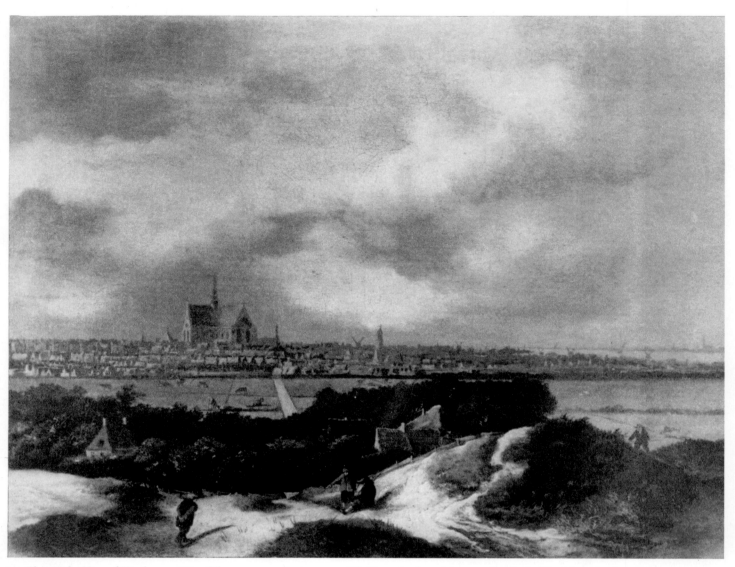

11. Claes Hals. *View of Haarlem.* c. 1660. Oil on canvas, 26 1/2 × 32 5/8″. Twenthe State Museum, Enschede, The Netherlands

12. Joost Jansz. Beeldsnijder. *Map of North Holland.* 1575. Colored woodcut, 36 7/8 × 27 3/4″. Provincial Atlas, State Archives of North Holland, Haarlem

20

ing by Edouard Manet, *Le Bon Bock,* in the Philadelphia Museum of Art. Manet had admired Hals's paintings in 1852 and was impressed by his sweeping brushstrokes. A French critic was indeed right when he said of Manet's painting, ". . . it was well done, but it was the beer of Haarlem."

The pure, chalky sand in the immediate vicinity of Haarlem forms a fertile soil for the growing of bulbs which, until about 1620, were imported from southern and eastern Europe, especially Turkey. The cultivation of tulips in particular became well known and made Haarlem famous as a flower town.

Another very important source of prosperity was the linen-weaving industry, which in Haarlem goes back to the thirteenth century when, as a result of guild riots, many

Flemings fled to Haarlem. After the fall of Antwerp in 1585, this industry was further promoted by the arrival of many skilled Flemings. It was also about this time that Hals's father, a "clothworker and weaver," migrated to Haarlem with his family. Since the invention of damask, the workshops of the Haarlem weavers had produced linen of the highest quality. Toward the end of the sixteenth century the colorful Haarlem linen became famous. One characteristic representative of this branch of industry was immortalized by Hals, namely, Quirijn Jansz. Damast, a weaver, who in 1642 became one of the city's burgomasters (colorplate 31).

The archives confirm that as early as the last quarter of the thirteenth century ships' wharves existed along the Spaarne. At the end of the fifteenth century, shipbuilding

13. Gerrit Berckheyde. *Marketplace at Haarlem, with View of St. Bavo's Cathedral.* 1696. Oil on canvas, 27 3/8 × 35 5/8".
State-owned Art Collections Department, The Hague. On loan to the Frans Hals Museum, Haarlem

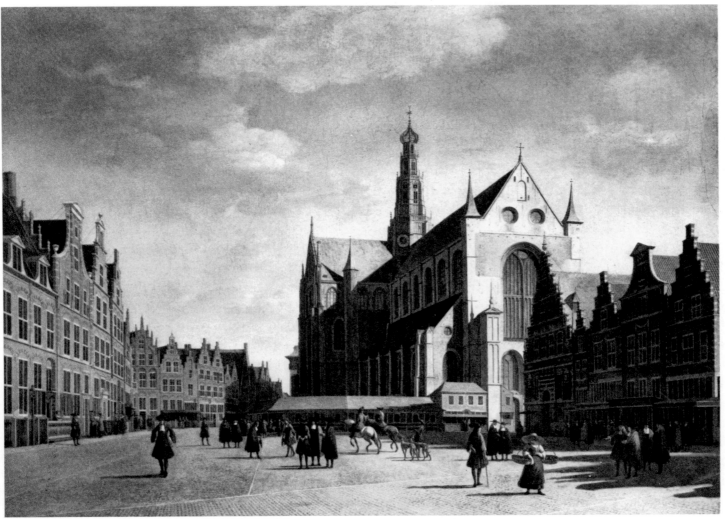

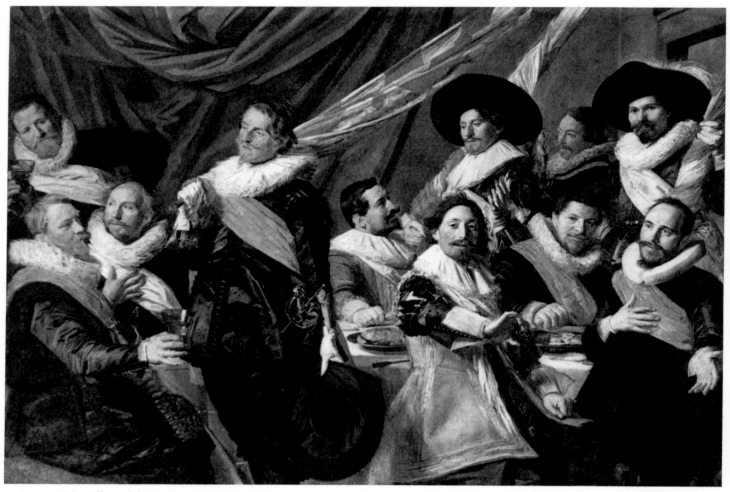

14. *Banquet of the Officers of the St. George Civic Guard Company*. c. 1627. Oil on canvas, 5′ 10 1/2″ × 8′ 5 1/2″. Frans Hals Museum, Haarlem

in Haarlem could be regarded as the third most important industry. On these wharves the so-called herring boats were also built for the herring fisheries, which in the seventeenth century proved to be a gold mine for the United Provinces. Even in 1728, eight hundred herring boats made three sailings a year, a sad contrast to our seas of today, threatened by depletion. A few of the millions of herrings caught through the centuries have been immortalized in the "small banquets" or "breakfasts" in the still lifes painted by Willem Claesz. Heda and Pieter Claesz., where they whet both our artistic and our culinary appetites.

Finally, Haarlem may also boast of its fame in the art of book printing. It still claims to have been the first in the invention of the art of printing, about 1440. A statue of the inventor, Laurens Jansz. Coster, stands in the heart of the city and is looked upon with as much pride by

Haarlemmers as Gutenberg's statue is by the citizens of Mainz. It is, however, an indisputable historical fact that the first newspaper in Europe, *Weeckelijcke courante van Europa,* appeared in Haarlem in 1656 and must therefore have been read by Hals. To this day Haarlem retains its reputation as a printing center.

Social life in Haarlem could boast of numerous charitable institutions known, as elsewhere in the country, as *hofjes,* erected since the end of the sixteenth century by wealthy burghers whose names usually remained linked with these institutions. These *hofjes* provided shelter to old women and sometimes also to impoverished old men of various denominations.

Some of the founders of these *hofjes* commissioned portraits from Hals. Unfortunately, these portraits were sold abroad in the nineteenth century to obtain money to restore or expand the *hofjes.* Thus the portraits of Paulus van

Beresteyn and his wife Catharina Both van der Eem were sold together in 1885 to the Louvre for one hundred thousand guilders, a sum which has left the Van Beresteyn Hofje considerably poorer than it had been. The portrait of the founder of the Van Heythuyzen Hofje, Willem van Heythuyzen, was sold in 1870 through the intermediary of an art dealer to the Brussels museum for seventeen thousand francs. And though the portrait of Jacobus Zaffius (colorplate 4) turned up only in 1919 in the showroom of the London art dealer H.M. Clark, with an unknown provenance, it is possible that this portrait was part of the inventory of the Vijf Kameren Hofje, founded in 1609 by the seventy-five-year-old Zaffius.

Last but not least we have the Haarlem school of painters. In the seventeenth century, tradition and prosperity provided fertile soil for the development of the art which reached its climax in the genius of Frans Hals. Karel van Mander tells us in plain language of this tradition in his *Schilderboeck* when he writes: "It has long been rumored that in Haarlem, in Holland, of old, or since very early times, there have been good, indeed the best, painters in the entire Netherlands, and this cannot be gainsaid or condemned: nay, rather should it be confirmed." Van Mander wrote these lines when the Romanizing trend, which he zealously propagated with pen and brush, had already reached its climax. It had followed the artistic production of the Late Middle Ages and preceded the naturalist school, which brought about emancipation from dependence on the great masters of the Italian Renaissance. These were the three periods, each of them falling roughly within a century, which covered three phases of the vigorous Haarlem art life, periods within which the restrained voice of the primitives, the boisterous sounds of the Renaissance and Mannerist artists, and finally the free harmony of Hals and his contemporaries successively formed the dominant characteristics. If we think of the impressive list of artists Haarlem produced, we are bound to realize that the development of their talents was stimulated by the forces at work behind the spiritual and economic life of the town. This is true of the greatest among them (for example, Jacob van Ruisdael and Hercules Seghers), notwithstanding the fact that the universal tendency in their work transcends local significance. But just as the urban character of Amsterdam must have exerted such indisputable influence on Rembrandt that it kept him within its boundaries for thirty-seven years, so must Haarlem have captivated Hals to keep him there for an entire life-span.

Artistic life has always depended on the environment. Thus in all cultural centers we see a fruitful interplay between environment and individual, as borne out in Europe by Florence as well as Rome, Bruges as well as Antwerp, and Haarlem as well as Amsterdam. Haarlem had the preconditions for a favorable cultural development so early that, as far as painting is concerned, we can put Haarlem before Amsterdam without being accused of disrespect or prejudice. Even before the towns of the northern Netherlands harbored important artists, the early school of Haarlem painters distinguished itself by its landscape painting. "It has been said and witnessed by the oldest painters," said Van Mander, "that traditionally the best and earliest manner of landscape painting began in Haarlem."

The rendering of nature in the paintings of the Haarlemmer Dirck Bouts and of Geertgen tot Sint Jans confirms the above statement. Their fresh landscapes, devotedly painted on panels, were a revelation of nature to the coming generations and predicted in their naturalist trends the mature creations, permeated with melancholy, of a younger son of the Haarlem family of painters, Jacob van Ruisdael. Thus we see that Hals's Haarlem could boast of a highly regarded artistic tradition.

The heyday of the Haarlem school is not only noteworthy for the fortunate influx of many artists of many talents. The Haarlem of the first decades of the seventeenth century was also the center of reaction against the domination of the academicians, whose eyes were too fixed on the south. As we have already stated, the nonconformist Hals was the mainspring of this reaction. His original brushwork broke through the restricted limits of academic conventions, and his genuine vitality still astounds us today.

The vitality of the Haarlem school of painting revealed itself most strikingly in the first quarter of the seventeenth century when it opened up new channels and created works of unprecedented freshness and originality, particularly in the "discovery" of nature. We should, in particular, mention Esaias van de Velde (1590/91–1630) and his pupil Jan van Goyen (1596–1656) as being among the finest of these painters.

The still-life genre which we have already mentioned in connection with the herring fishery could be regarded as a Haarlem school specialty. Hals had before him the

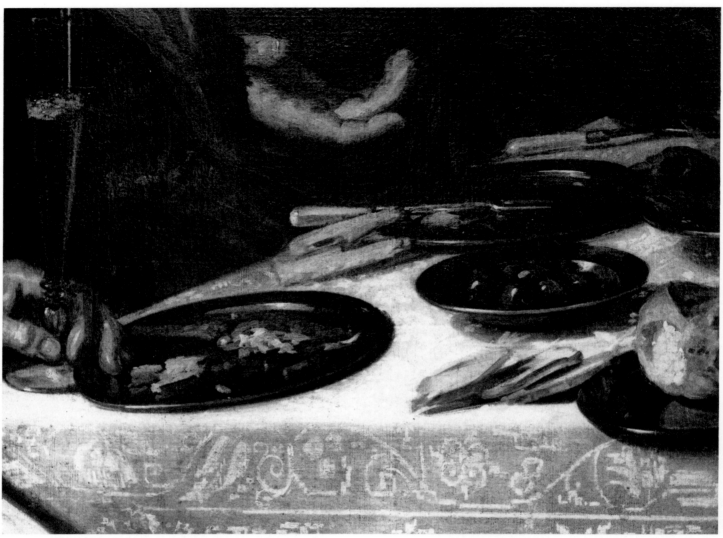

15. Still Life. Detail of *Banquet of the Officers of the St. George Civic Guard Company* (see colorplate 6)

accessories used by the Haarlem still-life painters, but he approached these accessories from a point of view entirely different from that of the patient still-life painters with their more contemplative natures. In his "still lifes" there was no slumbering "secret life" which the still-life painters were able, consciously or subconsciously, to reveal so brilliantly in those dead objects. Hals's food and table objects are bursting with "real" life, which they share with the guests at the civic guards' banquets (fig. 15). Thus Hals set a real meal before his guards in contrast to the quiet Haarlem "breakfast" pieces. Nevertheless, on closer view, these pieces often have something of the vitality of Hals's presentation. It has been said that the Haarlem still lifes seem but a crumb fallen from Hals's opulent table. This may be true, but we realize that the crumb fallen from his table is indeed no ordinary crumb, and for that reason alone far transcends its dimensions.

Haarlem remained a flourishing center of the art of painting, as may be seen from the fact that in 1661 no fewer than seventy-two painters were registered in the Guild of St. Luke. Side by side with the realistic trends, academicism lived on far into the seventeenth century in the work of conservative artists such as Salomon de Bray, the De Grebbers, and Caesar van Everdingen, until it finally died a little-lamented death. But the Haarlem burghers and their wives live on to this day, embodying the delightful variants of Hals's stirring orchestration.

They may be seen today in the historic building assigned to them in the Groot Heiligland, where the municipal collections were housed, namely, the Frans Hals Museum.

The original nucleus of the present museum complex consisted of the Old Men's Home, founded in 1608, which since 1810 served as an orphanage, and from 1913 on has provided a happy home for Haarlem's cultural heritage (fig. 16). Together with the Teyler Museum—the oldest museum in the Netherlands, founded in 1778—the Frans Hals Museum attracts thousands of visitors who have included Haarlem in their itinerary as one of the most important cultural centers of the Low Countries. Just as we meet El Greco in Toledo and Rubens in Antwerp in their own milieu, so we find Hals at home in Haarlem.

FINALLY, we should mention the background for Hals's métier for over sixty-six years and the "procedure" which he followed, consciously or intuitively, so that we may determine what standard the viewer should apply for a proper appreciation of his encounter with the sitter as well as with the painter himself. The verb portray is derived from the Latin *protrahere*, which in classical literature may be translated—apart from the literal meaning of "to bring out"—according to context, as "to bring into the light," "discover," or "disclose." We are left with the question: What is brought out, what is brought into the light when a model is immortalized by an artist?

For portraiture of distinction, that is, on a classical level, the answer could be that the artist brings to light or uncovers what lives in a more or less latent form behind outward appearance. To quote Pascal: "Material things are but a reflection of spiritual things, and God made the invisible manifest in the visible."

The separation of the "hidden life" from the visible world also applies when we consider the so-called lifeless objects which are the fascinating "living" subject of the still-life painting. It is this phenomenon in its manifestation that inspired Albrecht Dürer (1471–1528) to make his famous statement: "For verily art is embedded in nature; he who can extract it, has it." It is remarkable that more than three centuries later Paul Cézanne made the almost identical remark, which points to an unwritten law: "Nature does not lie on the surface, but hides in the depths. Through colors those depths are revealed on the surface. They rise up from the roots of the world."

Today it could also be said in this connection that the portraitist begins where the photographer ends. It is a fact that, however artistic a photographer may be, he remains dependent on his apparatus, the impersonal lens of his camera, which is the means by which he portrays his model, faultlessly, but automatically, and which records mercilessly whatever is visible on the surface, i.e., the optical appearance. What is fascinating about the photographer's art is not the "artistic approach"—involving the use of special equipment and shots taken from original angles—but also the development of photography. These are appreciable elements, which, however, are of an optical and technical nature, and must be regarded first and foremost as achievements of industrial art. The artist of repute, on the other hand, is not challenged by what he sees and feels, but by the invisible which he tries to uncover. With him the eye is the means, together with the mind and the imagination, and in that atmosphere he records what he has felt to be characteristic and essential when confronted with his model: in other words, abstract values. He selects as he works and re-creates his model in the abstract space of his panel or canvas, working in conjunction with reality, but rejecting what he deems nonessential. He "brings into the light" the spiritual elements which remain hidden to the nonreceptive eye. Thus the model can, in his "re-creation," arouse criticism as well as admiration, particularly as regards likeness, for every human being, and that includes the artist, has a different conception of his fellow man. Just as a crystal can be lit from different angles, the artist makes his own choice from many facets which can fascinate and intrigue us in the human countenance. A striking example is the portrait of *The Little White Girl* by James Abbott McNeill Whistler (1834–1903) in the Tate Gallery, London (fig. 17). Because the image is reflected in a mirror, we can see in one portrait two of the many facets of a face, whose interpretation is such a difficult task for the conscientious artist.

Maurice Quentin de La Tour (1704–1788) was such a conscientious artist. In a letter to the Marquis de Marigny, dated August 1, 1763, he "complains" about the phenomenon we have just mentioned: "Just think of the meticulous readjustments and laborious efforts needed to preserve unity of movement in spite of the changes that the vicissitudes of thought and the affections of the mind bring to bear on one's form and countenance! It is a different portrait with each and every change. Or to preserve unity of light when the path of the sun and changes in the weather necessitate constant adjustments in shading! A man eaten up with ambition for his art is surely to be pitied when he has to contend with so many obstacles."

The degree of likeness inevitably remains a futile source of discussion. Futile because individual impressions cannot be influenced. An interesting historical example is that provided by Prince Cosimo de' Medici. When in Amsterdam during his journey through the Netherlands, he wrote in his diary on January 2, 1668, that he was looking for portraits of the Admirals Tromp and De Ruyter, but was unable to find any that were true likenesses.

The soul, or the psyche, is the artist's aim, and the artistic value of a portrait can therefore be measured according to the degree to which the mind prevails over the physical appearance. However, the fascinating feeling of life that is the mark of a classical portrait also derives its vigor from the presence of the artist himself in the creation. He manifests himself without conscious intent through his vision and *mise-en-scène* by his brush and his coloring, in short, by a complex of characteristics which reveal his personal approach and experiences, and thus his "own nature." Anyone familiar with the pictorial arts, when seeing a detail from a classical work, will immediately be struck by the personal signature of the master, just as he will be disappointed by what is impersonal and imitated in the work of a copyist. When we see a classical portrait, our first impulse is to identify the artist in the work he has painted.

As mention has been made several times of the "psychological portrait," it should be pointed out that this is actually a very inappropriate term which the history of art has forced upon the classical portrait. Already in the 1930s Johan Huizinga (1872–1945), one of Holland's ablest historians, warned in a commentary on the *Regentesses* of Frans Hals: "Do not call it psychology." Indeed, Freud had not yet been born, and it could hardly be expected that Hals or Rembrandt applied psychology in their portraits. But the psyche, spirit, or soul—call it what you will—was indeed there. And Huizinga throws the baby out with the bath water when he continues: "Do not say that the painter succeeded in probing deep into their souls, he would never have thought of that. But his vision and skill were mightier than he himself ever knew or could have known, and he created a poem redolent of a whole era and an entire people." We, on the other hand, would say that in the group portrait of the *Regentesses* nothing can be detected that in the least suggests, directly or indirectly, the notion of a poem. Furthermore, it is more than "a whole era and an entire people" that find expression, it is the very thing the presence of which Huizinga denies—

convincing proof that his comments are based on false premises.

Even today, in accordance with Huizinga's point of view, the concept that a classical portrait reveals the spiritual qualities of the person portrayed is sometimes rejected. This attitude is symptomatic of the growing dehumanization of present-day society and of the tendency toward increased uniformity. This can be seen in certain trends of modern, and more particularly abstract, art in which the human figure is missing. Oscar Kokoschka rightly concluded that "there will be no portrait left of modern man, because he has lost his face and is turning toward the jungle." Little wonder that in this spiritual vacuum belief in the psychological approach of the classical artist diminishes or disappears.

But there is also a positive side to this tendency to deny the psychological quality of a portrait. For certain analyses credit the artist with more than he himself was aware of. We are thinking of the high-minded, literarily tinged, or tiresome psychological commentaries on whose wings Hals has been borne aloft into regions where he would certainly not have recognized himself. But we can hardly accept a complete rejection of the psychological phenomenon; if we did so, life and the essence of a work of art, even its *raison d'être*, would come to naught. Numerous opinions of artists through the ages disprove the fictitious reality of the soulless work of art. As characteristic evidence we should like to mention the opinion of the outstanding pastel painter referred to before, Maurice Quentin de La Tour, in his letter of August 1, 1763, to the Marquis de Marigny: "They think that all I am capturing is their outward countenance, but unknown to them I plunge to the very depths of their being and bring it back in its entirety."

By way of summary and illustration of what has been discussed above, I shall refer to three portraits, dated about the same period, by Nicolaes Maes, Rembrandt, and Frans Hals respectively (figs. 18, 19, 20). In 1661 Nicolaes Maes and Rembrandt painted the same model, Margaretha de Geer. Hals's portrait of Adriana Bredenhof is part of the above-mentioned group portrait of the *Regentesses of the Old Men's Almshouse* of 1664. Nicolaes Maes, who is here Rembrandt-like in his concept (later he was to move away from the master), shows himself to be a sound portrait painter with limited talent, a talent incapable of penetrating beyond the visual—"through a mask" (Rodin)—unlike Rembrandt, who had the striking ability to reveal the "nobility of heart" of his model behind her outward

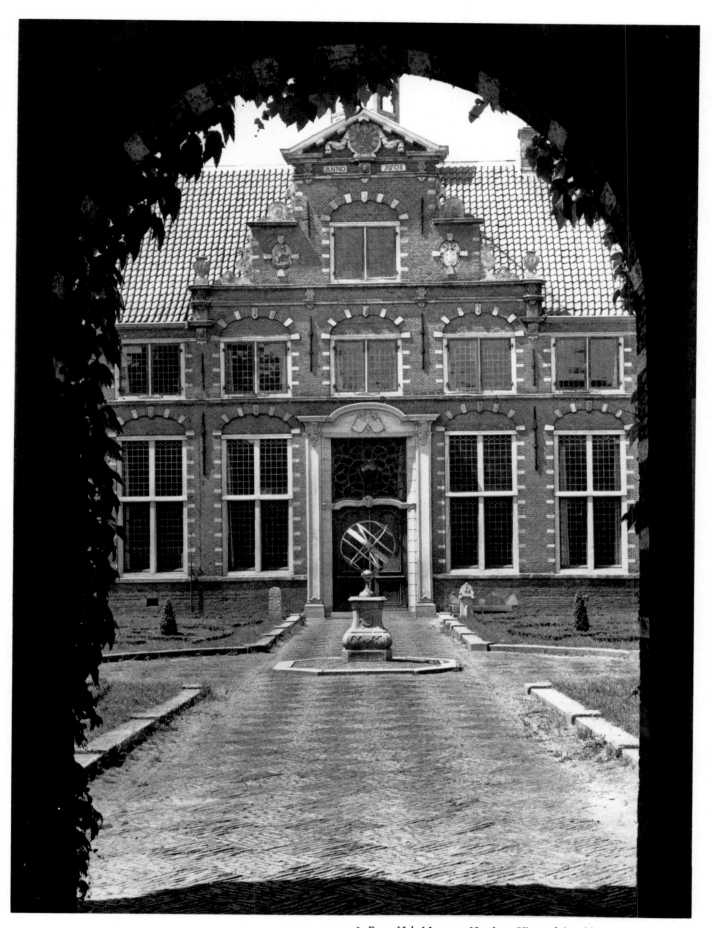

16. Frans Hals Museum, Haarlem. View of the old main building. 1608

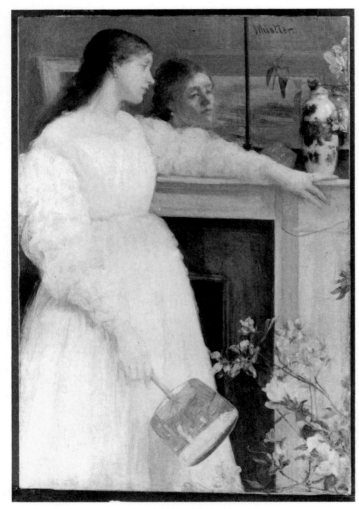

17. James Abbott McNeill Whistler. *The Little White Girl: Symphony in White No. II.* 1864. Oil on canvas, 30 1/8 × 20 1/8″. The Tate Gallery, London

18. Nicolaes Maes. *Margaretha de Geer* (detail). 1661. Oil on canvas; size of entire painting, 34 5/8 × 26 3/4″. Museum of Fine Arts, Budapest

19. Rembrandt. *Margaretha de Geer* (detail). 1661. Oil on canvas; size of entire painting, 50 3/4 × 38″. National Gallery, London

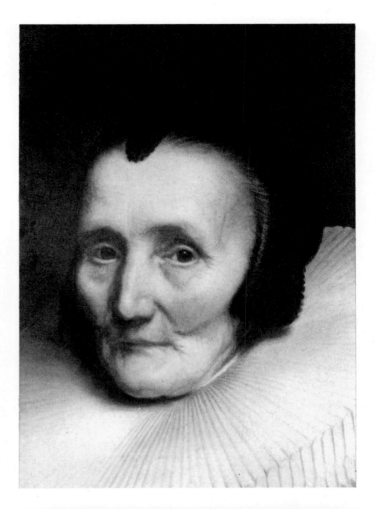

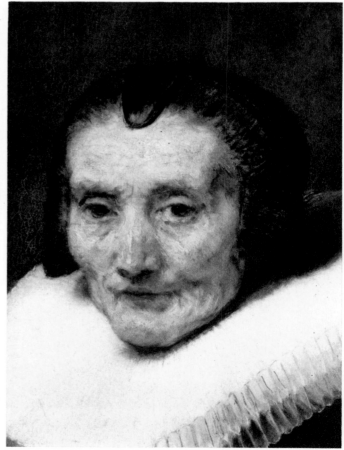

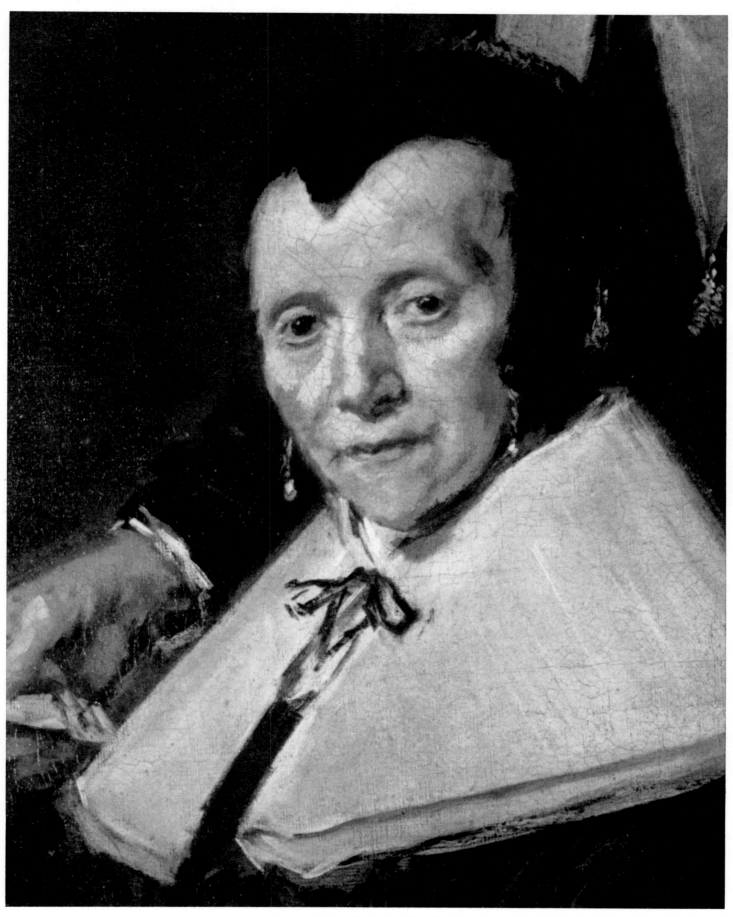

20. Adriana Bredenhof. Detail of *Regentesses of the Old Men's Almshouse* (see colorplate 46)

appearance. Portraits by painters incapable of showing the essence of their models can be compared with glimpses of the sun through wisps of clouds—we recognize its familiar appearance but we do not experience the vibrant fullness and warmth of its rays. In that respect Hals's work is always cloudless, and his portraits radiate the warmth of the living person.

It is also fascinating to compare the way Rembrandt and Hals approached their models. Both show the same genius in their artistic potential, but are strikingly different in their brushwork. Rembrandt is more compellingly present in his heavily impastoed portraits, while Hals's lighter technique seems to give his portraits a livelier touch. Yet Rembrandt's sonorous voice and Hals's lighter tones merge in a common human harmony.

LASTLY we come to the portraits of the civic guards and regents which we regard as the "symphonies" in Hals's work, with the harmony of life and color as the leitmotiv. The group portrait is peculiar to the northern Netherlands. Men and women meeting for a common purpose gave rise to commissions to artists for collective portraits. Such portraits were produced over a period extending from about 1530 to the first half of the nineteenth century and were intended to decorate the various halls where those who were portrayed met. They include such subjects as portraits of pilgrims to Jerusalem by Jan van Scorel (1495–1562), painted in the first half of the sixteenth century (Frans Hals Museum and Centraal Museum, Utrecht), officers and sergeants of the civic guards, feasting or parading (Rembrandt's *Night Watch*), assemblies of regents and regentesses, lecturing professors (*praelectores anatomiae*) with their surgery students (anatomy paintings), or parents with their children in family groups. Artistically the production of these panels and canvases could be divided into two groups. The first and larger group is mainly significant because of the reliable information it provides about manners and customs of the time, and comprises works often painted with great competence and skill, but lacking in vision and imagination. The result was that the subjects remained confined, not only within the area in which they now fulfill an historical and decorative function, but also in time, condemned to serve as illustrative material for their own epoch.

The second group provides just as much of the same information but surpasses the first group by the ability of its artists to make general human values prevail over the limited climate of the period. It is in this group that we find the best Dutch painting traditions in such works as Rembrandt's *Anatomy Lessons,* his *The Syndics of the Draper's Guild,* and his family portraits, as well as in Frans Hals's group portraits.

When we consider Hals's continuous production of group portraits, we realize that he was the first to conquer the problem of space. The difficult task inherent in the immortalization of a company of people was solved by Hals with a facility which comes as a relief after seeing the struggles of older colleagues. Although artists such as Dirck Barendsz., Cornelis Ketel, and Cornelis Cornelisz. van Haarlem (fig. 21) had already delivered the group portrait from the rigid pattern of full-face heads—at first recorded in rows one above the other—they had not as yet succeeded in bringing harmony to space; the composition is always too tight and the problems of the commissioned work get the better of the painter. The subjects, however excellently portrayed as a rule, still seem to lack any mutual contact. They are mostly squeezed together in a group which could be compared to a clumsy arrangement of beautiful flowers in too narrow a vase. Hals achieved a natural relationship, both between the people in the group and the spectator, who is drawn into the setting. Thus we experience in Hals's group portraits the same feeling as when we look at the individual subjects: the effortless transition in time which not only keeps alive those portrayed, but also the reality of the event as long as these works of art remain. In these collective groups, too, the artist broke with accepted tradition. He was able to cope with matter and time, bourgeois mentality and materialism, ostentation and vain display while respecting the actual motives of those who commissioned him, so that both the customs of the time and his sitters' wishes were duly heeded.

The greatest problem that an artist faces, when he acquits himself of his heavy task of portraying a number of contemporaries in one group, is that his subjects may appear rigid and the communication between them lifeless; in short, there is the danger of making them look like waxwork figures confined in a period museum. As we look at the civic guards of 1616 (colorplate 6) and are drawn into the life that flows on all sides over the frame, which cannot contain it, we may not realize how much the success of this group portrait is due to Hals's ingenuity.

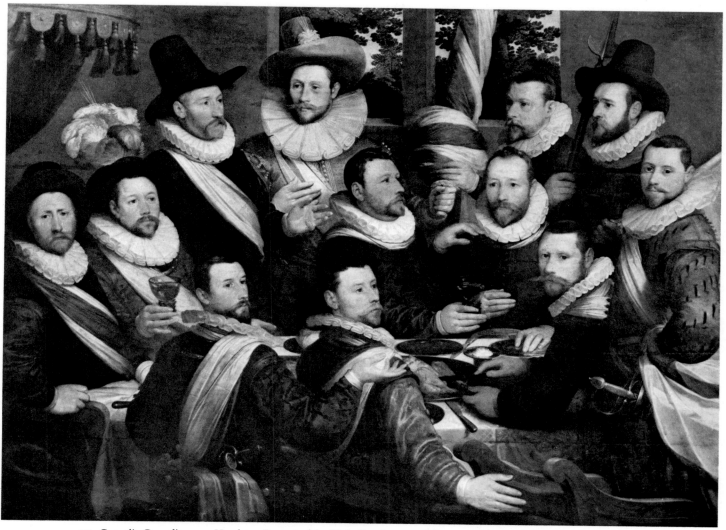

21. Cornelis Cornelisz. van Haarlem. *Banquet of the Civic Guards.* 1599. Oil on panel, 61 1/2 × 87 3/8″. Frans Hals Museum, Haarlem

What a challenge it was to project twelve guards at a table in the spacious meeting room within a space of five feet by ten feet without offending reality in every conceivable way. In order to grasp the magnitude of Hals's genius it may be instructive to look at the group portrait of a talented artist who faced the same problem seventeen years earlier: the guards portrait painted by Cornelis Cornelisz. van Haarlem in 1599 (fig. 21), also in the Frans Hals Museum.

We see here a group portrait by an artist who, in this case, was unable to rid himself of the tableau-vivant atmosphere in which so many of his colleagues, both before and after him, were mired. We also see in this portrait the compositional problem that Hals must have confronted in 1616, but that he skillfully overcame. Cornelis's unimagi-

native pyramid-shaped composition was rejected by Hals; instead, he favored a well-thought-out arrangement of figures, as we shall see further on. Cornelis's subjects are so little differentiated that the group portrait gives the impression that it consists of various members of a family, each one of whom seems to be an expressionless variant of the dominant family resemblance.

FINALLY, we should like to give a few more details about the historical background of the guards and regents. The guards, as we know them from traditional portrayals, must be regarded as a young offshoot of the guilds, the earliest of which originated in the fourteenth century. These guilds were still part of medieval

life when the Church had a strong influence on society. The confraternities of St. George, St. Sebastian, and St. Hadrian are reminders of this.

In the archives of Haarlem there is a fifteenth-century document in which the sheriff and the aldermen authorize the acceptance of the recruiting of one hundred and twenty guards into the Guild of the Crossbowmen of the *St. Jorisdoelen*, or St. George Company, which in the seventeenth century was still designated as the *Oude Schuts* (see fig. 22). In addition to this elite corps of urban patricians, the fraternity of St. Sebastian, who used the handbow, was also mentioned in the fifteenth century. In the sixteenth century, 1519 to be exact, a special firearms unit, the *Cluveniersdoelen*, was established under the protection of St. Hadrian. This unit was called the *Jonge Schuts* to distinguish it from the *Oude Schuts*. The fraternity of St. Sebastian ceased to exist as early as 1560, partly because the light handbow was no longer effective in battle. At that time, through reorganization, the two existing guilds of St. George and St. Hadrian acquired an entirely different character, becoming, in effect, town militia.

The town authorities had a decisive voice in their selection of leading personalities for the militia. The result was that in the seventeenth and eighteenth centuries most of the officers belonged to the regent families. The choice of the guards themselves was supervised by the magistrates. The guards' shooting exercises took place in the *doelen*, or guards' hall, the target they shot at being called a *doel*. The guards' banquets had their origins in the time of the guilds. While these repasts were originally paid for by the guards themselves, by 1558 the latter were being entertained each year by the magistrate, a privilege which apparently degenerated into excessive eating and drinking, as can be seen from an order dated 1633, which referred to the reprehensible fact that "in all gatherings of companies of corporals lasting an entire week, an excessive sum of money was spent at great expense to the municipality." After that it was specified that the corporalships should "once a year be allowed to foregather with the others (that is, to feast), and that this gathering should not last for more than three, or at the most, four days."

In very exceptional cases, in times of emergency, the guard companies voiced opinions on political matters. They also brought a touch of color to the community. The famous group paintings, which evoke the names of Hals and Rembrandt, give us a glimpse of a generation which saw more beer and wine flow than guards' blood.

The guards system finally became so estranged from its original function of defense that all that prevailed was the decorative element.

These guards portraits, painted to adorn their meeting halls in commemoration of the various corporalships, grew in the minds of later generations to be monuments of the material glory of old Dutch society. We see in the outward appearance of Hals's paintings of the guards a kind of "vanity fair," but also a demonstration of opulence, the life and color of which exude an irresistible charm.

Just as in the case of the guards paintings, the more sober regents paintings had already acquired a tradition in Haarlem in 1641 when Hals fulfilled his commission to portray the regents of Haarlem's St. Elizabeth's Hospital. The tradition of the portraying of regents did not, however, originate in Haarlem, for Hals was the first to receive such a commission in that city. As we shall see, he was able, while fulfilling this assignment, to find a surprising solution for the problems that immortalizing a governing board sitting behind a table can bring.

Regents and regentesses were the administrators of social and mostly philanthropic institutions, of which they were in charge. Thanks to their desire to have their portraits decorate their halls, many such paintings were made. The earliest, done by Aert Pietersz. in 1599, is in the Rijksmuseum in Amsterdam, where we can also see the most famous regents piece, *The Syndics of the Draper's Guild*, done by Rembrandt in 1662.

In addition to the regents portrait for St. Elizabeth's Hospital, Hals painted the regents and regentesses of the already mentioned Old Men's Almshouse in Haarlem in 1664. These paintings presented the difficult problem of grouping and portraying the subjects in such a way that some kind of living relationship was created between them, and the group did not become frozen into a tableau-vivant. In this type of group painting the danger is greater than that with the guards or anatomy-lesson portraits, as in the latter cases some type of action is present, providing the possibility of group management. Generally the regents pieces had the stereotyped appearance of a number of ladies or gentlemen sitting behind a board table, mostly painted full face, but hardly conveying the impression of mutual contact. They belong to the group portraits which we classified before under the first group. Frans Hals's regents pieces, however, deserve in this respect as high a score in the second group.

The numerous definitions whereby man has tried to

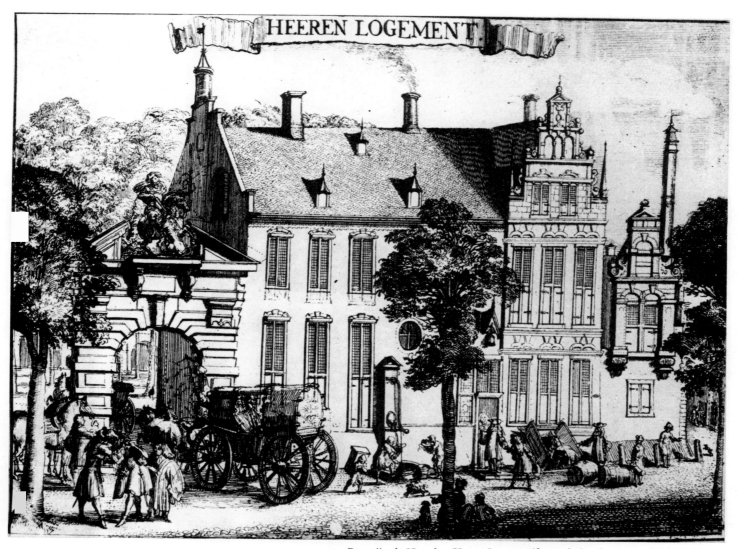

22. Romeijn de Hooghe. *Heeren Logement* (formerly headquarters of the St. George Civic Guard Company). Engraving, 6 7/8 × 9 1/4″. Municipal Archives, Haarlem

convey the notion of "art" have one thing in common, namely, that they throw light on only one facet of a complex phenomenon. Some definitions, on the other hand, are more comprehensive or apply specifically to a certain art form. One definition which can be applied to Hals's work is found in Claude Terrail's words: "Art is to idealize the commonplace and to materialize the unreal."

Familiarity with Hals's portraits makes us aware of the true balance between matter and spirit, a balance that was felt by Martin Buber (1878–1965) as the *Gestalt gewordene Zwischen*, between *substantia humana* and *substantia rerum*, between mind and matter, body and soul. As a portrait painter in a provincial community Hals had to face a bourgeois mentality, its materialism and vain ostentation. Terrail's definition expresses the victory of the mind over these enemies, as Hals made the mind conquer the banal. As an interested but detached observer, Hals was never vulgar with the vulgar or hearty with the hearty. He had the genius's ability to combine the character, essence, and appearance of his models, who, under his brush, lost their material weight while losing none of their "volume." If any artist had the unlimited ability to lift the temporary above the commonplace and to spiritualize what is transitory, that artist was Frans Hals.

33

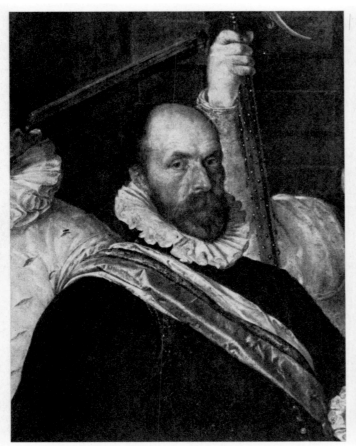

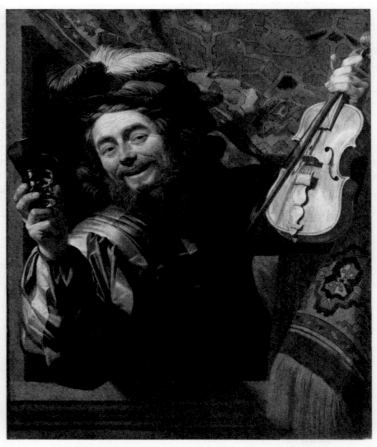

23. Cornelis Ketel. *The Company of Captain Dirck Jacobsz. Rosecrans and Lieutenant Ruysch* (detail). 1584. Oil on panel; size of entire painting, 48 7/8 × 93 1/4″. Rijksmuseum, Amsterdam

24. Gerard van Honthorst. *The Merry Fiddler.* 1623. Oil on canvas, 42 1/2 × 35″. Rijksmuseum, Amsterdam

25. Detail of fig. 24

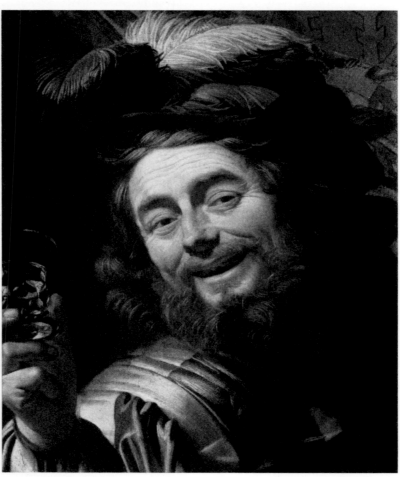

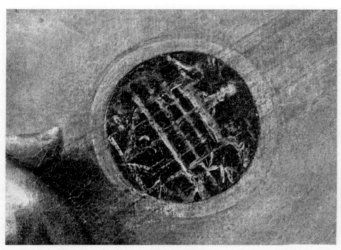

26. Judith Leyster. *The Serenade* (detail). 1629. Oil on panel; size of entire painting, 18 × 13 3/4″. Rijksmuseum, Amsterdam

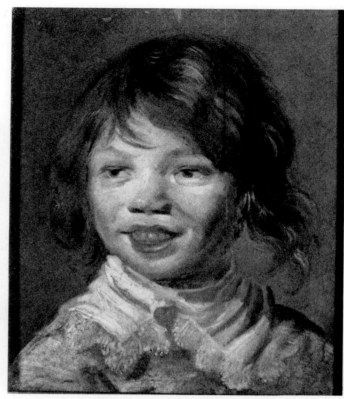

28. School of Frans Hals. *Laughing Boy*. After 1625. Oil on panel, 13 3/8 × 11 3/8″. Musée des Beaux-Arts, Dijon

27. Detail of *The Lute Player* (see colorplate 10)

29. Johan Damius. Detail of *Banquet of the Officers of the St. Hadrian Civic Guard Company* (see colorplate 18)

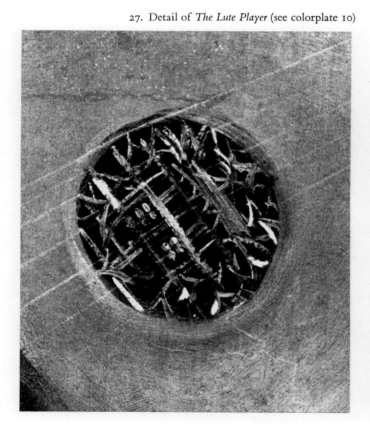

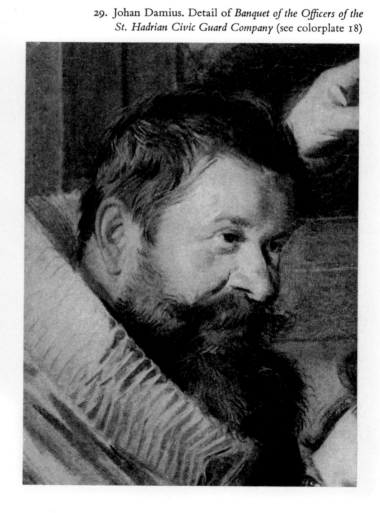

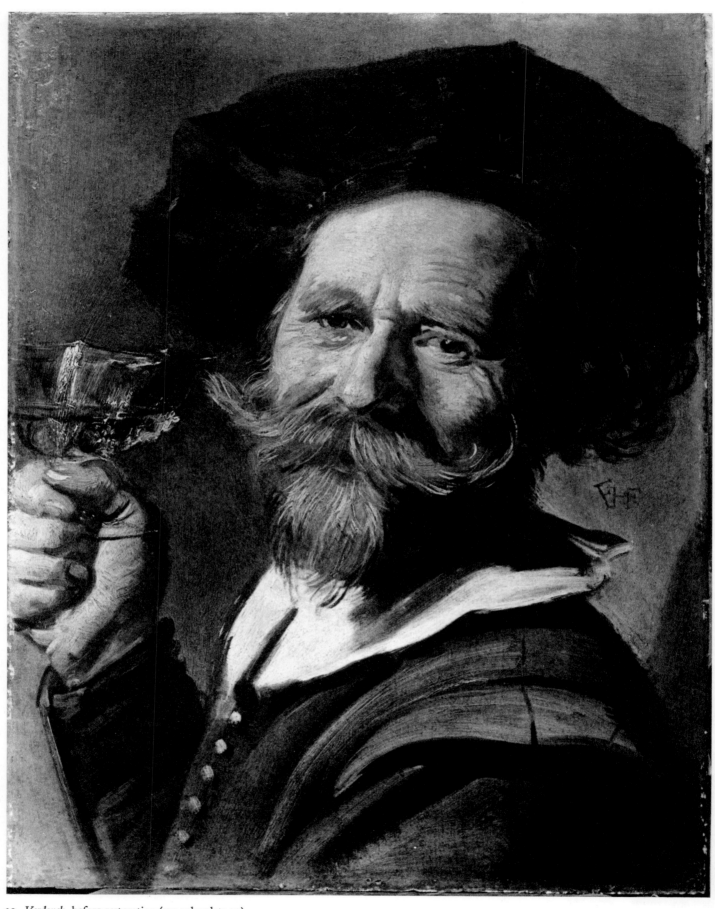

30. *Verdonck*, before restoration (see colorplate 17)

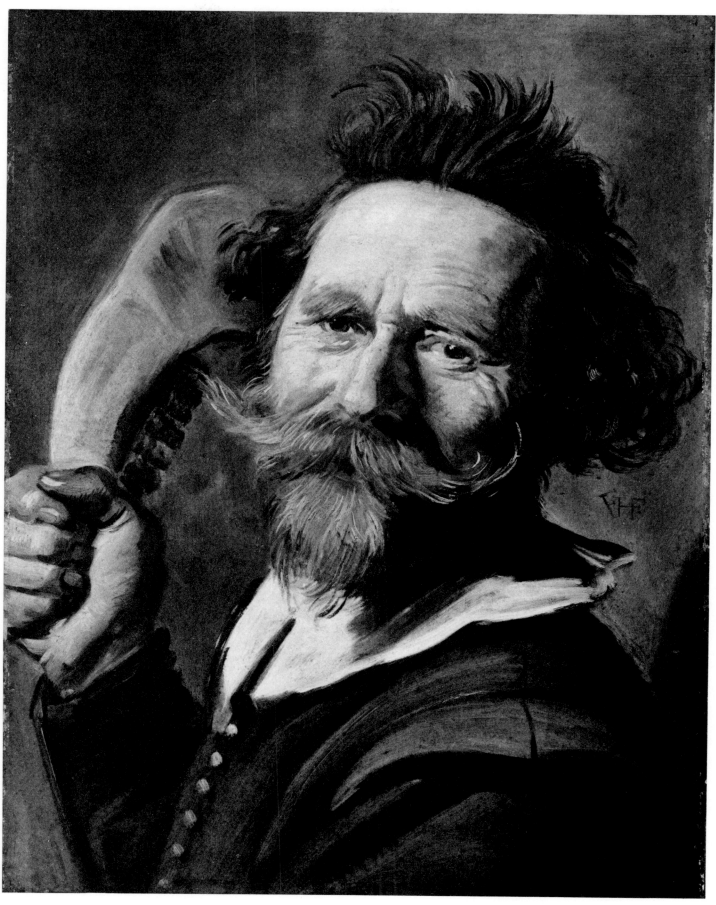

31. *Verdonck*, after restoration (see colorplate 17)

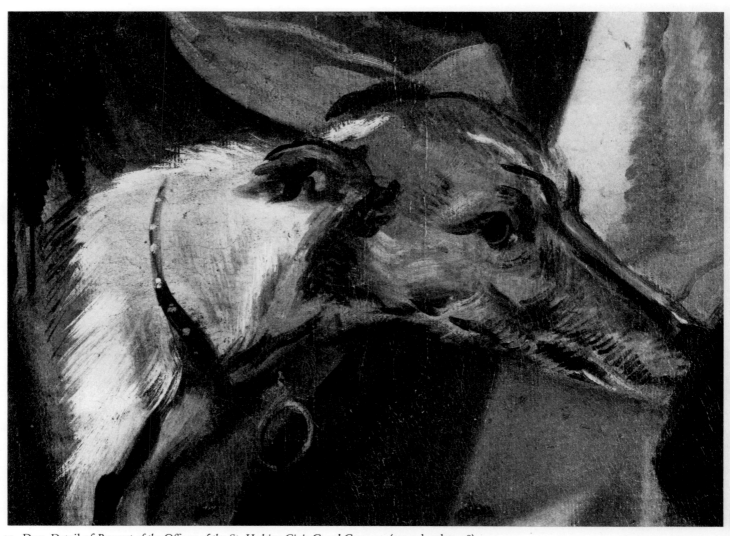

32. Dog. Detail of *Banquet of the Officers of the St. Hadrian Civic Guard Company* (see colorplate 18)

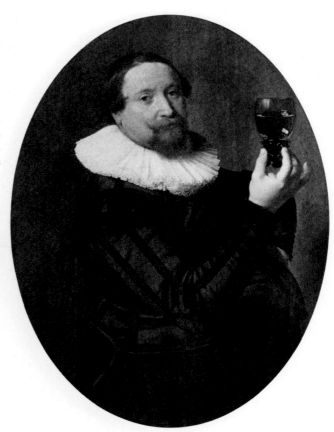

34. Nicolaes Eliasz., called Pickenoy.
Maerten Rey. 1627. Oil on panel,
39 × 29 1/8″.
Rijksmuseum, Amsterdam

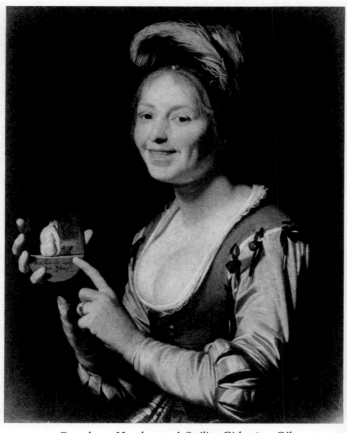

33. Gerard van Honthorst. *A Smiling Girl*. 1625. Oil on canvas,
32 × 25 3/8″. The St. Louis Art Museum. Purchase: Friends Fund

35. Detail of fig. 34

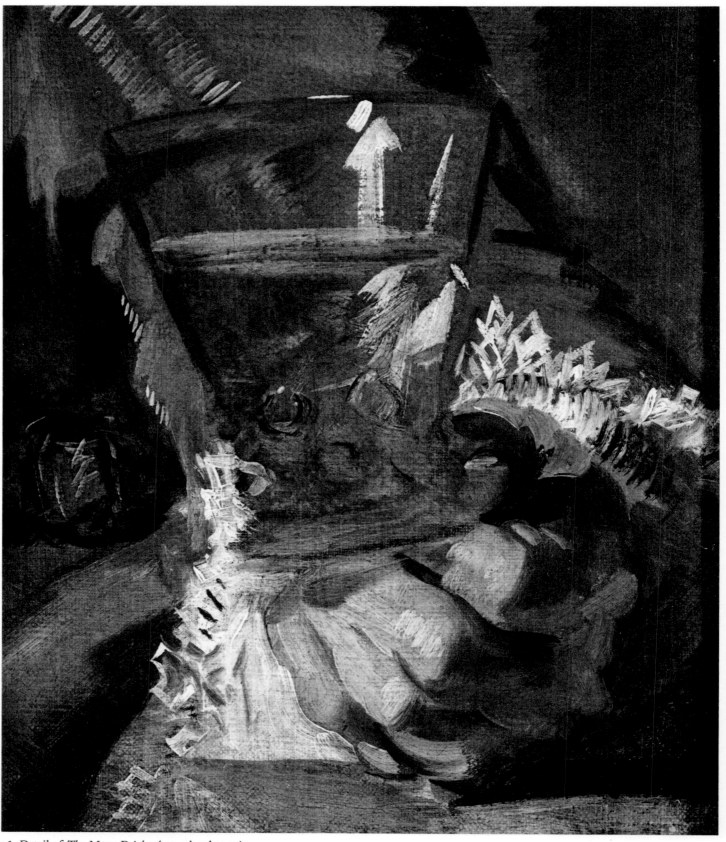

36. Detail of *The Merry Drinker* (see colorplate 22)

(opposite, top)
37. Rembrandt. *The Company of Captain Frans Banning Cocq and Lieutenant Willem van Ruytenburch*, known as *The Night Watch*. 1642. Oil on canvas, 11′ 11″ × 14′ 4″. Rijksmuseum, Amsterdam

(opposite, bottom)
38. *Officers and Sergeants of the St. George Civic Guard Company*. 1639. Oil on canvas, 7′ 2″ × 13′ 10″. Frans Hals Museum, Haarlem

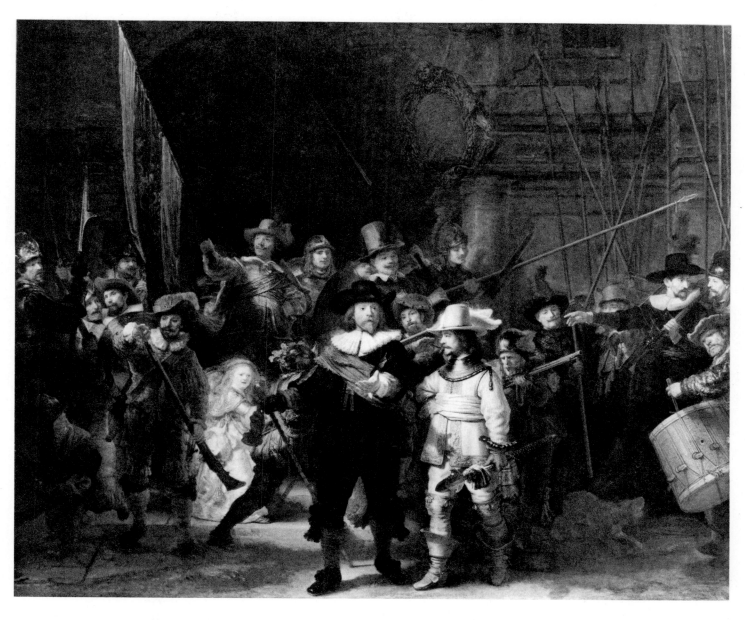

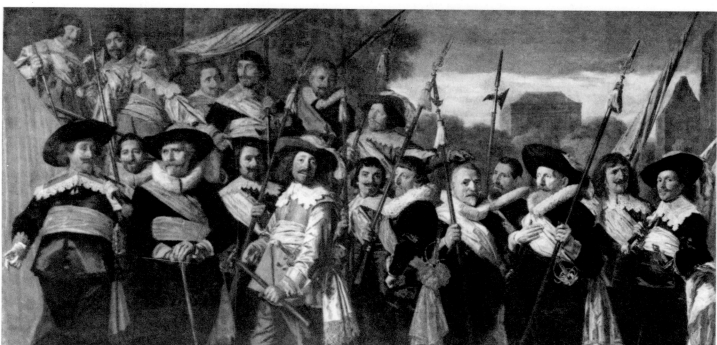

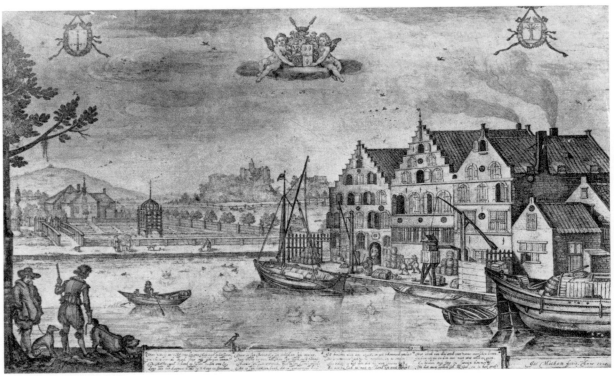

39. Jacob Adriaensz. Matham. *Brewery "The Three Lilies."* 1627.
Oil on panel, 28 × 45 5/8″. Frans Hals Museum, Haarlem

40. D. de Wit and P. H. Jonxis, after W. Hendriks. *Grote Doelenzaal at Haarlem*
(headquarters of the St. Hadrian Civic Guard Company). Engraving. Frans Hals Museum, Haarlem

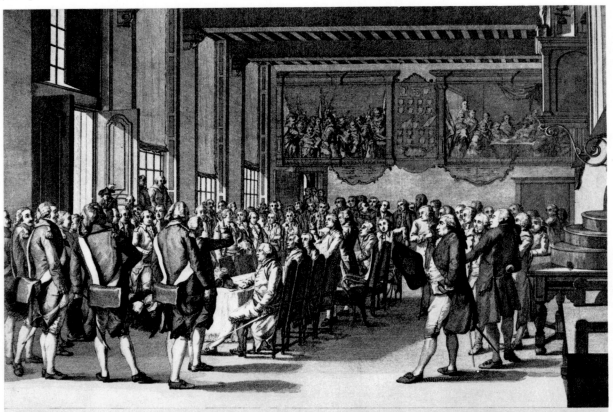

AFBEELDING der PLECHTIGE BEËEDIGING van het BATAILLON
PRO ÁRIS & FOCIS, als een der BATAILLONS, van de nieuw
opgerechte Schuttery der stad HAARLEM op den 5 April 1787.

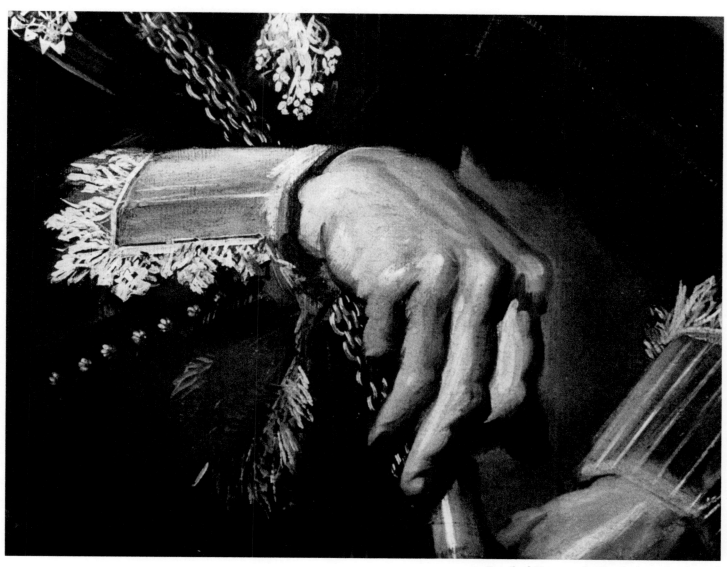

41. Detail of *Pieter van den Broecke* (see colorplate 26)

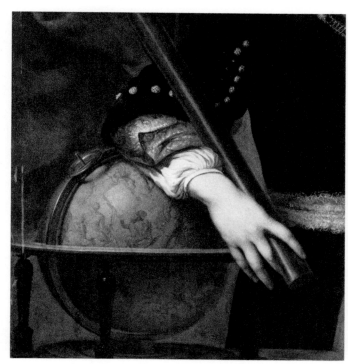

42. Ferdinand Bol. *Michiel Adriaensz. de Ruyter* (detail). 1667.
Oil on canvas; size of entire painting, 61 3/4 × 54 3/8".
Rijksmuseum, Amsterdam

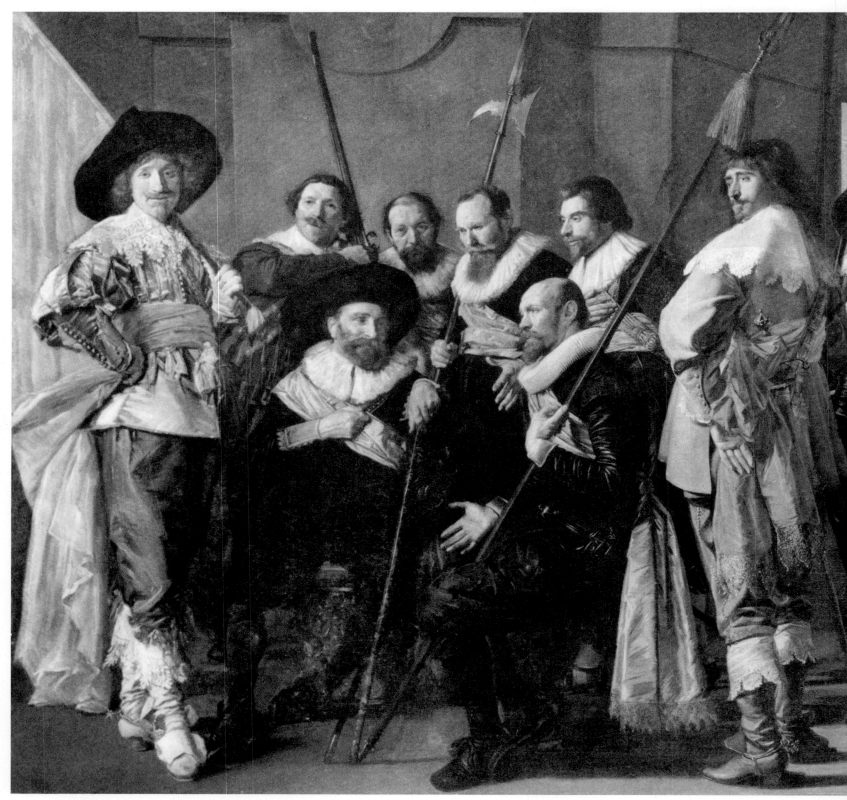

43. Frans Hals and Pieter Codde. *The Company of Captain Reynier Reael and Lieutenant Cornelis Michielsz. Blaeuw*, known as *The Meagre Company.*
1633–37. Oil on canvas, 6′ 10 1/4″ × 14′ 1″. Rijksmuseum, Amsterdam

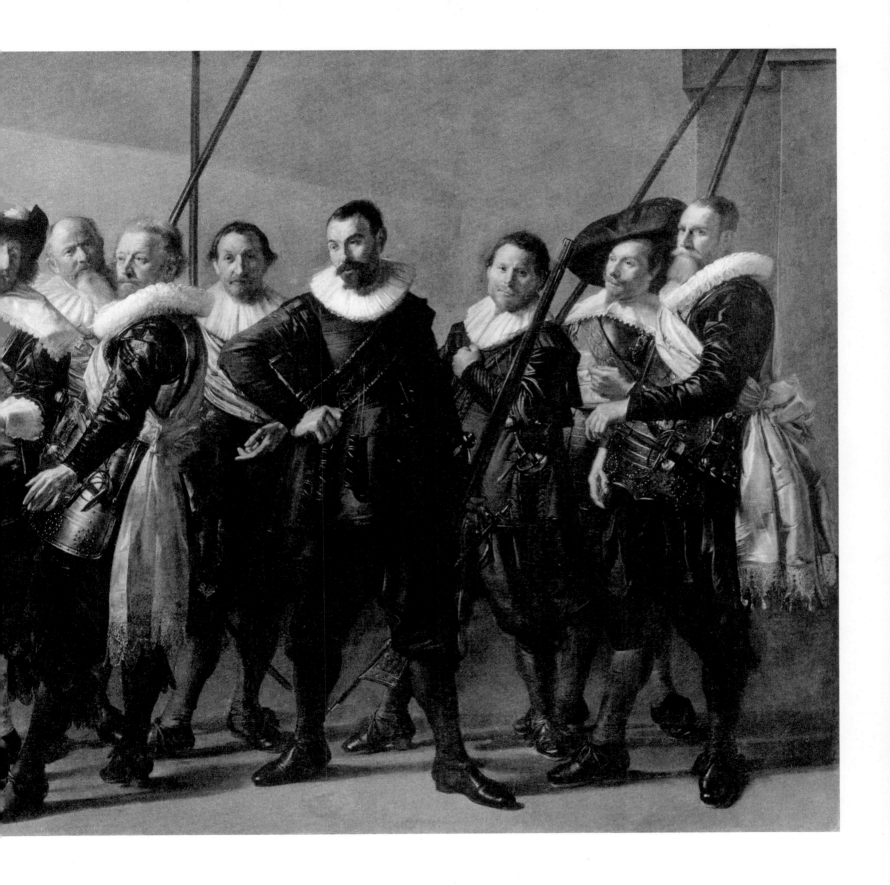

44. Rembrandt. *Eleazar Swalmius* (detail). 1637. Oil on canvas; size of entire painting, 52 × 43″. Royal Museum of Fine Arts, Antwerp

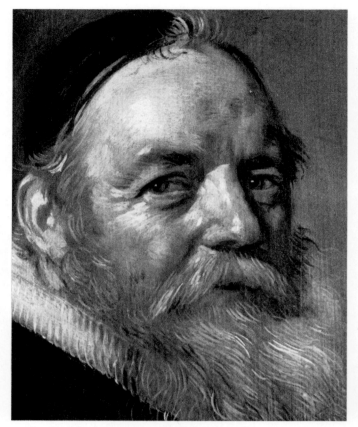

45. Detail of *Hendrick Swalmius* (see colorplate 32)

46. Detail of *Hendrick Swalmius* (see colorplate 32)

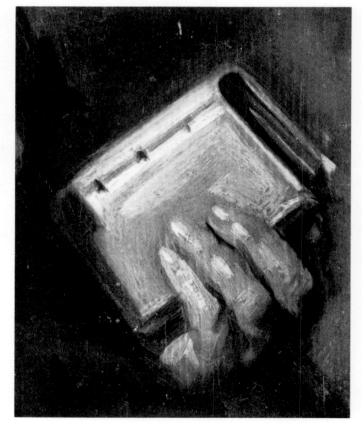

47. Detail of *Jasper Schade van Westrum* (see colorplate 37)

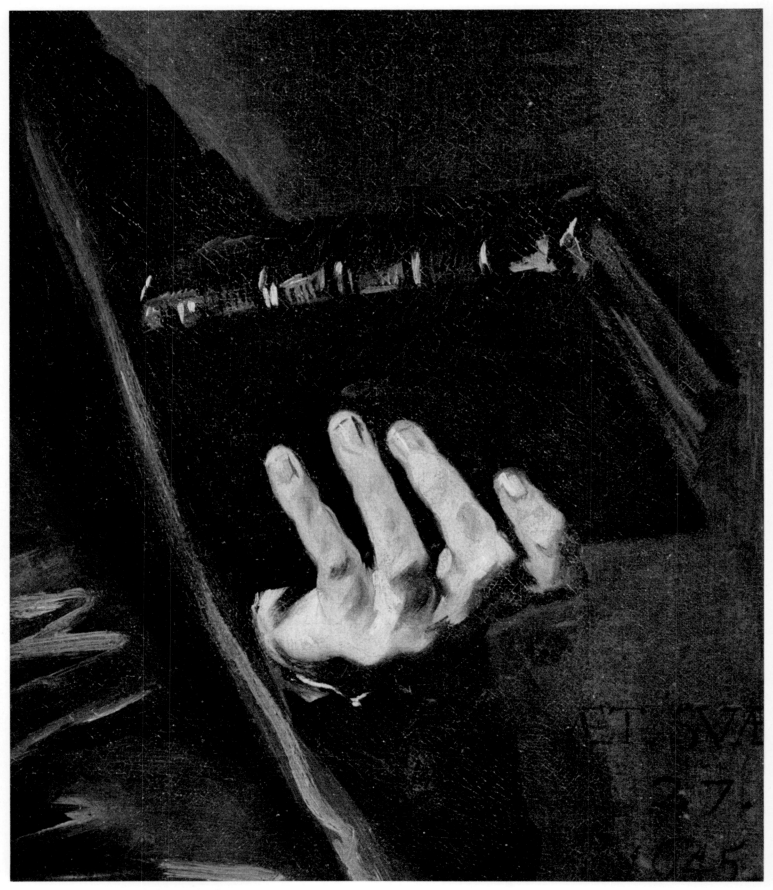

48. Detail of *Johannes Hoornbeek* (see colorplate 39)

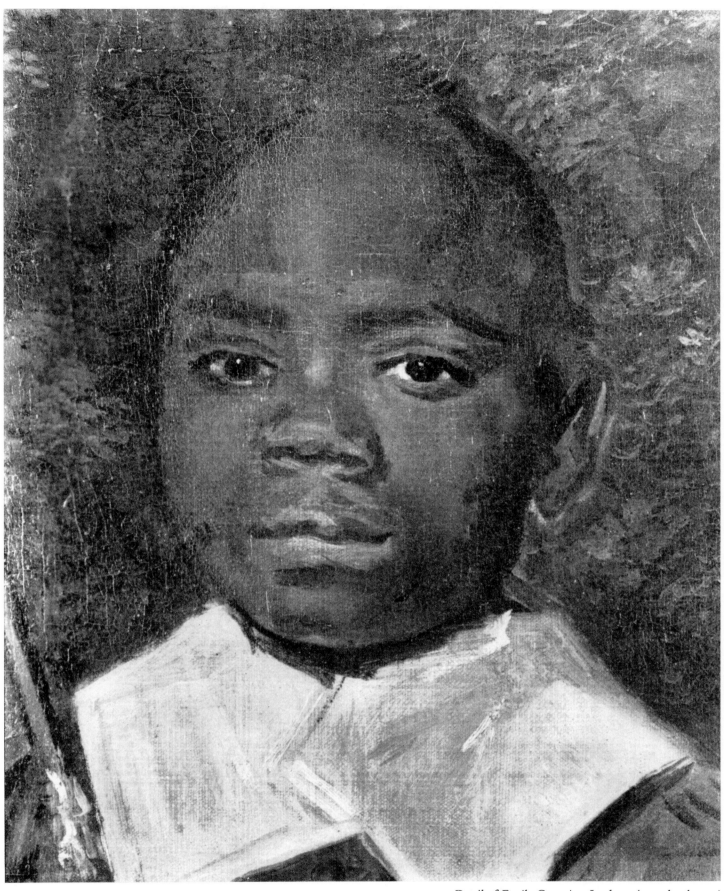

49. Detail of *Family Group in a Landscape* (see colorplate 40)

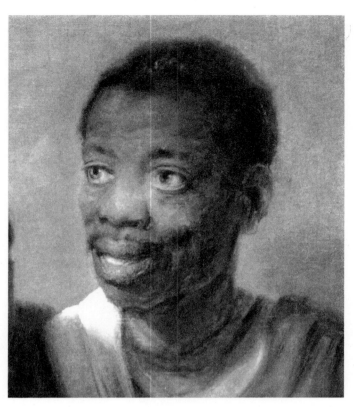

50. Rembrandt. *Two Negroes* (detail). 1661. Oil on canvas; size of entire painting, 30 3/4 × 25 1/2″. Royal Cabinet of Paintings, Mauritshuis, The Hague

(opposite)
52. *Cornelia Vooght Claesdr.* (detail). 1631. Oil on panel; size of entire painting, 49 3/4 × 39 3/4″. Frans Hals Museum, Haarlem

51. Detail of *Herman Langelius* (see colorplate 44)

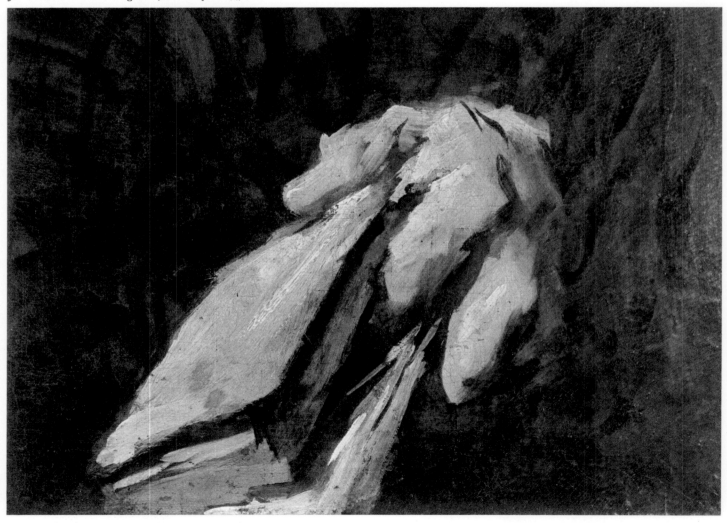

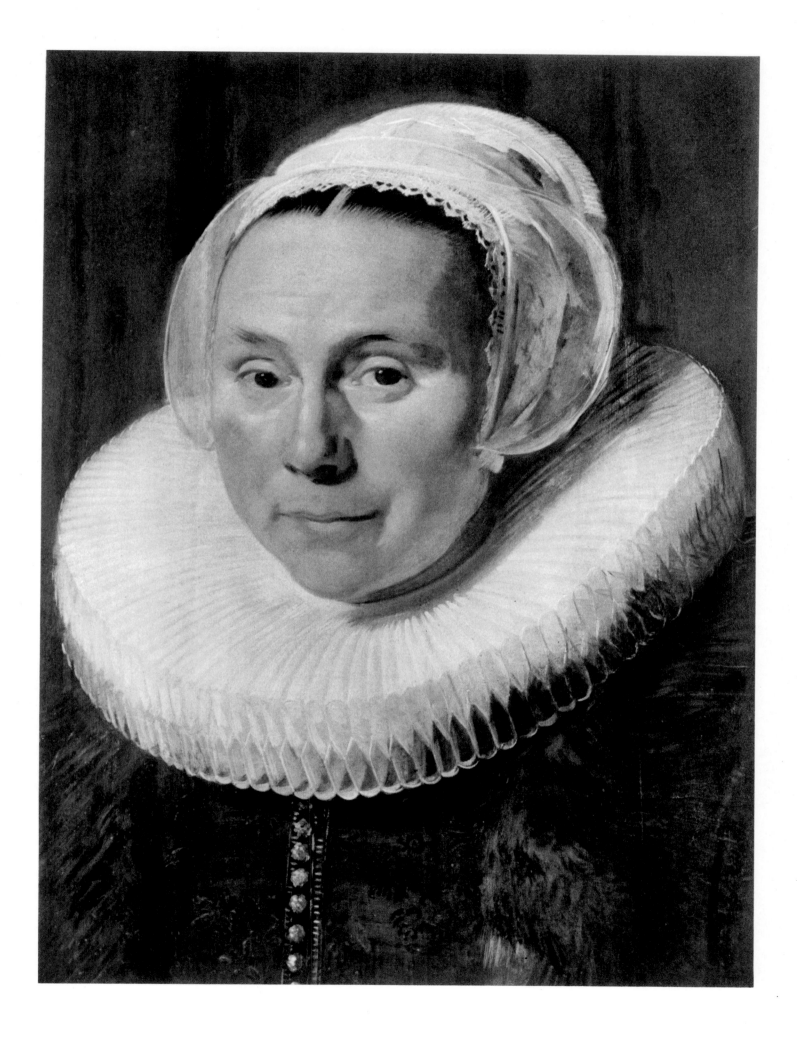

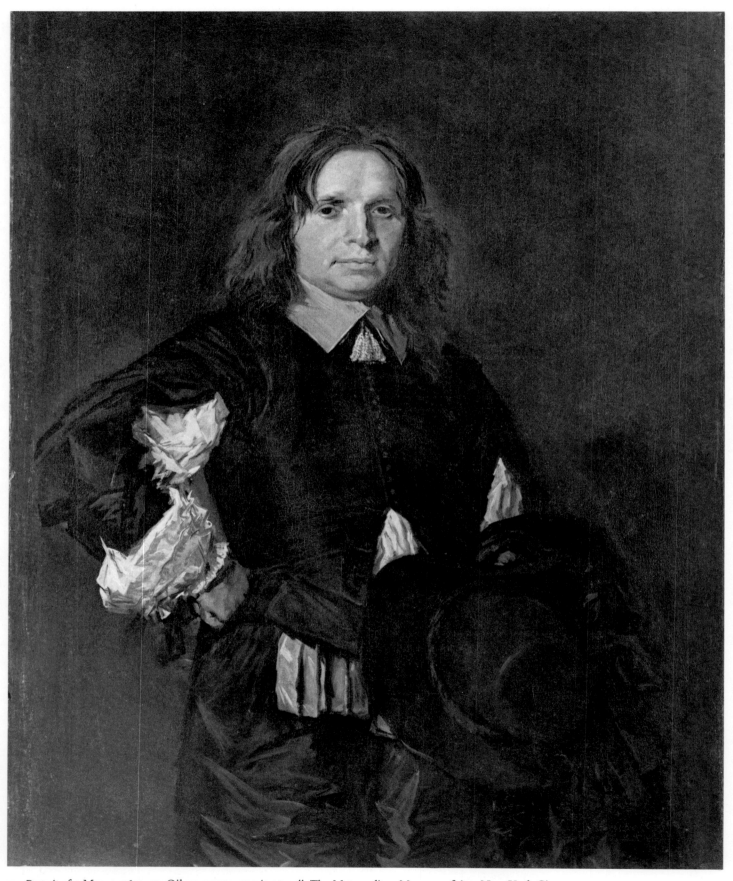

53. *Portrait of a Man.* c. 1650–52. Oil on canvas, 43 1/2 × 34″. The Metropolitan Museum of Art, New York City.
Gift of Henry G. Marquand, 1890

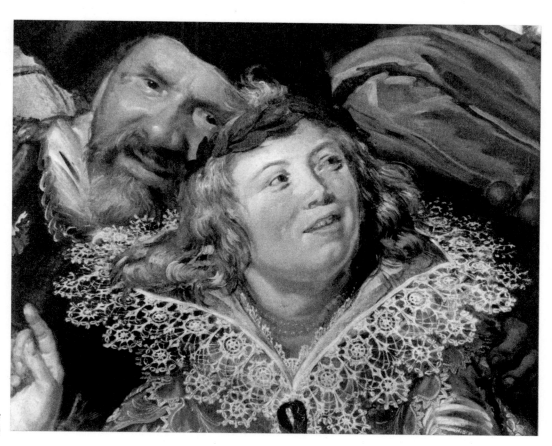

54. Detail of *Shrovetide Revelers*
(see colorplate 5)

55. Detail of *Shrovetide Revelers*
(see colorplate 5)

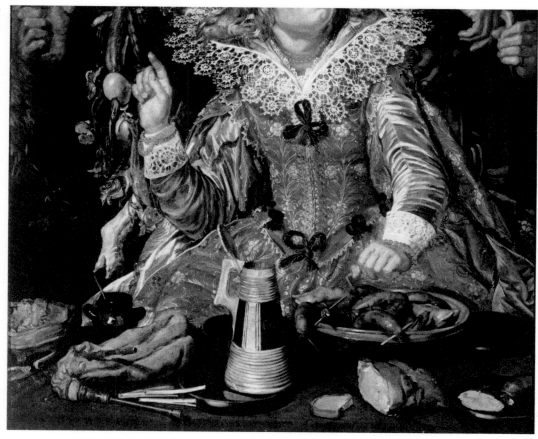

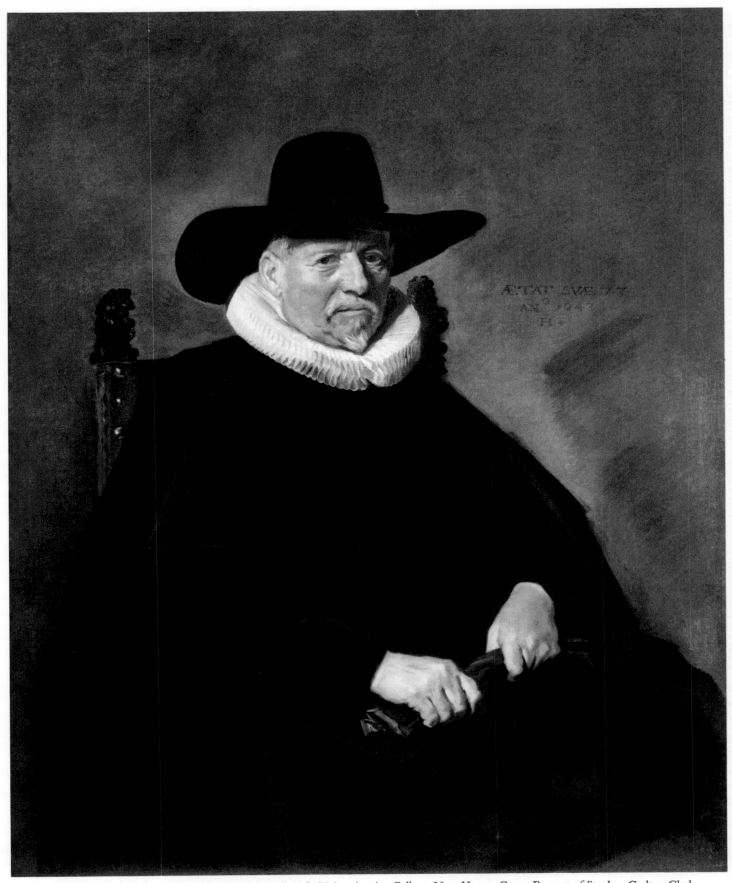

56. *Heer Bodolphe.* 1643. Oil on canvas, 48 1/2 × 38 3/8″. Yale University Art Gallery, New Haven, Conn. Bequest of Stephen Carlton Clark

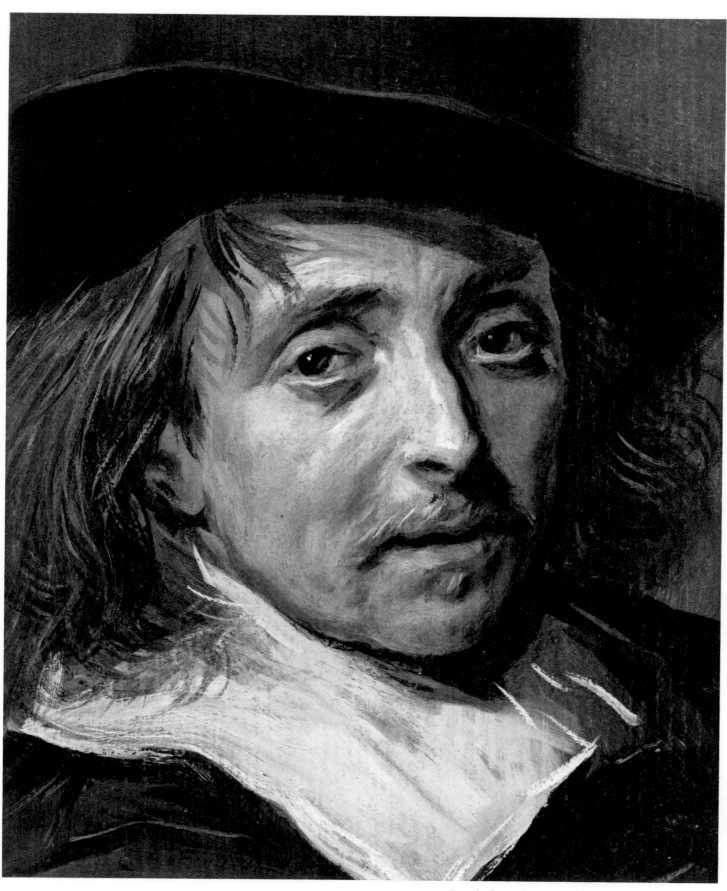

57. Detail of *Seated Man Holding a Branch* (see colorplate 38)

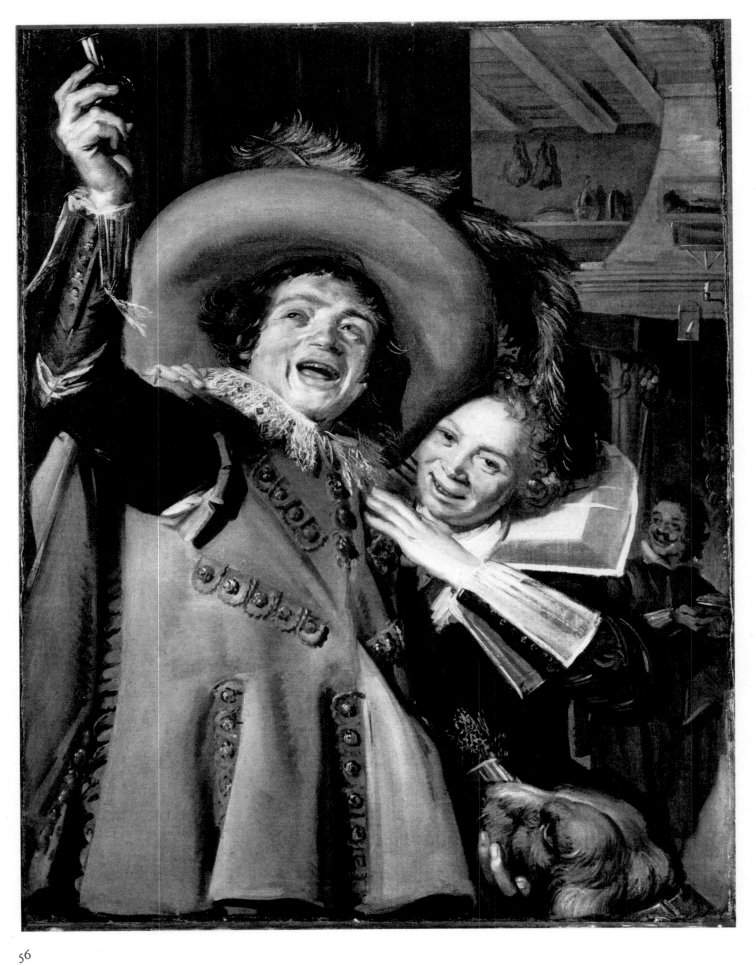

59. *Portrait of a Preacher*. c. 1625.
Oil on canvas, 24 × 20".
Courtesy of the Fogg Art Museum,
Harvard University, Cambridge, Mass.
Bequest of Nettie G. Naumburg

60. *Portrait of an Elderly Lady*. 1633.
Oil on canvas, 40 1/4 × 34".
National Gallery of Art,
Washington, D. C.
Andrew Mellon Collection

(opposite)
58. *Yonker Ramp and His Sweetheart*. 1623.
Oil on canvas, 41 1/2 × 31 1/8".
The Metropolitan Museum of Art, New York City.
Bequest of Benjamin Altman, 1913

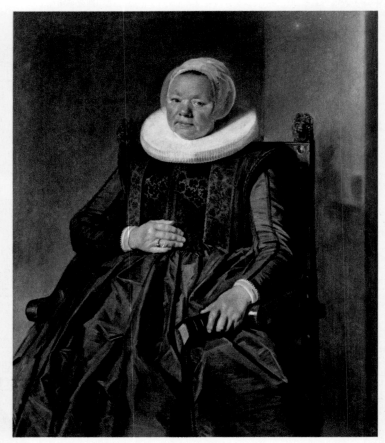

61. *Portrait of a Young Woman.* 1634. Oil on canvas, 43 × 32 1/2″.
Baltimore Museum of Art. Jacob Epstein Collection

62. *Portrait of a Woman.* 1635. Oil on canvas, 45 7/8 × 36 3/4″.
Copyright The Frick Collection, New York City

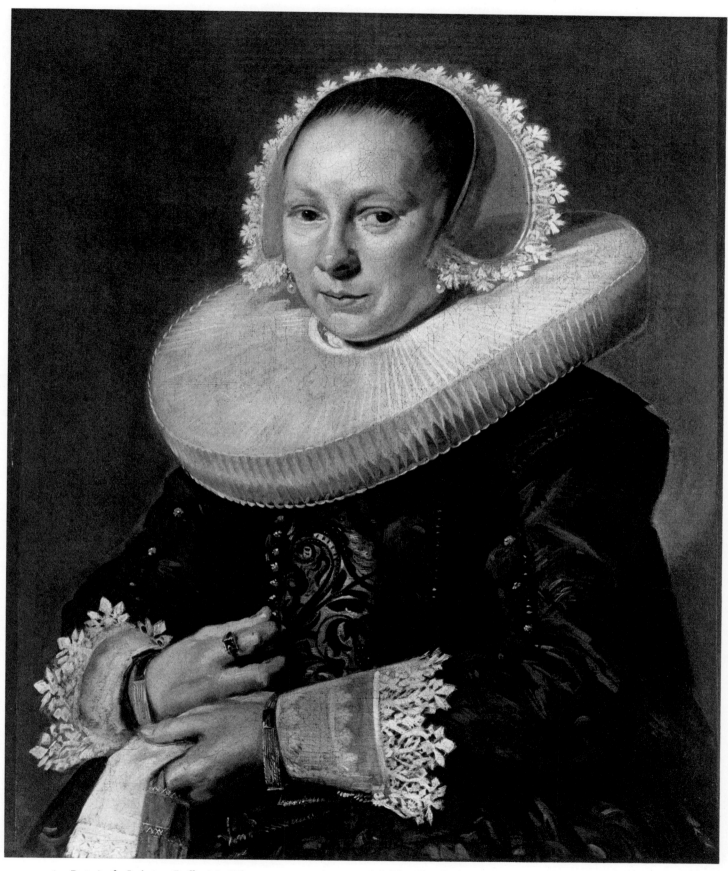

63. *Portrait of a Lady in a Ruff.* 1638. Oil on canvas, 27 1/2 × 21 1/4″. The Cleveland Museum of Art. Purchase from the J. H. Wade Fund

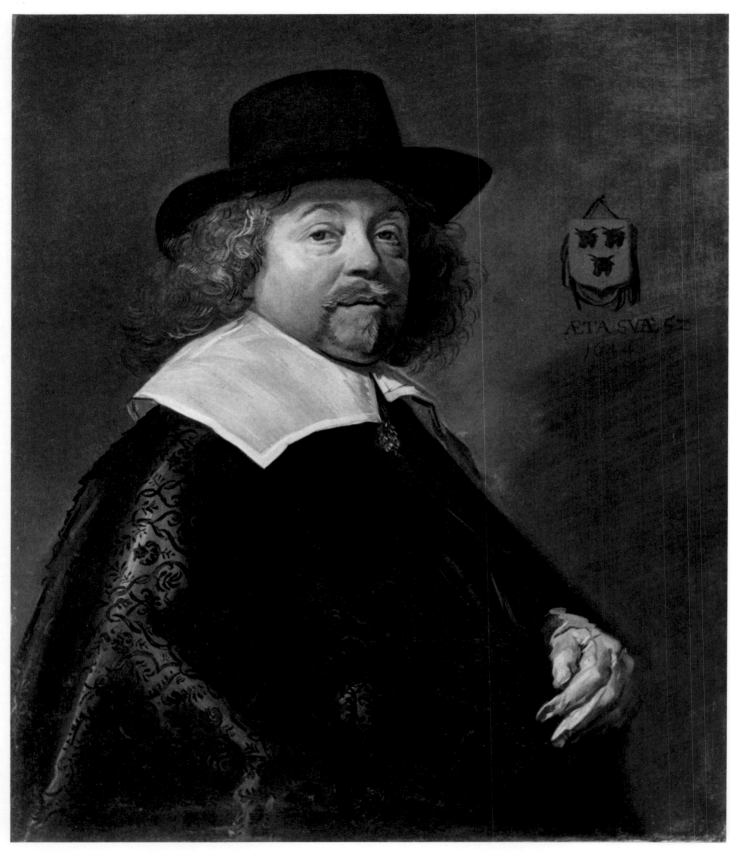

64. *Joseph Coymans*. 1644. Oil on canvas, 33 × 27 1/2″. Wadsworth Atheneum, Hartford, Conn. Ella Gallup Sumner and Mary Catlin Sumner Collection

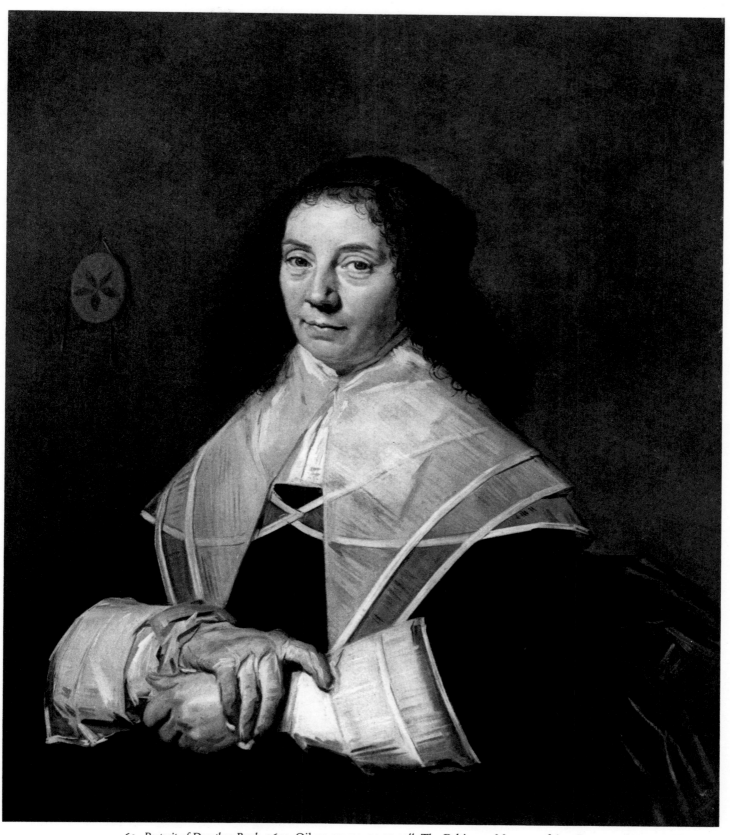

65. *Portrait of Dorothea Berck.* 1644. Oil on canvas, 34 × 29″. The Baltimore Museum of Art. Bequest of Mary Frick Jacobs

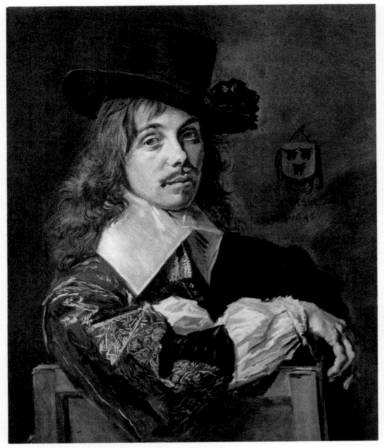

66. *Balthasar Coymans.* 1645. Oil on canvas, 30 1/4 × 25″.
National Gallery of Art, Washington, D. C. Andrew Mellon Collection

67. *Portrait of a Gentleman.* c. 1650–52. Oil on canvas, 41 1/4 × 35 1/2″.
Nelson Gallery–Atkins Museum, Kansas City, Mo. Nelson Fund

68. *Portrait of a Painter.* c. 1650–52. Oil on canvas, 39 1/2 × 32 5/8″.
Copyright The Frick Collection, New York City

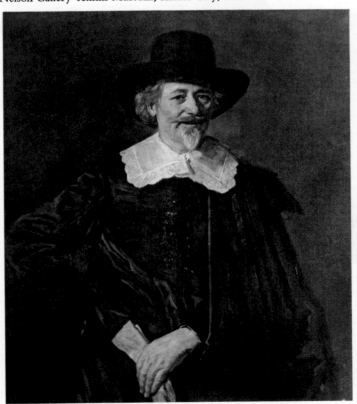

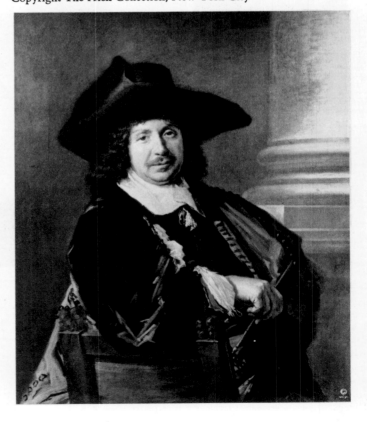

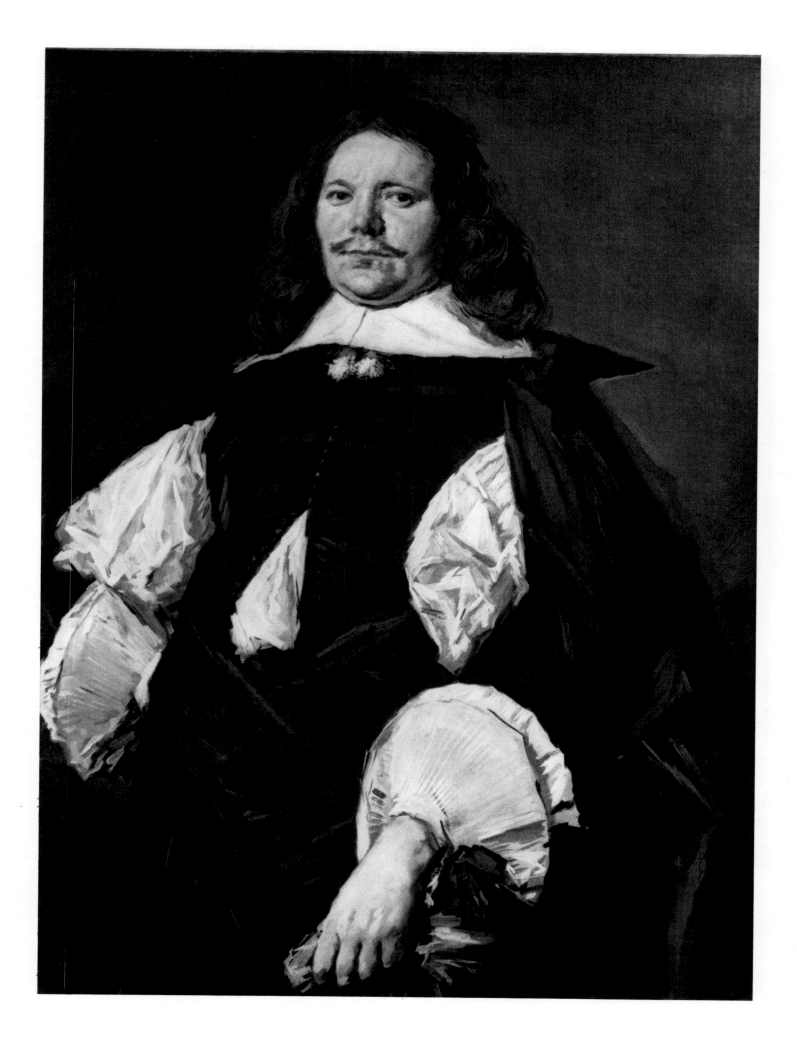

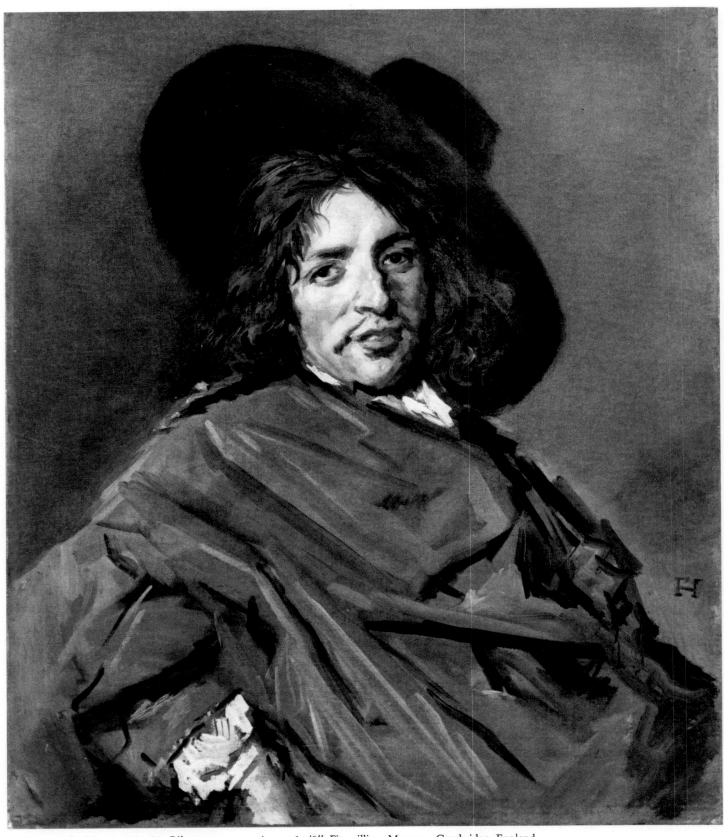

70. *Portrait of a Man.* c. 1660–66. Oil on canvas, 31 1/2 × 26 3/8″. Fitzwilliam Museum, Cambridge, England

COLORPLATES

Colorplate 2
PORTRAIT OF A MAN HOLDING A SKULL (BARTOUT VAN ASSENDELFT?)
1610–11
Oil on panel, 37 × 28 1/2"
The Barber Institute of Fine Arts, Birmingham, England

"Youth learns to see, old age to oversee." This statement by Max J. Friedländer is borne out if we compare Hals's earliest known works with those of his later and last years, which show his expressionist tendency. The portraits of both Jacobus Zaffius (colorplate 4) and Bartout van Assendelft show the interest taken by young Hals in the art of the versatile Cornelis Ketel (Gouda 1548–Amsterdam 1616), who, after working in Fontainebleau, was a portrait painter until 1581 at the court of Queen Elizabeth of England. There he was praised by Karel van Mander as an outstanding painter. Hals's early portraits, in which we see the influence of Ketel, stand out because of the three-dimensional and illusionistic qualities which give Ketel's paintings such strength and liveliness (see fig. 23). Modeled in light with an occasional impressionistic touch, Ketel's work unknowingly introduced the free and open orchestration which later lent such attraction to Hals's more mature work. The resemblance between the work of Ketel and that of the young Hals lies particularly in what Hals, after Ketel's inspiring example, "learned to see": the independent life in which the various parts of the body and dress are in total harmony. This complete integration was accomplished by Hals five years later in the depiction of the head of Jacob Laurensz., captain of the St. George Civic Guard Company (colorplate 7). Thus the big leap from 1610–11 to 1616 already shows the development which will lead Hals's work to complete victory over substance, to the grandiose overview which Friedländer spoke of (see colorplate 47).

Since the sitter has not been positively identified as the sixty-year-old Bartout van Assendelft (c. 1558–1622), it may be wiser to introduce him as the "Man Holding a Skull." As Hals always stressed the human rather than the social, the saying "What's in a name?" would be most apt here. Like the portrait of Zaffius, the model here was given a skull to hold. The rhetorical gesture of his right hand emphasizes the idea of vanity, while the earnest countenance suggests meditation on death. The cuff and collar already point toward Hals's inclination to dissolution of substance. The somewhat stiff deportment of the model, reminiscent of the stereotyped attitude of the older portrait painters, justifies our belief that this portrait antedates that of Zaffius.

The unidentified coat of arms at the upper right is flanked by the inscription ITA MORI / AETAT SVAE 60.

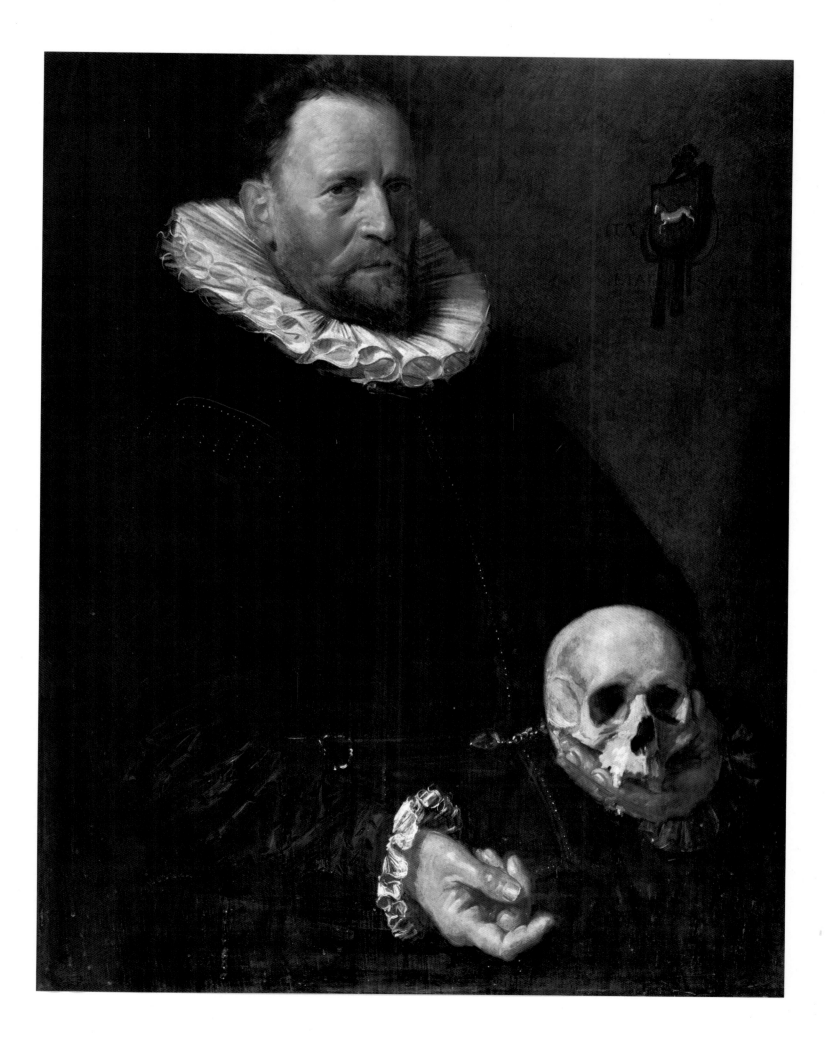

Colorplate 3
PORTRAIT OF A MAN HOLDING A SKULL
(BARTOUT VAN ASSENDELFT?) *(detail)*

The painting and presentation of the skull are extremely powerful. Hals's masterly hand has given it a dimension which brings us face-to-face with the mystery of death.

Some sixteen or eighteen years later, Hals once again depicted a skull in the painting of a dapper young man, who at one time was thought to be Hamlet acting in Shakespeare's famous gravedigger scene, an assumption which was rightly dismissed as "more attractive than accurate." The painting is in the collection of Major Sir Richard Proby, Bt., Peterborough, England. As the skull in Hals's pseudo-Hamlet is shown at three-quarter view to the right, the confrontation is not as suggestive as in this earlier painting, where the empty eye sockets directly face the spectator.

In connection with the fascinating development of Hals's work, it is worth noting the painting of the hand which holds the skull. The fingernails of this strongly modeled hand are true to life; later on, such nails will be abstracted into "accents" in which the supreme effect of the light dominates substance (compare fig. 2).

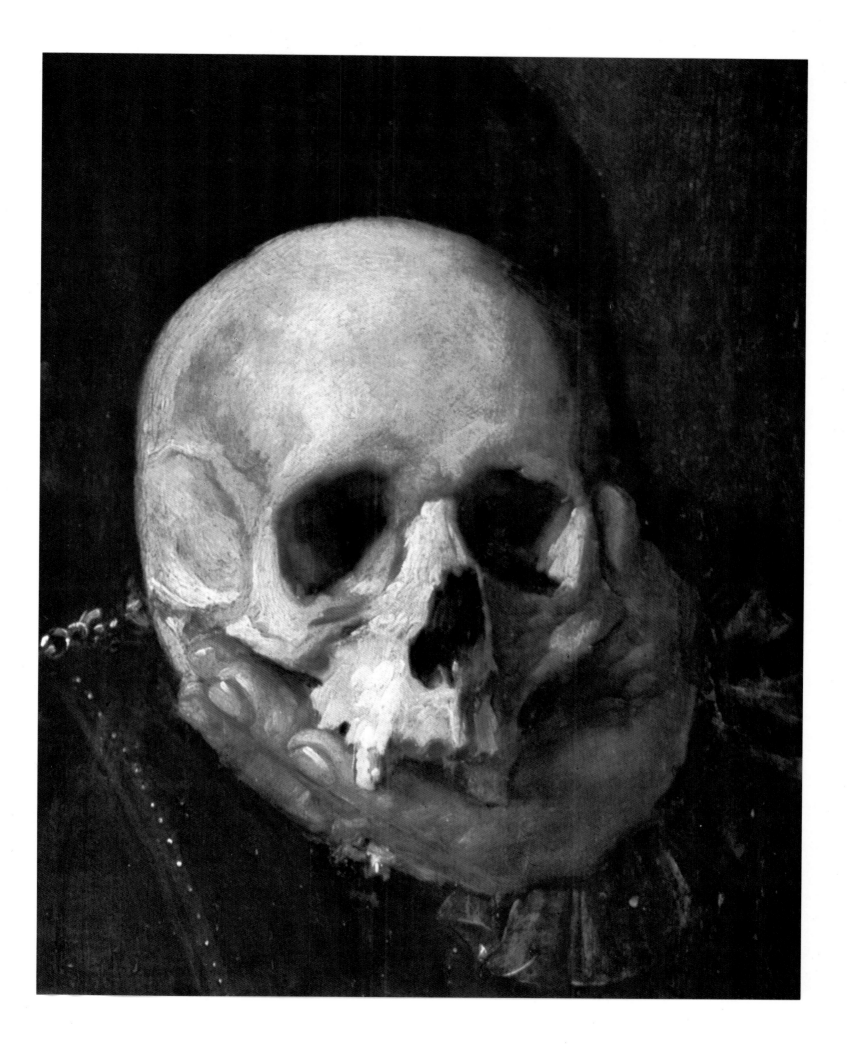

JACOBUS ZAFFIUS
1611
Oil on panel, 21 1/2 × 16 1/4"
Frans Hals Museum, Haarlem

The earliest known dated work by Frans Hals is a portrait of the seventy-seven-year-old Jacobus Zaffius (1534–1618), abbot of the Augustine monastery in Heiloo (near Alkmaar) in 1568 and invested three years later as provost and archdeacon of the Episcopal Chapter in St. Bavo's Church in Haarlem.

The portrait is dated 1611 and must therefore have been completed by Hals between the ages of twenty-six and thirty. Although it has suffered from time, its present condition is such that we can see, bearing in mind the vision and workmanship of the painting, that it was done by an outstanding artist. The portrait already represents a mature stage in Hals's earlier work, which is lost for reasons unknown to us.

More justice would be done to the intense countenance of Zaffius if it were seen in its original form with the skull Hals had placed in his hand. Unfortunately, the portrait has come down to us in a mutilated condition, as we can see from the engraving which Jan van de Velde made in 1630 from the undamaged original (fig. 8). The engraving shows the priest seated in an armchair by a table with the fingers of one hand resting on a skull, while the other hand is gesturing as if he were preaching: "For dust thou art and to dust shalt thou return."

This moralizing tendency reminds us of Renaissance and Baroque portrait painters, who gave their models skulls as accessories when they were shown meditating on life and death. This "all is vanity" sentiment is often reflected in the face of the subject and shows his concern over the salvation of his soul, as here in Hals's painting.

But in this almost tortured face we also seem to observe the traces of an emotional life sometimes faced by mortal danger. Zaffius had lived through the siege of Haarlem by the Spaniards in 1572–73, and had also witnessed the violence and destruction wrought by the plundering rabble in St. Bavo's Church on May 29, 1578.

In 1609 Zaffius founded in Haarlem the Vijf Kameren Hofje, today the Frans Loenen Hofje, an example of his devotion to charitable works, a devotion which he shared with many Haarlemmers before and after him.

The coat of arms and inscription "Aetatis Svae/77 An° 1611" were probably added later, after the panel had been mutilated, in imitation of Hals's original inscription.

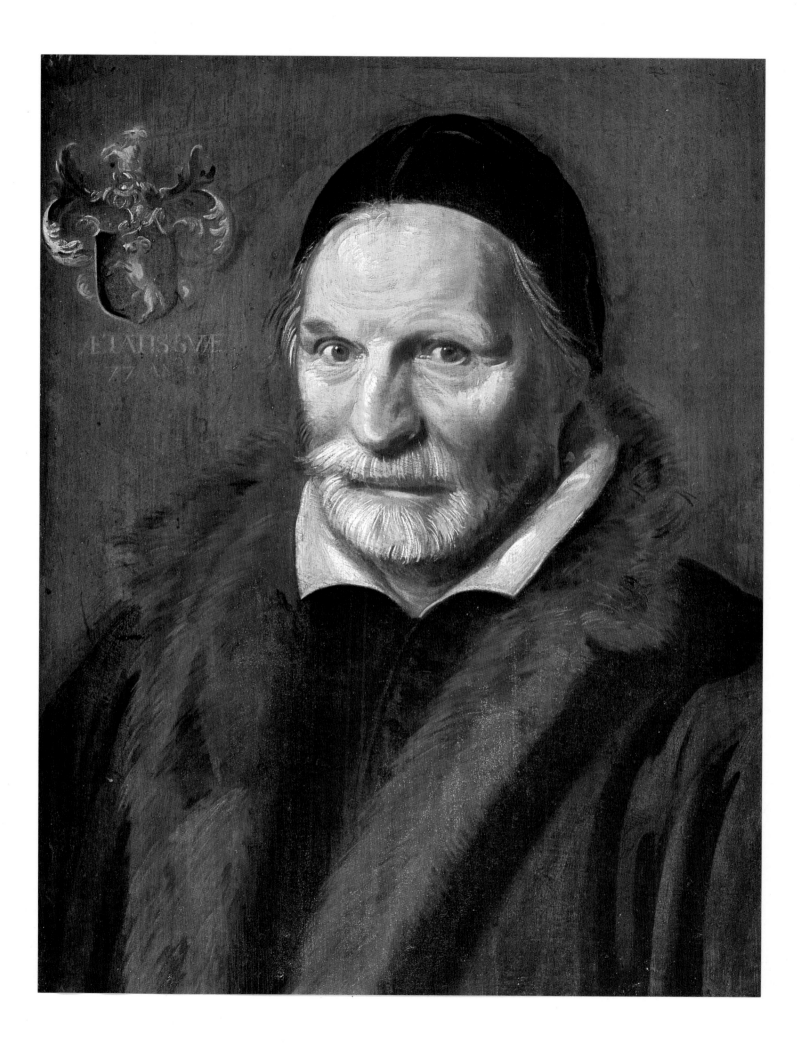

Colorplate 5
SHROVETIDE REVELERS
c. 1615
Oil on canvas, 51 3/4 × 39 1/4"
The Metropolitan Museum of Art, New York City
Bequest of Benjamin Altman, 1913

The exuberance of the Shrove Tuesday revelers afforded Hals the opportunity to depict a drinking bout, the result being a party far more Burgundian than Dutch; furthermore, it is a party filled with eroticism, as we shall see.

Although the joy of living and a carefree attitude are not alien to the solid Dutchman, there was no pictorial tradition in the northern Netherlands, until this time (c. 1615), in which spontaneity and inhibition were depicted as they are here. We can undoubtedly find the reason for this in the exuberant Flemish temperament of Frans Hals, whose brushstroke, to the very last touch in his old age, remained pregnant with life.

The Shrove Tuesday celebrations elicited a more subdued response in the works of Hals's brother Dirck, Willem Buytewech, and Cornelis Dusart. However, Hals's compatriot Adriaen Brouwer, in similar scenes, approached Hals's vitality. "The most phenomenal shamelessness with which a woman has ever entered Dutch painting" is how Frederik Schmidt-Degener describes the appearance of the woman who, both literally and figuratively, is the center of this rowdy party. The word "appearance," just used, should probably be understood in the theatrical sense of the word, as the subjects were undoubtedly not all original Shrovetide revelers. Among them certain known types have been recognized who fit into the atmosphere of contemporary popular theater. The glutton, leaning familiarly against the woman, with his pipe stuck into his hat, can be recognized as Peeckelhaering (Pickle Herring) because of the two herrings tied to his string of food. He was a locally known type who also appears in the works of Buytewech and Dirck Hals. The figure on the extreme right can be identified as Hans Wurst, in view of the long sausage which hangs from his cap. He certainly makes no secret of his intentions, as his vulgar gesture shamelessly reveals.

The richly attired woman, crowned with a laurel wreath (see fig. 54), does not allow herself to be intimidated in this atmosphere of dubious innuendos; she seems to set the tone with the motion of her right hand. Must we suspect something mischievous in the way in which she draws Hans Wurst's attention to Peeckelhaering's sausages? Like the other items in this dangling display, we must interpret the pipe stuck in Peeckelhaering's hat and the foxtail in his right hand as traditional erotic symbols of folly. In this atmosphere, latent with emblems, we see in the wooden spoon stuck in the cap of the reveler behind Peeckelhaering the customary allusion to wastefulness, while in the seemingly innocent bagpipes in the left foreground—added as a sexual symbol—more music can be found than the innocent viewer would suspect.

The canvas is signed on the tankard in the foreground with Hals's initials, fh, the only known work that bears his monogram in small letters (see fig. 55). A cleaning of the canvas in 1951 revealed that the five figures in the background were later painted over.

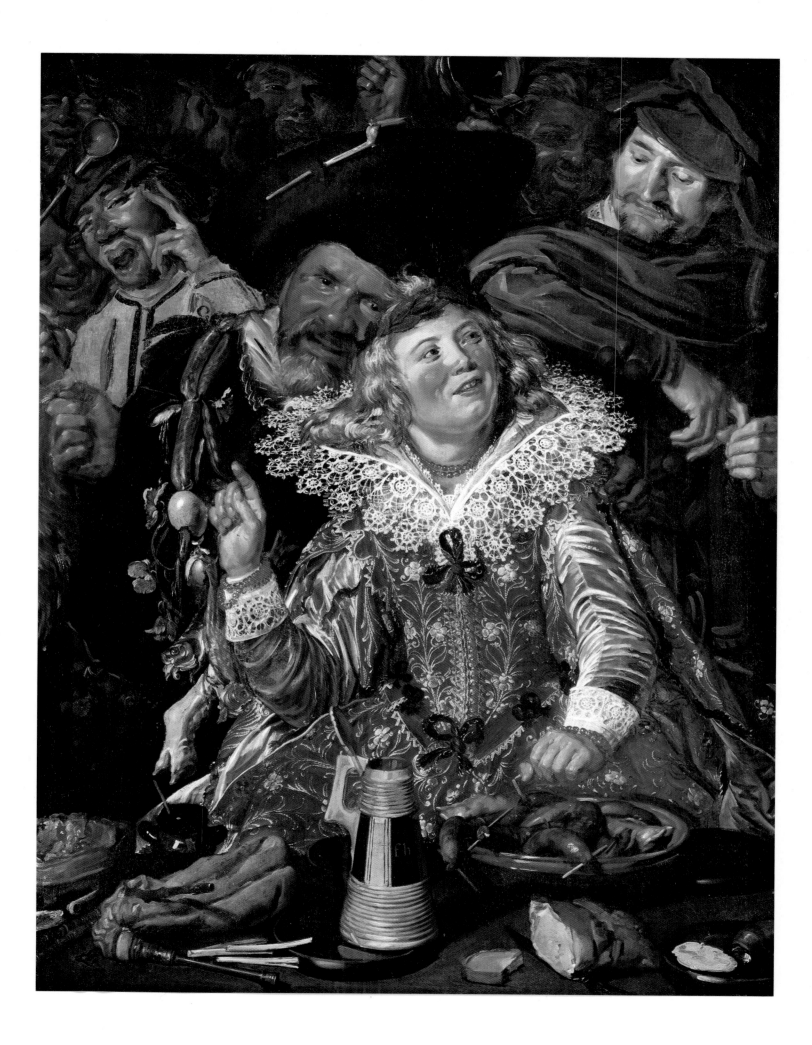

Colorplate 6
BANQUET OF THE OFFICERS OF THE
ST. GEORGE CIVIC GUARD COMPANY
Dated on the arm of the chair at left: 1616
Oil on canvas, 5' 8 7/8" × 10' 7 1/2"
Frans Hals Museum, Haarlem

Hals's first painting of a civic guard company stands out as the work of a genius when compared with group portraits by earlier artists. In the introduction we pointed out the great difference in approach by comparing Hals's painting to a guard company painting by Cornelis van Haarlem (fig. 21), which can be regarded in its composition and artistry as a weak forerunner of Hals's masterpiece.

The formal pyramidal composition of Cornelis's group was discarded by Hals in favor of a group around a table. He has placed his models, who relate to one another and to the spectator, in a three-dimensional space that is heightened by the tactile painting of the figures. The three-dimensional effect is further increased by two diagonals, which give an impression of space. On the left the heads of the three seated figures form a diagonal, which is continued in the standard-bearer and his standard. The other diagonal is formed by the heads of the two standard-bearers on the right and the head of the company attendant, who is entering with a dish laden with food. The figure in the middle foreground emphasizes the space between front and rear, while the sashes in the city colors, red and white, which form part of the guards' insignia, give added life to the whole space.

The cramped canopy in Cornelis's painting is replaced in Hals's work by spacious drapery, worthy of the throne of a Venetian Doge. This accessory, drawn from Hals's imagination, is the focal point of the table: beneath it sits the colonel, wearing an orange sash. Having drunk rather freely, he is maintaining decorum somewhat stiffly. His glass raised, he is reacting to the second standard-bearer on the right, who, in giving his greeting, has doffed his hat with a flourish.

The young fashionably dressed standard-bearer (far right) serves as a link to the colonel, his partially unfurled banner continuing the diagonal grouping of the three figures at the head of the table. Just under the ruff of Captain Nicolaes van der Meer (in the middle foreground) we can see the gloved fingers of the standard-bearer who, with his gesturing left hand, presents the leading personality of the company—the colonel. To the right, against the wall, are a halberd and a spontoon, the guard badges of sergeants and lieutenants respectively.

The food and the damask tablecloth form the delightful still life which we have already mentioned in our introduction. Contrasted to Cornelis's frozen group, Hals's is alive even in insignificant details. Material adjuncts, in no way neglected, play a useful role in accentuating life. Typical of this are the ruffs, which have been painted in a masterly manner. The starch we see in Cornelis's ruffs has, with Hals, become dissolved in light.

It is unfortunate that museum visitors tend to view group portraits as a whole as they walk past, rather than reflect on each portrait in all its exciting details. To get an idea of what people are overlooking, we would refer to colorplate 7, which gives us a closer view of one of the twelve officers, Captain Jacob Laurensz.

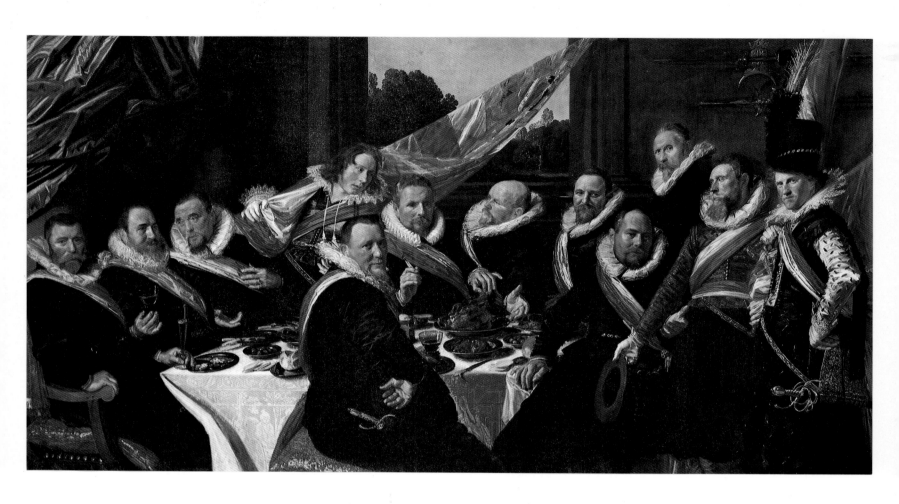

BANQUET OF THE OFFICERS OF THE
ST. GEORGE CIVIC GUARD COMPANY
(detail of Captain Jacob Laurensz.)

The Dutch poet Adama van Scheltema (1877–1924) used to tell artists: "Create your art like running water, the drops of which are already filled with the sound of waves." Frans Hals created such art: any one of his details, when isolated from the total picture, remains full of the life of which it forms an integral part. This is true of the detail of Captain Jacob Laurensz., whose head, as *pars pro toto*, personifies the essence of all the features which make this painting of the banquet of the officers, held in 1616, a milestone in the development of the Dutch group portrait.

Our *metteur-en-scène* Hals, in his masterly way, shows Captain Laurensz. conversing with the colonel, seated on his right. His pose expresses exactly how, in conversation, a table companion would lean deferentially toward a person of authority. Although the depiction of face and hands is still reminiscent of the realistic art of Cornelis Ketel, Hals has gone a step further in the development of his brushwork, which now shows a freer touch, a touch which reminds us of something Arnold Houbraken wrote: "It is said that he [Hals] was wont to apply the paints on his portraits thickly and smoothly, and thereafter to work in the brushstrokes." This application of paint points to a technique which makes it possible to improvise freely. This tendency becomes increasingly characteristic of Hals's brushwork and guards him against adhering to one single manner of painting, as was the case with so many of his contemporaries.

If we speak in terms of art history, it can be said that Hals's life work developed from impressionistic to expressionistic. While his earlier portrait painting shows an impressionistic trend, we must not confuse his form of impressionism with that of the great Impressionists of the late nineteenth century, however much they may have regarded Hals as their forerunner. To them the eye came first; they recognized only the wealth of colors and the festival of light while denying the substance and what lies concealed behind it. That is why the impressionism of Claude Monet and his fellow artists formed part of the trend toward abstract art without their suspecting it.

Hals's impressionism also shows a disintegration of the substance, but at the same time a respect for anatomy and the intrinsic outward appearance of man and objects. It is astonishing how, with a single light touch of his brush, he was able to combine—in one whole form—volume, matter, color, tone, mood, anatomy, and character!

Captain Jacob Laurensz. is one of sixty-eight guards whom Hals painted among five guard company paintings between 1616 and 1639. All five are now exhibited in the Frans Hals Museum in Haarlem. A closer acquaintance with one of them can serve as encouragement to appreciate all of Hals's group portraits, not only as a whole but in their brilliant detail.

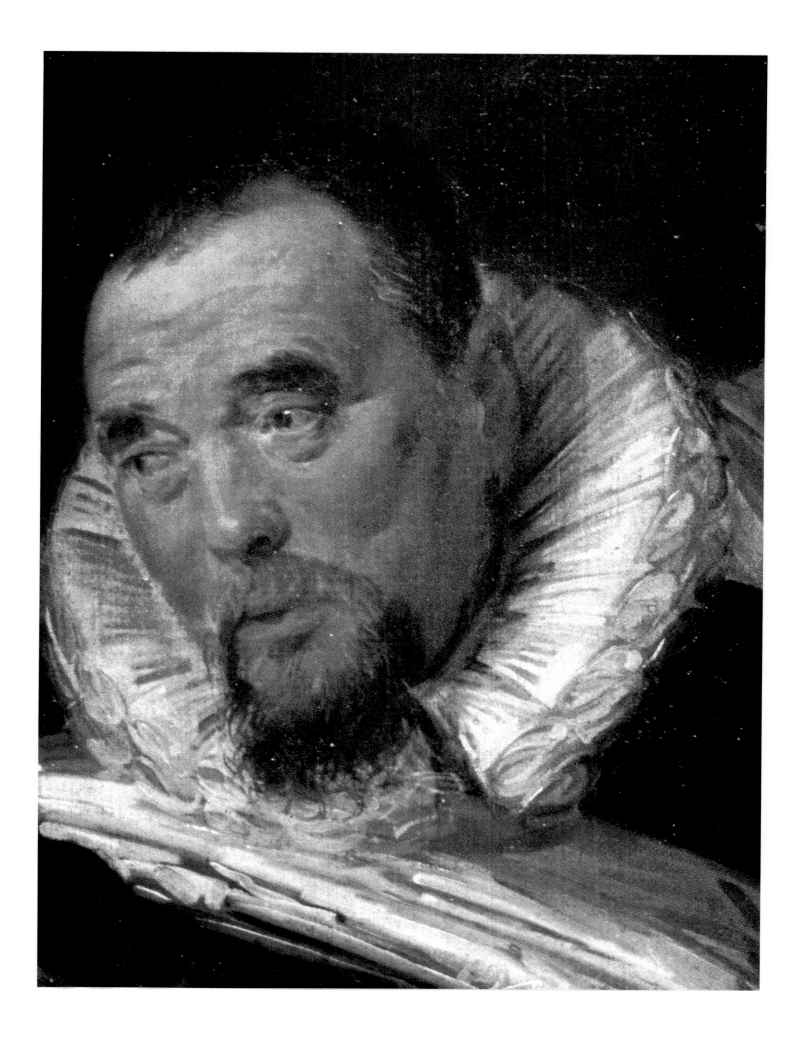

Colorplate 8
NURSE AND CHILD
c. 1620
Oil on canvas, 33 7/8 × 25 5/8"
Staatliche Museen, Berlin-Dahlem

Many portraits of children and genre portraits have been attributed to Hals, but their authenticity is generally either doubtful or unacceptable. They stand on the periphery of his art and reveal an imitative hand and an inability to achieve his masterly level. In addition, there are, from a later period, numerous copies and notorious forgeries which show that children's portraits must have been very popular among his contemporaries and successors. Seymour Slive, in his excellent work on Frans Hals, has thoroughly sorted out the "nursery" paintings ascribed to Hals and reduced the authentic children's paintings to reasonable proportions.

These children's portraits owe their charm to the fact that they are untouched by life's problems. One could say that the absence of such problems is inherent in a child's world and thus in a child's portrait. But it must be remembered that the vision of an artist is bound to reveal itself in a child's portrait, too, so that we can see in it not only the innocent nature of the child, but the mature experience of the artist. A striking example of this is Rembrandt's painting of his son Titus at the age of thirteen (1655) in the Boymans-van Beuningen Museum in Rotterdam. With his fatherly love and concern, Rembrandt has woven a chiaroscuro representation of his son lost in thought, in whom we can indeed detect a preoccupation with life's problems, but they are, in effect, the father's problems.

In Hals's paintings of children one does not encroach upon a child's world. What is so delightful about his children's portraits is the very fact that he leaves their world intact, and the child to his own carefree environment. The Berlin museum is the enviable owner of this panel known as *Nurse and Child*, which could be called "The Festival of Childhood." The models for this double portrait are unknown. Having no documentary proof to fall back on, it would seem justified to prefer the traditional title *Nurse and Child* to that of *Mother and Child*. The woman has been given an unmistakably secondary place as a servant, not least by the contrast of her modest black clothing with the opulent dress and finery of the child. A woman offering fruit to a child is a common motif in early family portraits and is no proof of position or relationship. But traditions and customs are of only secondary importance, as the picture is permeated with warm human feeling which makes it so moving that we become oblivious to place, time, and manners.

Though the child wears a frock, we cannot be certain whether it is a boy or a girl. Little boys in their infancy also wore long skirts and lace bonnets. The strap hanging at the child's back is one of two which served as reins.

Compared with often rather stiff portrayals which give a child the appearance of a miniature grown-up (we are thinking here of the children's portraits of Terborch), Hals's painting, with the child against a background of security, personified in the devoted nurse, sparkles with life. We can sense here how Hals was able to perceive spiritual qualities through contemporary dress without actually consciously striving to do so. Through the touch of his brush, the rich design of the child's dress creates a gay springtime atmosphere on Holland's soil, with the child's face standing out like a flower.

78

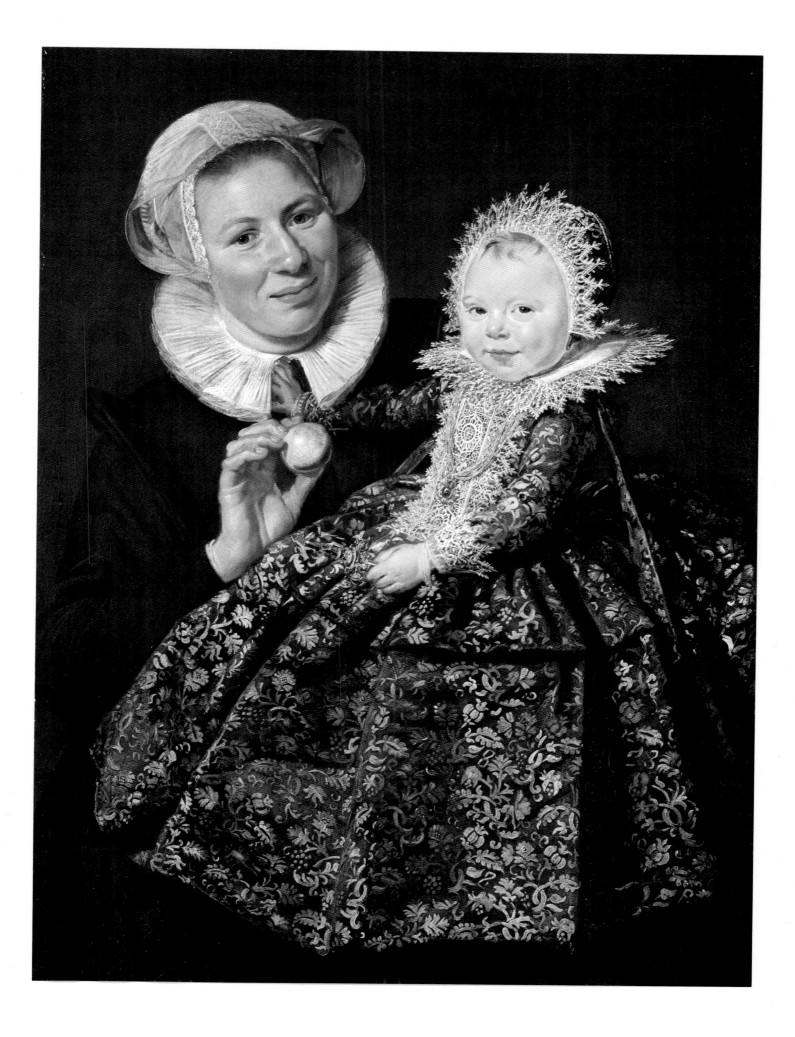

NURSE AND CHILD (*detail*)

Here we have a close-up of the "blossom sprung from Dutch soil." It is delightful how Hals has placed eyes, nose, and mouth into the little round head, decked in a lace "diadem" down to beneath the ears. Flaxen wisps of hair on the forehead seem to want to go off in all directions, thus accentuating the child's perky expression. The lace, detailed and yet boldly painted, is not treated as a monotonous abstract pattern, as, for example, in a Van Miereveld painting, where we have the feeling that scissors were used instead of a brush.

Hals's lace gives the impression of a staccato accompaniment. The opulent finery conveys not merely the idea of wealth, but also enhances the spiritual quality of the child, whose vulnerable existence seems to be symbolized by the fragile lace.

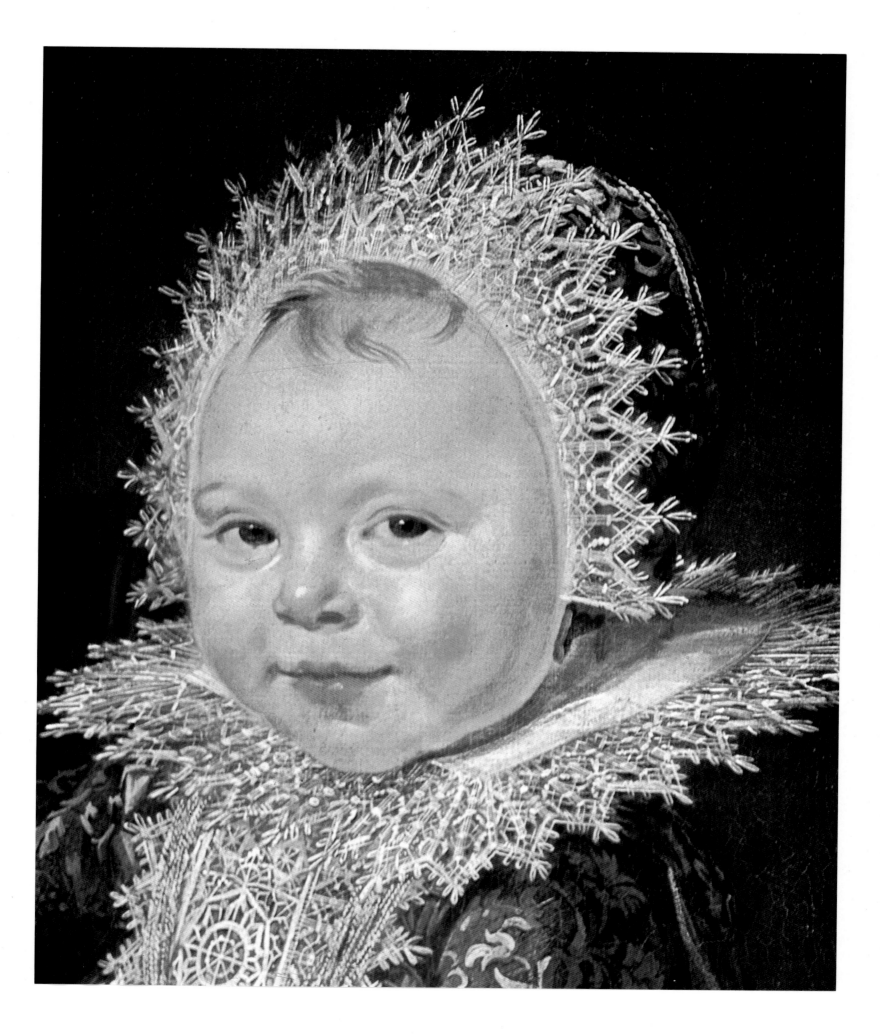

Colorplate 10
THE LUTE PLAYER
c. 1620–22
Oil on canvas, 27 3/4 × 24 1/2"
Collection Alain de Rothschild, Paris

The intercommunication in today's world makes it difficult for modern man to realize how divided the small territory of seventeenth-century Holland was from an artistic point of view. Certain towns and provinces—Haarlem, Leiden, Delft, Amsterdam, Utrecht, Middelburg, and others—became well known for their own schools of painting. The "absolute art of painting," as now lauded in the abstract, gives artistic life a worldwide character, as a result of which the world has shrunk. It is helpful to realize this when we consider the independence of various painting centers in the seventeenth century and the influences which were mutually felt.

The Utrecht school occupied a very special place of its own. In the sixteenth century Haarlem and Utrecht had inherited a common reputation for being centers of international academicism. Because of the realism of Frans Hals and his fellow painters in Haarlem this reputation declined; in Utrecht, however, it persisted for a longer period. One of the most important representatives of the Utrecht school was Gerard van Honthorst (1590–1656), who worked in Italy from 1610 to 1622. While there, he fell under the influence of the chiaroscuro style of the revolutionary Caravaggio (1573–1610), who made a strong impact not only on the Utrecht school but, and with more grandiose results, on Rembrandt and Johannes Vermeer. Honthorst mastered chiaroscuro, with the source of light outside the picture, to such a degree that he was nicknamed Gherardo della Notte (Gerard of the Night).

While Hals retained his identity, he was nonetheless affected by the Utrecht school in his choice of subjects, the use of intense light, and the lively coloring. Honthorst and his followers introduced the lifesize half-length genre portrait in the Caravaggesque style with musicians in theatrical costumes (fig. 24). *The Lute Player* is a striking example of this type of portraiture. The imitative and academic interpretation of Caravaggio's creations in the Utrecht manner blossomed in the Haarlem climate. Compared with the Utrecht academic interpretation, Hals's personal rendering in *The Lute Player* comes as a deliverance. It is free of anything suggesting subservience to an "imported" fashion or style. The carefree pose, the colorful clothes, the relaxed placement of the hands on the cherished instrument, and the jaunty head framed by wild hair guarantee that the strumming of this troubadour will echo through the centuries.

Hals's interpretation of the lute's sound hole deserves special attention. It results in a more or less abstract form which in reality is more decorative than practical. We realize how inimitable Hals's touch is when we see the otherwise skillful copy of *The Lute Player* (Rijksmuseum, Amsterdam), thought to be the work of Hals's pupil Judith Leyster. The inspired rendering of this detail becomes a hesitant imitation in the copy, and proves that Hals's touch could not be equaled (figs. 26, 27). All the copyist could do was simulate Hals's result, losing the original vigor in the process, as a movement is repeated in a slow-motion film.

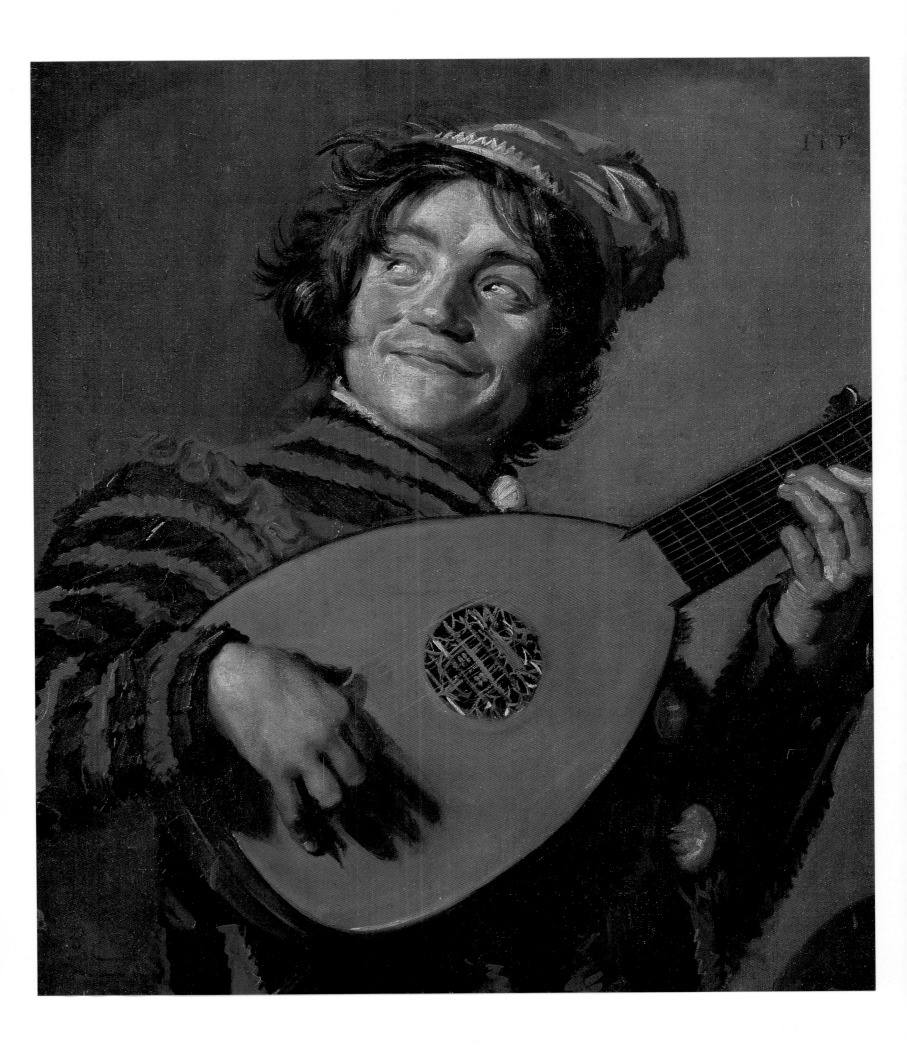

Colorplate 11
LAUGHING BOY
1620/1625
Oil on circular panel, 11 5/8"
Royal Cabinet of Paintings, Mauritshuis, The Hague

This small portrait shown against a circular background is—as in the work of a medallist—adjusted even in the smallest details to the round shape. It bears two signatures: one showing traces of a joined monogram, FHF (Frans Hals fecit), at the upper left, and a second monogram, FH, to the left of the collar. But the really convincing signature to the whole picture is the seemingly reckless brush-work itself, the force of which is manifest when we compare the panel with the weak brushwork of one of three existing copies. In this connection we think of the pastiche in the Dijon museum, which misses the tension of the original, if only because of the unwarranted transformation of the circular composition into a square one (fig. 28). Such a copy shows once again how impossible it is to equal the brio of Hals's brush, which effortlessly reveals the complex elements of his observation, both physical and psychological. Every inch reflects the spontaneous life of this panel, brimming with youth. The boy's mouth bursts open like ripe fruit, as he boldly laughs at life—uncomplicated, free, honest, and full of mischief. The teeth catch the light or reflect it. Through this interplay of light and substance, the laugh escapes that fixity which we usually see in such portraits and which today reminds us of those irksome toothpaste commercials.

The energy of the artist finds an outlet in the exuberance of the brushwork, which depicts the delightfully unruly hair, the creased collar, and the bold, mischievous look. One wonders whose child could have sat as a model for this painting. One of Hals's own sons? That has indeed been suspected, but who could prove it with any certainty? The question could be answered by another: Would it matter very much if we did know the identity? The artist created not the portrait of "a" child, but the synthesis of "the" child, with the emphasis on the true characteristics which the Dutch poet Martinus Nijhoff (1894–1953) so strikingly expressed when he wrote that the heart of a child is "warm and detached," "beyond this world and free of care."

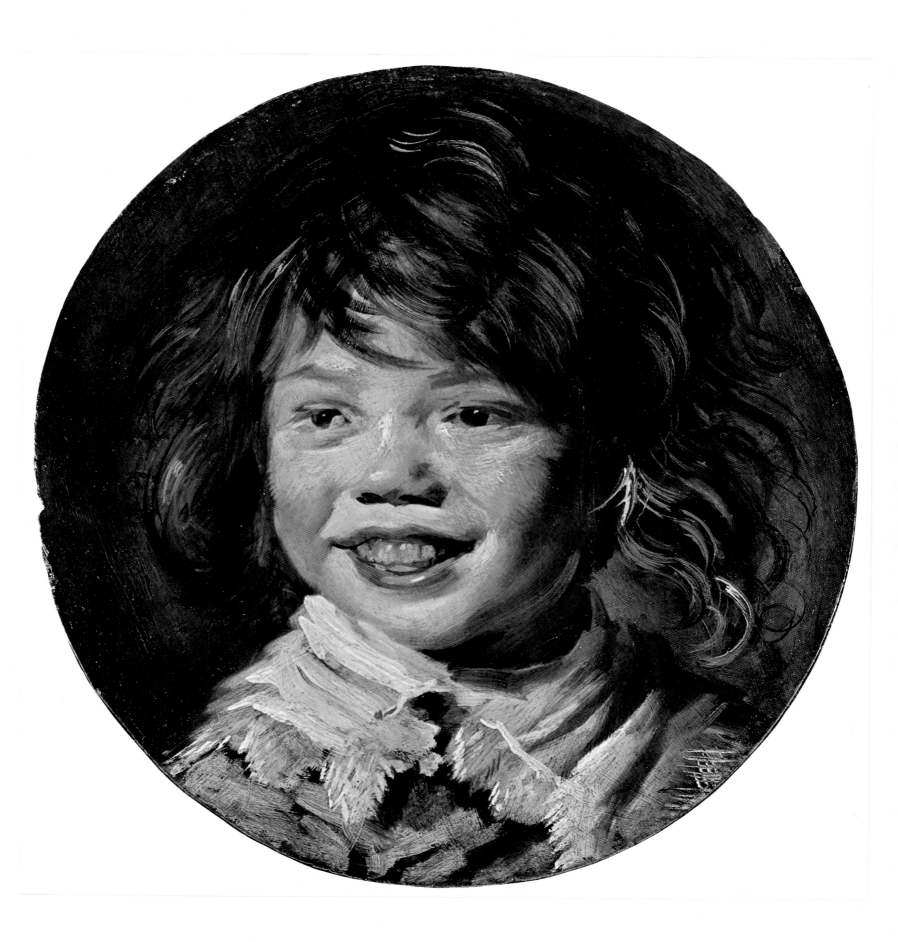

Colorplate 12
MARRIED COUPLE IN A GARDEN (ISAAC ABRAHAMSZ. MASSA AND BEATRIX VAN DER LAEN?)
c. 1622
Oil on canvas, 55 1/8 × 65 1/2"
Rijksmuseum, Amsterdam

A comparison of Hals's portraits of Isaac Massa, one in the Art Gallery of Ontario in Toronto (colorplate 16), painted in 1626, and the other in the Fine Arts Gallery, San Diego, California, painted about 1635, would seem to justify our identifying the man in those pictures as the Massa who in 1622 married Beatrix van der Laen, born in 1592.

Because of the similarity in subjects, this canvas could be placed between two equally well-known works, namely, the portrait of Peter Paul Rubens and his wife, Isabella Brant, painted twelve years earlier (Alte Pinakothek, Munich), and Rembrandt's *Jewish Bride* in the Rijksmuseum, Amsterdam, dated about 1665. There is an unmistakable affinity between the creations of these fellow country-men, Rubens and Hals, with one big difference—the happiness of Paul and Isabella is portrayed in a more restrained manner, conveying an impression of some-what stately posing so that this otherwise fascinating work tends to be formal and official. Hals, on the other hand, invites us into a world in which the inner experi-ence can be felt through a complete sense of the moment. The faces of the subjects and the natural composition are a challenge to place, time, convention, and matter.

Completely different is the atmosphere in Rembrandt's portrayal of the Jewish bride and her groom who, with their exalted feelings, are secure in the conse-cration of their love. In contrast to Rembrandt's serious symbolic representation, Hals evokes an almost ostentatious display of happiness. There is a fascinating and delightful nonchalance about the way he presents Isaac and Beatrix in a free, natural setting devoid of all convention. In all three compositions nature plays a symbolic background role, for an age-old tradition placed lovers in parks and gardens, usually with a fountain or spring (of life), as in Hals's painting.

There is, however, more hidden symbolism surrounding the happy couple. At the right, ivy is curling around the woman's feet, climbing up behind her and twining itself around a tree. This must be taken as a symbol of true love and affection, for ivy even clings to a dead tree ("His decline cannot tear him away from me," says an old emblem book!). The thistle in the left-hand corner, close to the husband, is also a sign of fidelity. This plant, which in German is called *Männertreu*, might also be interpreted in an erotic sense as an aphrodisiac; or like a disappointed teenager who considers *Männertreu* as a wild flower, blooming one day and withering the next. The peacocks in the garden are probably an allu-sion to Juno, the goddess and protectress of marriage, while the urns and ar-chitectural fragments allude to the transitory nature of happiness.

However, none of these symbolic elements is in the least bit obtrusive. The dominant element is the natural setting, with the manor in its beautiful surround-ings in the background. All in all this is a display of love and luxury, of opulence and savoir-vivre, elements which make this chosen couple—unbeknown to them—a symbol of transitory happiness on earth.

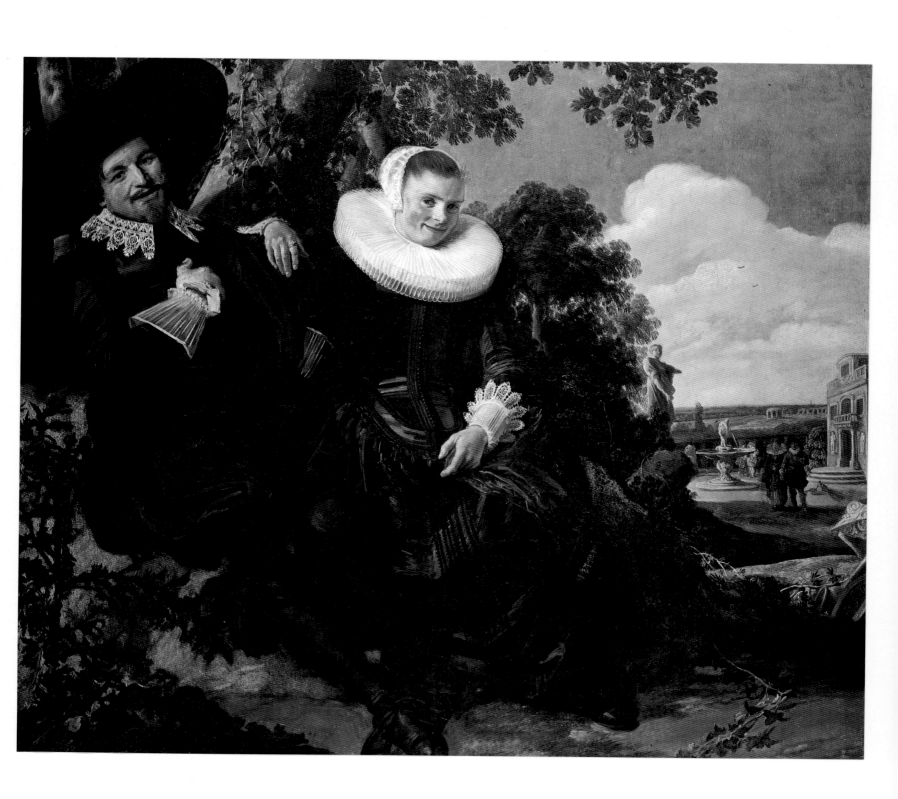

Colorplate 13
THE LAUGHING CAVALIER
Inscribed in the upper right corner: Aeta Svae 26/ A° 1624
Oil on canvas, 33 × 26 1/4"
The Wallace Collection, London. By permission of the Trustees

The Laughing Cavalier is only one of many misleading titles among old paintings, titles which originated during the second half of the nineteenth century when Romanticism was in vogue. It has been said with good reason that each epoch makes its own history of the past. In such a context the nature of a title can be indicative of the period in which it was created. About 1880 this portrait of an unknown man began to be called *The Laughing Cavalier*. Such a title points to a frame of mind that was more attracted by a type than an individual, more interested in history (or should we say the antique?) than in reality. The title, with regard to the character of Hals's model, is irrelevant and expresses more than is justified, since in fact the man does not *laugh*, at least not to the extent of showing real merriment. A suppressed smile indicates an awareness of one's own importance and well-being; it is far more an expression of self-satisfaction than a laugh.

Our purpose in objecting to this title is to discover the man behind the type. So superlatively has the subject emerged from the painter's brush that he is regarded as one of Hals's most brilliant creations. It is just as if in this portrait Hals, inspired by the possibilities the model offered him, has used his potential to the utmost. The presentation and style indicate that he had drawn fresh inspiration from the Utrecht Caravaggesque climate of which we spoke when we discussed *The Lute Player* (colorplate 10).

In connection with the development of Hals's art, it may be of interest to take a look at another vain person, namely, Jasper Schade van Westrum, who was his model twenty years later (colorplate 37). Without in any way disparaging the masterly presentation of the cavalier, we see how, in the case of Jasper, Hals, by getting further away from the substance, gives more room to the spirit.

88

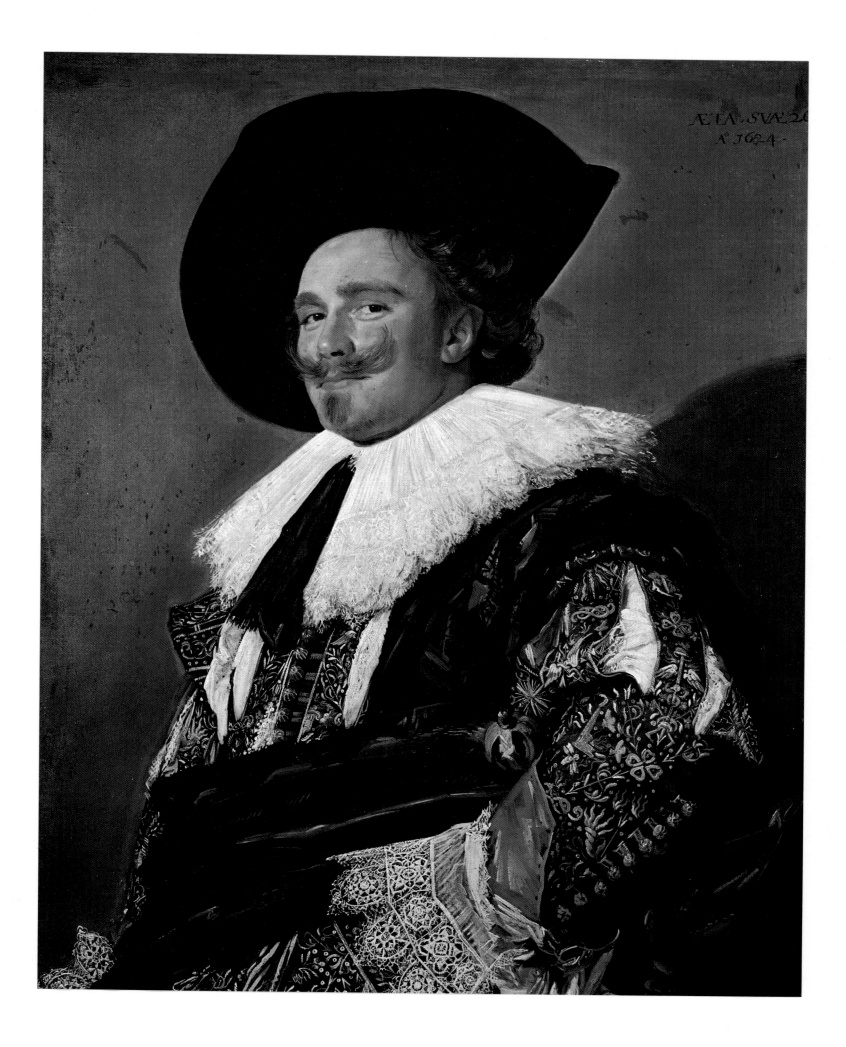

Colorplate 14
THE LAUGHING CAVALIER (*detail of the sleeve*)

In musical terms the pictorial orchestration of *The Laughing Cavalier* could be described as a "symphony with a drumbeat," the drumbeat being the overwhelming effect of the phenomenal painting of the sleeve, which dazzles the eye.

What control is needed to prevent all these decorative details, contained in so small a space, from dominating the picture, and yet to do them full justice! The nine buttons on the sleeve, for example, merge with their buttonholes into the picture as a whole. This also applies to the lace, cuff, and linen of the shirt, which shows through the slits in the sleeve of the upper arm. The white of the lace creates its own light effect as do the adjacent parts, standing out against the overall coloration.

What a profusion there is in this richly decorated elbow! This display of emblems, however, throws no light on the subject's identity or on his status in the community. We see first of all a caduceus, that winged wand intertwined by serpents which is a symbol of Mercury's power to exorcise evil spirits. As Mercury was an active and versatile god, excelling in speed and resourcefulness, his field of action was so wide that he was the patron not only of doctors and merchants but also of scholars and artists.

Around the Mercury emblem are bees, winged arrows, flames, and flaming cornucopias. We can assume that the ostentatious display of these emblems of love point to the man's amorous conquests or ambitions. This would justify the conclusion that his proud demeanor and his seductive eyes are aimed at the weaker sex. Our overall impression is of a "seductive cavalier" rather than a "laughing cavalier."

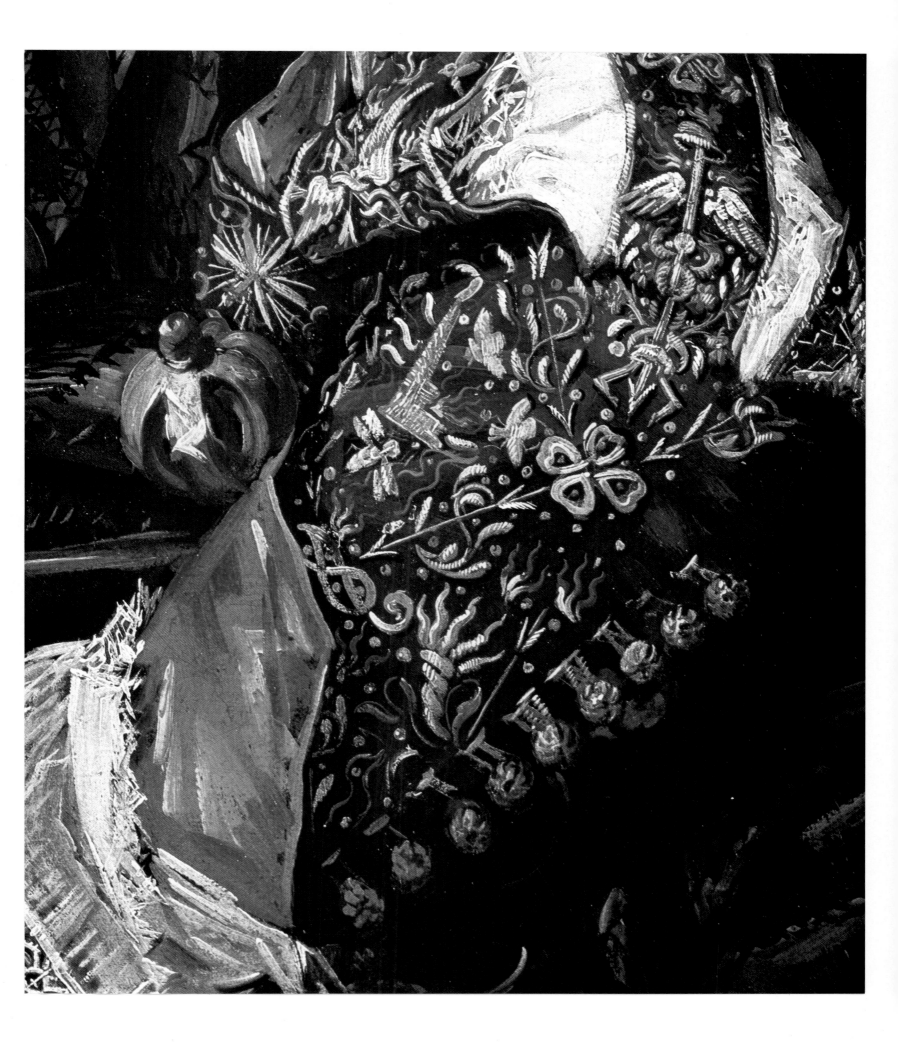

Colorplate 15
ST. LUKE
c. 1625
Oil on canvas, 27 5/8 × 21 5/8″
State Museum, Odessa

The reports in 1959 and 1960 of the discovery by Mrs. Irina Linnik of Hals's Evangelists, St. Luke and St. Matthew, in the storeroom of the State Museum at Odessa were a double surprise. First of all, the recovery of works by Hals, which had disappeared over the course of centuries, was a rare and happy event. It was made even more exciting when it turned out that the lost portraits were Evangelists. Religious paintings by Frans Hals? This caused a stir among art historians, only a few of whom were inclined to attribute the paintings to Hals. A foolproof provenance and subsequently discovered signatures showing Hals's initials confirmed the accuracy of this attribution, which had already been fully borne out by the brushwork, characteristic of Hals, that matched his productions of about 1625.

The existence of religious works by Hals was already known from information found in old inventories: four separate paintings of the Evangelists were part of the auction of Gerard Hoet in The Hague on August 25, 1760. In 1771 they were auctioned on two more occasions before turning up in the collection of Catherine II of Russia in the Hermitage. On March 20, 1812, the Four Evangelists were moved from the Hermitage and placed in one of the churches in Tavricheskaia Guberniia in the Crimea. After that their trail was lost until two of them, St. Luke and St. Matthew, were found in Odessa, where they were listed as by an "unknown nineteenth-century painter." Though this description proved false, it illustrates the "modern" look of Hals's paintings.

Legend makes St. Luke a painter and thus the patron of the art of painting (hence St. Luke's Guild). We know of many representations of the saint at his easel painting the Virgin. There is the sublime picture by Rogier van der Weyden in the Museum of Fine Arts in Boston, replicas of which can be found in the Hermitage in Leningrad and the Alte Pinakothek in Munich. In this painting the ox, apocalyptic symbol of St. Luke, lies hidden under a lectern, and in Hals's painting, too, the animal is more or less hidden behind St. Luke's resting left arm.

Without accusing Hals of eclecticism, we see, in the interpretation of his unusual subject, that he also leans toward the realism of Caravaggio, but in doing so does not reject the traditions of the older generation.

If St. Luke is not one of Hals's most brilliant creations it is due—allowing for the condition of the painting, which suffered during its wanderings—to his failure to visualize divine inspiration in the way a Rembrandt or an El Greco could. Rembrandt's apostles and his evangelist St. Matthew in the Louvre emerge impressively from the chiaroscuro; El Greco embodied his religious convictions in the spiritual image of St. John the Evangelist in the Prado, Madrid. But is it not really unjust to speak of "failure," when Hals's nonreligious vision was wholly foreign to such an approach at such a lofty level? The reverent attitude of the old man—whose head has kept its original brio—is more suggestive of his looking far back into the past while writing his reminiscences than of inspired harkening to the voice of the Holy Ghost. Nonetheless, because of the unintended profanation in Hals's humble human approach, his St. Luke appeals to us just as much.

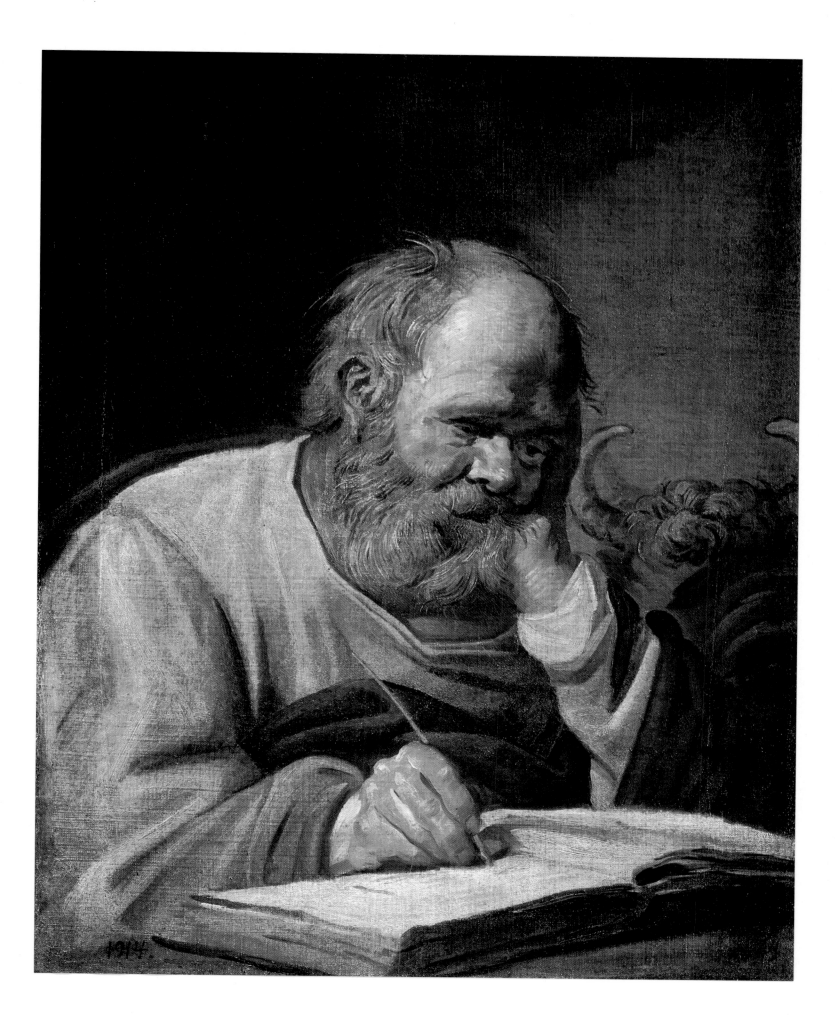

Colorplate 16

ISAAC ABRAHAMSZ. MASSA

Inscribed and dated on back of chair: Aeta/ 41/ 1626
Oil on canvas, 31 1/2 × 25 5/8"
Art Gallery of Ontario, Toronto. Bequest of Frank P. Wood, 1955

If the identification of the couple in the Rijksmuseum is correct—and we do not doubt this—then we have already made the acquaintance of Isaac Abrahamsz. Massa, who, four years earlier, sat beside his first wife, whom he married in 1622 (colorplate 12). Massa was born on October 7, 1586, in Haarlem and was buried in St. Bavo's Church on June 20, 1643.

This portrait is an outstanding example of Hals's work in the 1620s. It is interesting to compare it to another painting in this book, namely, *The Laughing Cavalier*, dated 1624 (colorplate 13). Comparing Hals's models in general is as exciting and intriguing as are our observations of our own relations with other people, observations which confirm the law of nature—that each individual is unique in his inner structure and his outward appearance. In the portraits by classical masters, who can bring out the inner being of their subjects, this astonishing uniqueness leaves a far stronger impression than do the portrayals of painters who want to achieve a likeness, who "satisfy themselves with a 'near enough'," to quote Maurice Quentin de La Tour.

Thus what we find so fascinating in Hals's work is the vital atmosphere in which every individual immortalized by him is rooted. Each model fits into the position imposed by the master to emphasize what he wishes to bring out.

In *The Laughing Cavalier* and in *Isaac Massa* we perceive two different worlds. While the bearing of the vain cavalier is marked by a superficiality which accounts for the outward display from which he draws his strength, Massa presents himself as an intelligent, energetic, and deeper personality. Hals emphasized these characteristics in his presentation. Massa's face is lit by the reflection of the skillfully painted collar, the effect of which is heightened through the contrast of the dark hat and jacket.

The personality of the man is borne out by the information we have about his eventful life. Around 1600, at the age of about fifteen, he was sent to Russia to learn the trade of a silk merchant. During the eight years that he spent there, the country was suffering from famine, war, and corruption. Since he "knew better than anyone the ills of this country," he wrote an account (*Histoire des guerres*) of his experience. It was not published until 1866.

Massa also distinguished himself as a mapmaker. Among the maps he produced is a rare plan of seventeenth-century Moscow. Thus he was active in many ways—as a merchant, historian, geographer, and cartographer. On July 21, 1623, he was a witness at the christening of Hals's daughter Adriaentgen, which may be an indication of friendship—or, in any case, good relations—with the Hals family.

The northern-looking landscape on the right side of the portrait, probably painted by Pieter Molyn, undoubtedly alludes to Massa's stay in Russia. The twig of holly he is holding is a symbol of steadfastness or friendship, since holly remains the same through the seasons. In the Fine Arts Gallery in San Diego there is a portrait of Massa dating from about 1635 from which Adriaen Matham made an engraving—visible proof of his popularity.

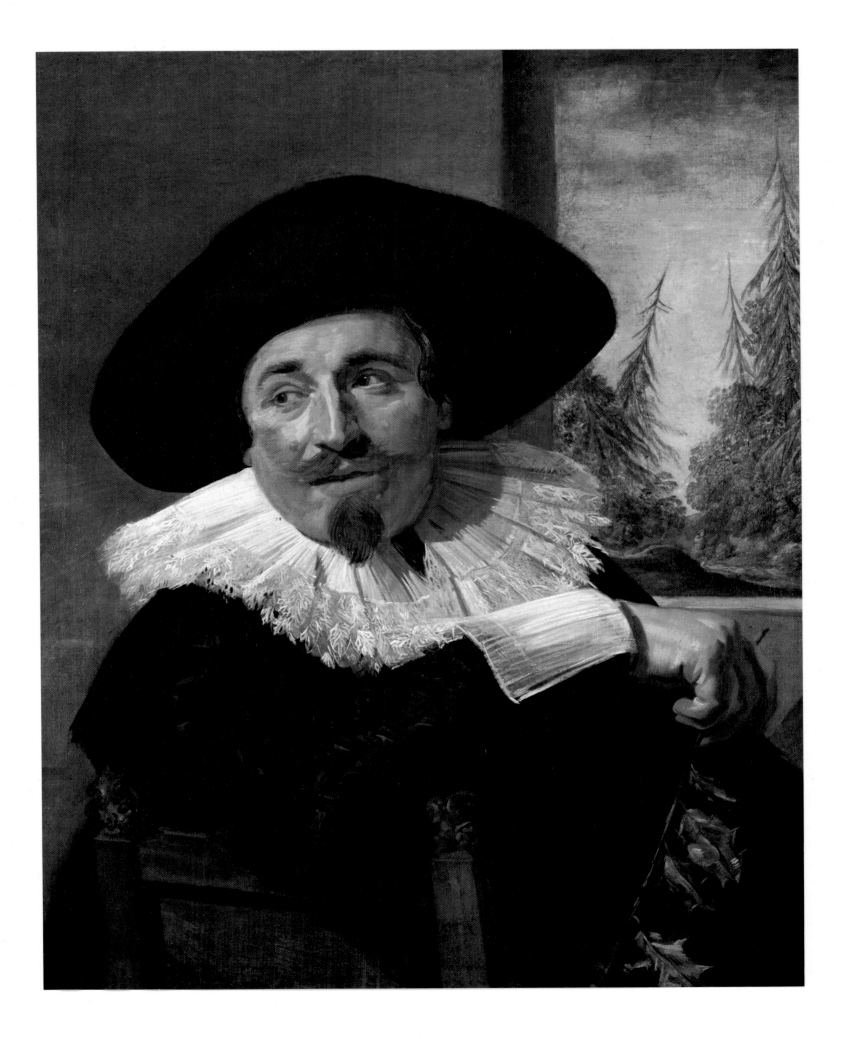

Colorplate 17
VERDONCK
c. 1627
Oil on panel, 18 1/4 × 14"
National Gallery of Scotland, Edinburgh

When this portrait was given to the National Gallery of Scotland in 1916 by John J. Moubray of Naemoor, it was known as *The Toper*. As figure 30 shows, the model wore a beret of wine-colored velvet and held a short-stemmed glass in his right hand. In 1927, the restorer A. M. de Wild suggested that the beret and glass had been painted in and that the original panel must have been identical to the engraving, in reverse, made from this work by Jan van de Velde II (c. 1593–1641; fig. 9). The translation of the verse under the engraving reads as follows:

This is Verdonck, that outspoken fellow
Whose jawbone attacks everyone.
He cares for nobody, great or small,
That's what brought him to the workhouse.

When the painting was still in private hands before 1895, the jawbone and the profuse wild hair were apparently looked on with disfavor. It is symptomatic of the time that a need was apparently felt to make an irrefutable Frans Hals even more genuine by additions and thus to enrich his work with yet another "merry drinker." It remains a riddle how this "drinker" could have gripped a glass as if he wanted to attack someone with it!

A. M. de Wild finally removed the glass and the beret so that from then on Verdonck could resume his threats with the jawbone alone (fig. 31). He may, through his threats, have ended up in the workhouse, but his face does not give the impression of a malevolent man. Perhaps he used the jawbone only in moments of ill temper. It is indeed difficult to guess what lies behind that fierce moustache!

Hals, however, did not—indeed, could not—restrict himself to the characterization of a tramp in a mere genre portrait. This is no vagabond type à la Adriaen van Ostade, that entertaining chronicler of seventeenth-century Dutch peasant life with its taverns where even vagabonds could find shelter. Van Ostade was a keen observer, whose small world, in the words of the late professor Willem Martin, was governed by "quiet enjoyment." Hals broke through this euphoria without becoming dramatic, like Rembrandt in his masterly drawings and etchings of this kind.

Hals caught the vagabond in the man, and the man in the vagabond: the vagabond in his skin tanned by wind and weather, his shaggy hair and powerful fist; the man in his gaze under the overhanging eyebrows and the sensitive features under the weathered surface of his sturdy head.

The panel is signed on the right above the collar: FHF.

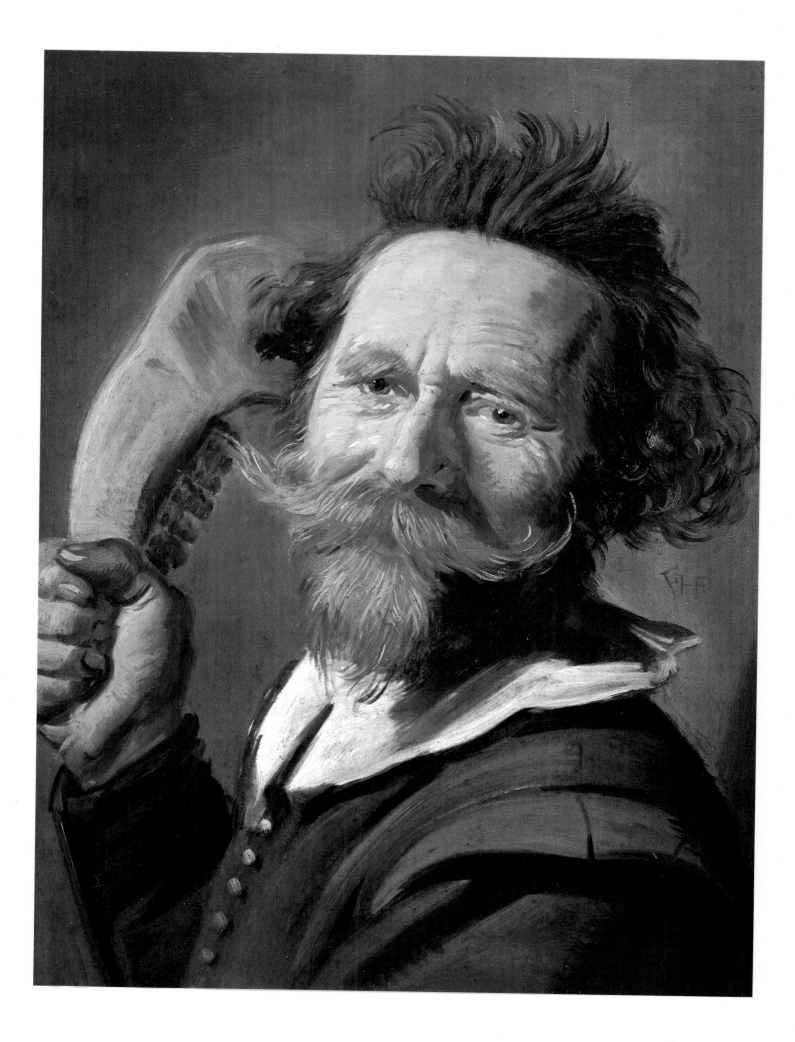

Colorplate 18
BANQUET OF THE OFFICERS OF THE
ST. HADRIAN CIVIC GUARD COMPANY
c. 1627
Oil on canvas, 6′ × 8′ 9″
Frans Hals Museum, Haarlem

The subjects with whom we have become acquainted so far can be regarded pictorially as the heralds of a fundamentally new approach by Hals to the group portrait. If we compare the banquet of 1627 with that of 1616 (colorplate 6), we find that the flexible and illusionistic portrait painting which had sprung up as a new realism from the paintings of Cornelis Ketel resulted in a more colorful atmosphere with such figures as those of *The Lute Player* (colorplate 10) and *The Laughing Cavalier* (colorplate 13). While this atmosphere still reflects the prevailing fashion, the relaxed and more decorative grouping, seen in colorplate 18, which is enhanced by the change from a three-dimensional to a two-dimensional structure, marks a new stage in Hals's group portraits. Where the earlier banquet was composed in depth, the whole scene is now spread out parallel to the background, the diagonals no longer suggesting perspective, but remaining parallel to the picture plane.

The company consists of two equivalent groups which are differentiated in the center by the two captains sitting back-to-back. Another captain, seen between them, acts as a link between the two groups. This link is further emphasized by the gestures of the hands reaching out toward each other in the center of the composition, and by the barman who holds a Jan Steen jug and is handing over a full glass, an action explained by the ostentatious display of the empty glass held upside down in front of the window.

The Haarlem *Cluveniersdoelen*, or Harquebusiers, was established in 1519 as a special firearms section, with St. Hadrian as its patron. The guards of the *Cluveniersdoelen* were called the *Jonge Schuts* to distinguish them from the members of the *St. Jorisdoelen*, or St. George Company, referred to as the *Oude Schuts*.

Whereas Hals depicted the members of the *Oude Schuts* in 1616 in a fanciful setting with columns and a loggia-type window without glass, most improbable for a Dutch shooting hall, the members of the *Jonge Schuts* of 1627 pose in a room where the light streams in from the side and from behind through leaded-glass panes, a natural and realistic interior.

The more playful brushwork gives the color orchestration a note that resounds clearly in the guards' festival—a festival in blue, white, red, green, yellow, gold, and orange playing around the dark patches of the guards' dress. Let us not forget the dog in the lower left corner. Note the way in which Hals, with a few brush-strokes, caught the characteristics of its breed (fig. 32).

The canvas is signed FHF with joined initials on the chair at the left.

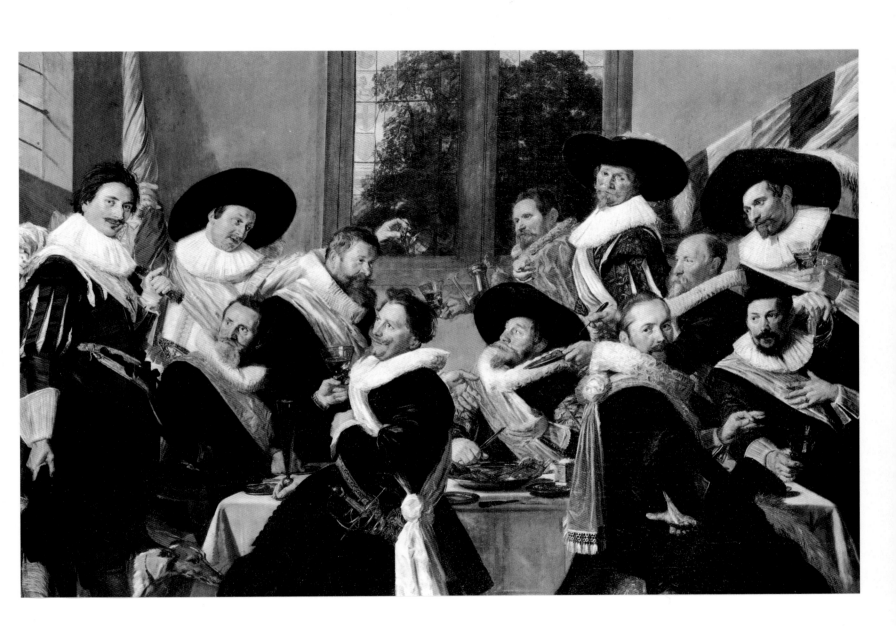

Colorplate 19
BANQUET OF THE OFFICERS OF THE
ST. HADRIAN CIVIC GUARD COMPANY
(*detail of Captain Willem Warmont*)

We have selected Captain Willem Warmont to represent the *Jonge Schuts* of 1627, but not because his portrait is any better than those of his colleagues. All twelve representations are equally successful, and any preference would be only personal according to some characteristic which the onlooker finds appealing.

Warmont gives the impression of being a self-possessed man; the posture Hals has given him shows that he intended to express self-assurance in his model, not only in the face, but also in his attitude and in the hands. Here we see how each figure, removed from the group, maintains its own existence and is fully alive as an individual.

This detail affords us an unforgettable confrontation with the substantive form which dissolves under Hals's touch. Thus, for example, the skillfully painted ruff becomes evanescent as it merges with the light. The strong light below the man's ear diminishes as the ruff fades out until we can barely see the arabesque pattern of the pleats against the emerging texture of the canvas, so thin is Hals's application of paint in the shadow under the ear. The rendering of the hair is also highly skillful. To our amazement, it is visibly rooted in the skin.

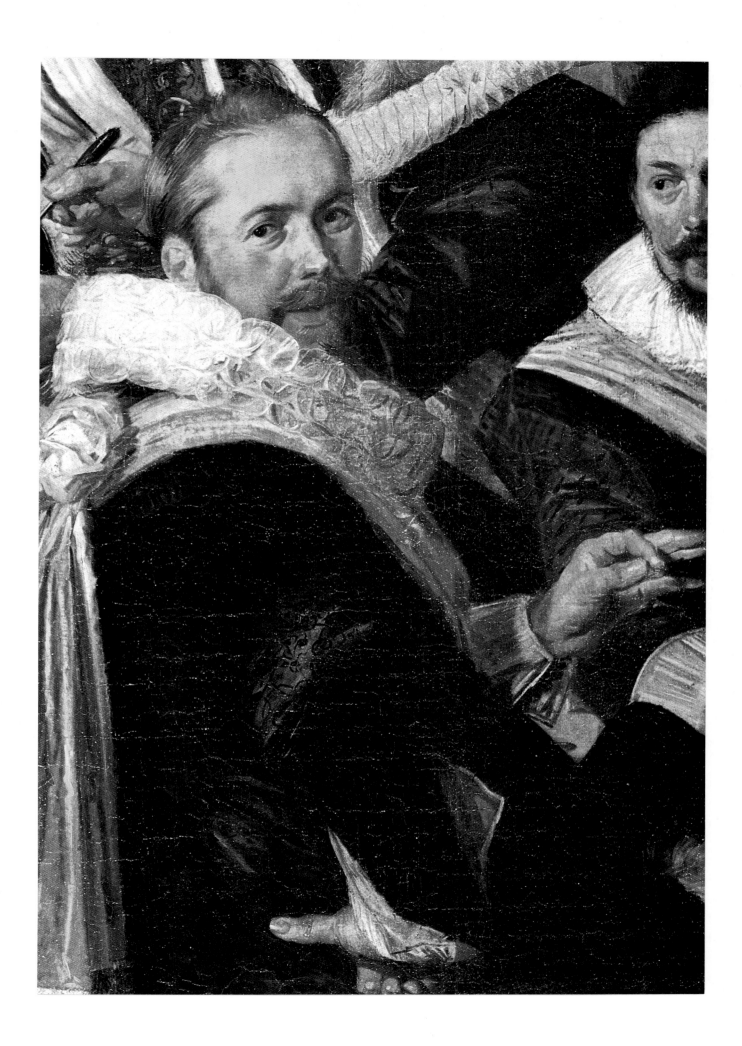

BANQUET OF THE OFFICERS OF THE
ST. GEORGE CIVIC GUARD COMPANY
(*detail of Boudewijn van Offenberg*)
c. 1627
Oil on canvas; size of entire painting, 5′ 10 1/2″ × 8′ 5 1/2″
Frans Hals Museum, Haarlem

If Hals's group portraits escape being confined in a frozen tableau-vivant, it is
not only because of his ability to keep alive the actions and mutual contacts of his
models and to make the inanimate objects part of that action. The skillful trans-
position and the harmonizing of the scale of colors, which are characteristic of a
guards' banquet, play an important part here.

If we want to have some idea of the difficulty of such transposition, let us
imagine we are facing a group of guard officers, sitting at a table or parading amid a
profusion of colors which, together with the various accessories around them,
dazzle the eye. We must not forget the ever-changing light which constantly
affects the colors, with all the problems this poses for the artist.

If the local colors of the *doelenzaal*, or guards' hall, were reproduced unmodi-
fied on the panel or canvas, a gaudy commonplace scene would result, a scene in
which the warm, cold, and neutral colors would compete, and in which the light's
creative role would be ineffective and the subtle tones which create the atmosphere
of a work of art would be lost. In his re-creations, intuitively or consciously,
Hals harmonized these colors into color symphonies.

The keenly analytical Eugène Fromentin rates Hals in his *Maîtres d'autrefois*
(1876) with artists like Titian, Rubens, and Velazquez among the colorists, since
they observe color in nature more acutely than form, and they master color
better than line. "In order to obtain delicate or pronounced nuances, one should
be able to select them well on the palette and to set them successfully next to each
other in the painting. Part of this complicated art is governed by some fairly
constant laws of nature, but for the greater part it depends on the talents, habits,
instinct, ideas, and sudden perceptions of every artist." The detail reproduced on
the opposite page is convincing affirmation of Fromentin's statement.

The gloved right hand of the standard-bearer, Boudewijn van Offenberg,
grips the traditionally short pole of the banner. The bearer, who had to be of pre-
sentable appearance, was required to make his standard sway and turn during
a parade. Standard-bearers were recruited from among "able bachelors wherever
they were available." If they married, they lost their rank. The standard-bearer
of *The Meagre Company* of 1637, whom we will meet later (colorplate 29), is
unsurpassed in the way he holds himself.

But let us return to the detail: this brilliant piece of painting requires no com-
ment. In it Hals triumphed over matter and light, and also color. The viewer him-
self must examine this field of colors closely and see in it the confirmation of what
we have said above. One thing that should be pointed out is the orange glow on
the glove, caused by the reflection of the orange sash opposite. This effect is not
taken from reality but has been added by Hals for the sake of color balance. It
shows his understanding of the language of color and his ability, when rendering
local color effects, "to give each color its scope," to quote Matisse.

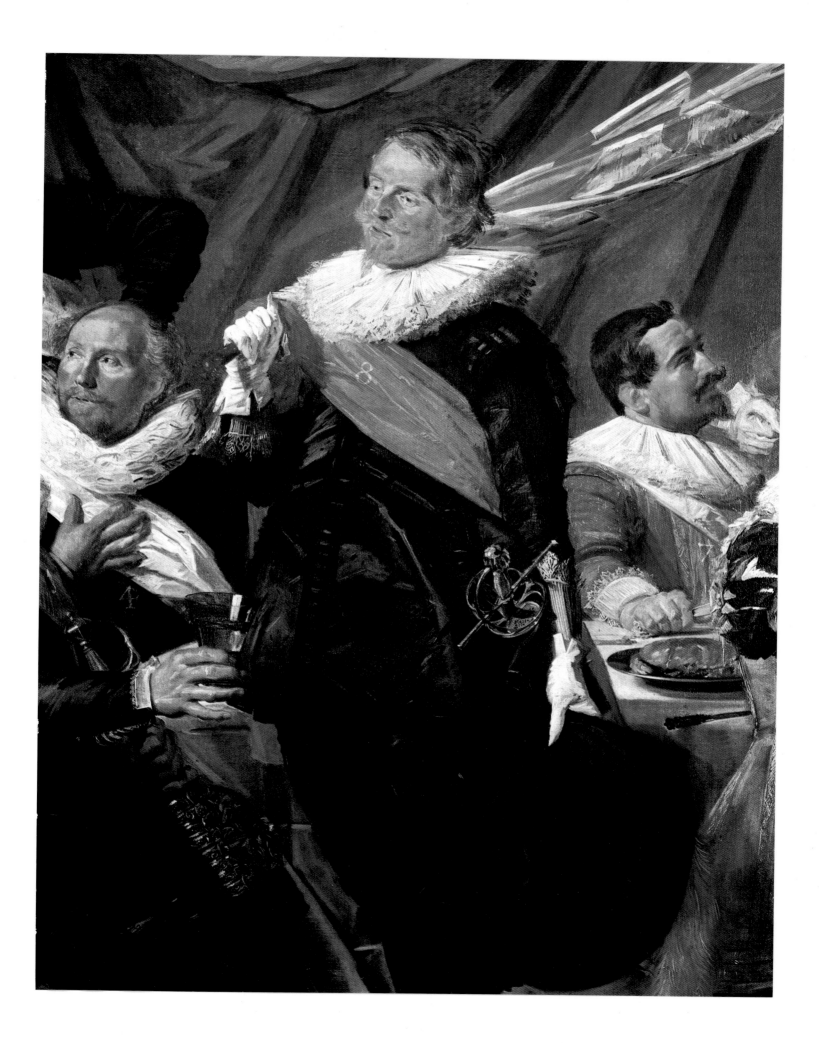

Colorplate 21
GYPSY GIRL
c. 1628–30
Oil on panel, 22 3/4 × 20 1/2"
The Louvre, Paris

The genre paintings executed in the 1620s reached their apotheosis in a painting in the Louvre that can be regarded as one of Hals's most brilliant creations: the *Gypsy Girl*, painted about 1628–30. The title dates from 1870 and has been maintained since, although it cannot be proved that the portrait really represents a gypsy girl. As a genre painting this courtesan-like figure with her mischievous side glance fits into the Caravaggesque chiaroscuro style, but escapes the somewhat common rendering from the Italian by the Utrecht masters who, despite their highly developed craftsmanship, were often restricted by an uninspired and vulgar frivolity (see fig. 33). Hals's spiritual qualities (which are evident in this picture) protected him from the vulgar and the frivolous. Slive rightly points out that "Hals, who was called a toss pot and worse by his early biographers, did not paint a single coarse or vulgar picture during his long career."

Even in this representation, which was daring for the time, Hals showed restraint, for however bold his model may seem in her dress, bearing, and look, she does not exceed the bounds of propriety. Her true social background emerges unrestrained and challenges all bourgeois decorum. The transparently painted flimsy dress is rendered in quick, light touches, pregnant with psychic implications. Of course, this is the reaction of the man of today who has become accustomed to "absolute art in painting" which, with the abstract art of Kandinsky, brought about a revolutionary reversal in the artistic traditions of so many centuries. And yet, it would not be the first time in the history of art that artists transcended time and place, sharing the same vision, using the same means, and realizing that vision regardless of their medium. It goes without saying that Hals's tendency, tied as he was to his own time, was to respect the observable form, in contrast to the anti-naturalistically oriented painters of abstract art.

In connection with this abstract element, we should also like to point to the indefinable and unique background of this masterpiece. There can be no doubt that Hals has projected the domain of the girl, who, free as a bird, was a misfit in her social cage. This background could be viewed as the unfurled flag of a free outlook on life, of which the panels are blue for the heavens, gray for the clouds, and gold for the sunlight. There is splendor, too, in the whiteness of the opulent bosom against the shades of white and gray of the blouse. Pentimenti, which may be seen in raking light on the left side of the bosom, show that Hals had originally made the decolletage less daring, but also that, when he completed it, he knew exactly how far he could go. We are led to toy with the idea of how splendidly he could have painted the female nude. Undoubtedly, he would have surpassed Manet's *Olympia*!

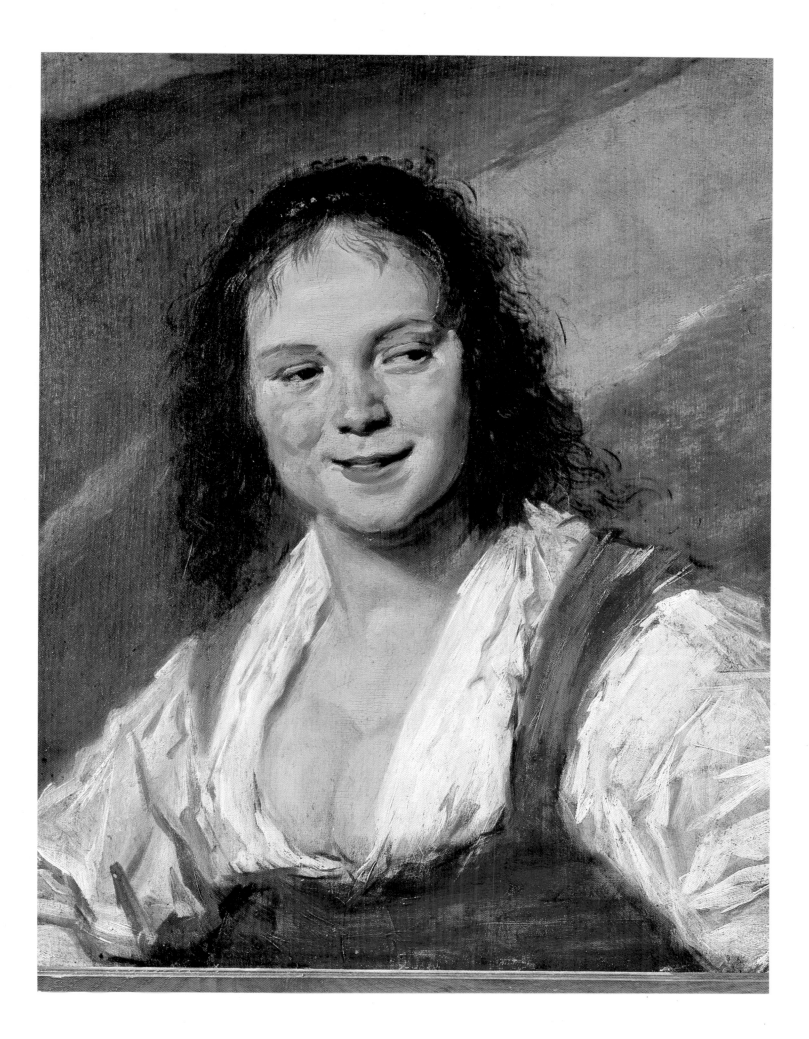

THE MERRY DRINKER
c. 1628–30
Oil on canvas, 31 7/8 × 26 1/8"
Rijksmuseum, Amsterdam

The Merry Drinker is yet another portrait where the genre element is so dominated by the personality of the model that it does not fit into the category of works of art which illustrate the manners and customs of the time and are therefore classified as genre paintings. In his *Lexikon der bildenden Künste* of 1883, Dr. Hermann Müller defined genre painting as "the kind of painting that depicts life in its varied manifestations—scenes and events from everyday existence, adhering strictly to genre in general, to humanity, without mentioning any particular person by name." Hals remains outside these scientifically defined limits, because, as far as *The Merry Drinker* and indeed *The Lute Player* and *Verdonck* (colorplates 10, 17) are concerned, what he had in mind was the man and not the type.

Here, too, the nineteenth-century title is debatable, though it must be acknowledged that the drinker is in a good mood. But in the seventeenth century, paintings were not given descriptive titles. Such titles can confuse and even falsify the artist's real intention. A classic example is Rembrandt's *The Night Watch*. This world-famous title persists despite the fact that the departure of the guards is taking place in full sunlight!

Though the title *The Merry Drinker* is not so misleading, it does not convey the essence of the portrait precisely because Hals breaks out of the anecdotal tendency of the genre portrait. Furthermore Hals may be depicting one of the five senses, in which case our toper would represent Taste, especially the joys of drinking.

Many museumgoers will accept the title and recognize *The Merry Drinker*, but overlook the transcendent skill shown in this masterpiece. How much Hals surpasses the usual interpretation of his subject can be seen if we compare his *Merry Drinker* with a painting by an Amsterdam contemporary, Nicolaes Eliasz., known as Pickenoy. This work shows the wine merchant, and barman of the *Voetboogdoelen*, or Crossbowmen, in Amsterdam, Maerten Rey, painted in 1627 at the age of thirty-two (fig. 34). First of all, Hals's Haarlem had a gayer and more lively atmosphere that is strikingly demonstrated in a comparison between them.

The highly able but conventional Eliasz. may be convincing because of his sound craftsmanship, but compared to Hals his work is lacking in life. In contrast to the sturdy grasp with which Hals's drinker holds his glass (fig. 36), Rey seems to have lost all the blood from his right hand, which looks as if it were made of a waxlike substance (fig. 35). Hals, however, had the ability to capture the essence of the form in a swift application of paint. Eliasz.'s glass is professionally and flawlessly painted, but it would be better suited to a still life. It cannot convince us of its festive function in the total picture. With Hals, glass and function merge effortlessly. The glass loses its material weight, merges with the whole, and flashes like a perpetual "toast" through time. Eliasz. said that he always tried to complete his work "in the way the patron wished and ordered." That Maerten Rey was satisfied with his immortalization as a burgher is evident from his look of a self-satisfied bourgeois. *The Merry Drinker*, however, shows Hals's ability to catch and portray, not status, but life itself.

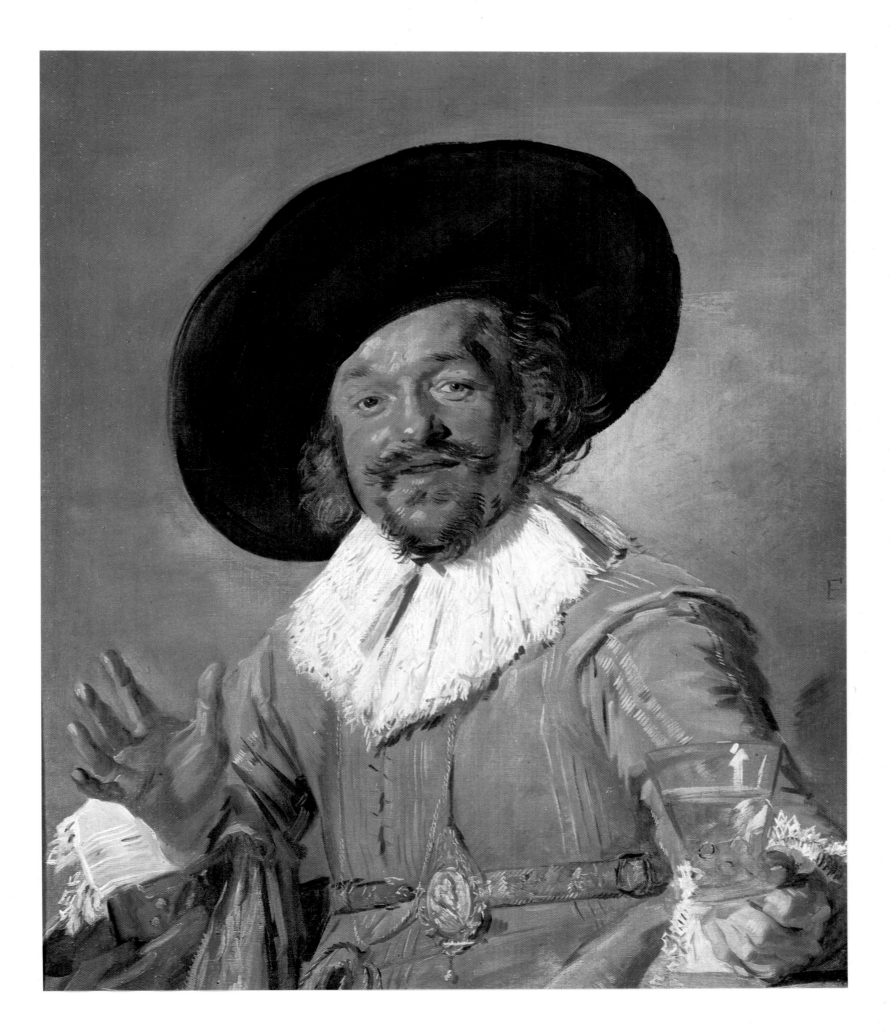

Colorplate 23
THE MERRY DRINKER (*detail*)

This is a close-up not only of a face but of the virtuoso Frans Hals himself who, in this unforgettable painting, reveals to us the genius of his artistry.

One of the Utrecht painters, Gerard van Honthorst, painted a similar subject in 1623, namely, *The Merry Fiddler*, which is now in the Rijksmuseum (fig. 24). It is an example of the Utrecht school in the Caravaggesque style, which we have already discussed in our commentary on *The Lute Player* (colorplate 10).

It remains to be seen, however, whether the fiddler is actually as merry as the title of his portrait claims. A close-up of his face (fig. 25) shows that the man was probably more tired than merry after his lengthy posing in artificial light, the source of which is outside the picture. That he is tired we can deduce from the fixed laugh on his face, which has lost all spontaneity and appears as a frozen grin. Honthorst, with academic fidelity, reproduced every hair on the head and in the beard. Just as with Eliasz., the picture gives the effect of a bloodless surface, behind which all life has been extinguished. Painted in an illusionistically perfect way, such a portrait displays a waxwork precision, inclined to please the eye rather than to stimulate it the way Hals's brilliant composition does.

The realistic head of Hals's model reveals an inner life. With unerring accuracy the artist has captured the essence of the man. The surface of the face is composed of smooth areas and the brushstrokes merge into one another. Hair, moustache, and beard all play their part. Hals painted far more economically than an accurate rendering of the live model would seem to require: "Self-limitation reveals the master" (Goethe).

Apart from Hals's featherlight touch, the flowing and immaterial element in his painting is due to the *alla-prima* technique he employed. In this technique, which originated in Italy, the artist applied his paint wet, that is, in one even layer, in contrast to the earlier method of applying the paint layer by layer, which required more time to dry. Hals's spontaneous *alla-prima* technique ensured that his models remained alive. *The Merry Drinker* is convincing evidence of this.

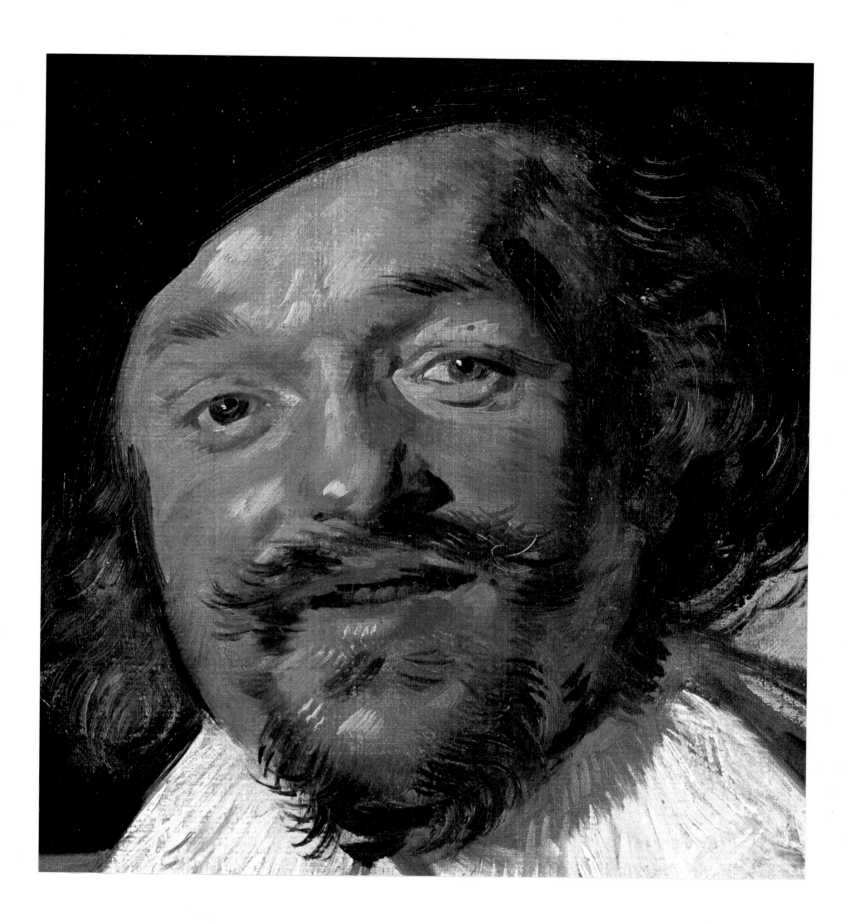

Colorplate 24
OFFICERS AND SERGEANTS OF THE
ST. HADRIAN CIVIC GUARD COMPANY
c. 1633
Oil on canvas, 6' 9 1/2'' × 11'
Frans Hals Museum, Haarlem

Gathered around a table in the garden of the still existing *Oude Doelen*, the officers and sergeants of the *Cluveniersdoelen* were painted before leaving for a parade. The painting is marked by a fine sense of balance. The diagonal format of the banquet has been abandoned in favor of a horizontal composition. The artist has again divided the officers into two groups. The group at the left has gathered around the dominant figure of Colonel Johan Claesz. Loo. The group on the right leans toward the colonel but forms a separate unit. The seven figures at the right move around a table at which Lieutenant Hendrick Gerritsz. Pot is seated holding a book, which may contain the minutes of the meeting. As a counterpart to Colonel Loo we have Captain Andries van der Horn, who is in the center of the right group. The difference in the atmosphere of the two groups is typical of Hals's keen sense of observation: the relaxed attitudes of the officers on the right show that they can move more freely because they are outside the authoritarian sphere of Colonel Loo. The two figures in the center of the composition, back-to-back on opposite sides of the table, link the two groups.

With a certain rigid elegance the officers are trying to assume attitudes which will convince the spectator of their importance. What a difference in the life-style they represent as compared with the sturdy generation shown in the banquet of the guards of 1616 (colorplate 6), where the fashionably dressed younger guards are already knowingly heralding the life-style Hals reveals to us in 1633.

The spontoons of the lieutenants, the halberds of the sergeants, and the colorful banners of the standard-bearers project above the group. The color symphonies of 1627 are combined here in a broader orchestration, though the effect is more subdued. The rich browns and greens of the trees in the background (probably painted by another hand) may have lost some of their color and light through the lapse of time and possible restoration. They form a harmonious sounding board for the wealth of colors in the summery grounds of the *Oude Doelen*.

It is interesting to compare Rembrandt's concept in his *Night Watch* (fig. 37) with that of Hals in this guards painting, which was created nine years earlier. The guards in Amsterdam and Haarlem give an entirely different aspect to a similar guards display. Vincent van Gogh was right in one of his letters to his brother Theo when he said: "As to the pictures by Frans Hals—he always remains on *earth*—one can speak about them. Rembrandt is so deeply mysterious that he says things for which there are no words in any language." Indeed, whereas Rembrandt overwhelms us with the luster of the parade, Hals impresses us with the life of the paraders. Rembrandt's chiaroscuro creates an atmosphere in which the guards are coming toward us in a group; the optical effect is so suggestive that the imaginary line between the scene and the spectator seems to disappear. Hals reacts more to the decorative demands of his commission by keeping the flow of portraits alive and transparent.

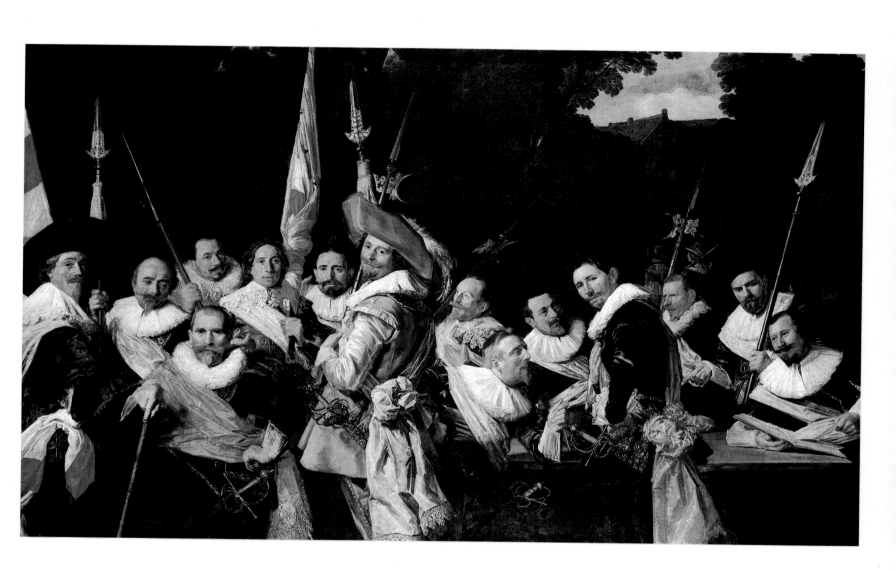

Colorplate 25
OFFICERS AND SERGEANTS OF THE
ST. HADRIAN CIVIC GUARD COMPANY
(detail of Colonel Johan Claesz. Loo)

One of the most fascinating figures among those prominent in the guards companies is Colonel Johan Claesz. Loo, proudly sitting among his men, whose faces reflect how much they are aware of the privilege of being admitted to his presence. Loo was appointed a member of the town council in 1618 and an alderman in 1619. Between 1620 and 1658 he was, with intervals, burgomaster of Haarlem for twenty years, and from 1649 to 1651 served as deputy in the States-General. He died on October 7, 1660. He owned the Three Lilies Brewery, which, like Loo's homestead, "Velserend," was painted in 1627 by Jacob Adriaensz. Matham (1571–1631; fig. 39).

Only occasionally do we remember the names of Hals's subjects in the guards paintings. Although their names are fully known, they are not mentioned here since they are important only when we deal with local history, an historical treatment of the guards system, or in a thorough art-historical study such as that by Seymour Slive, in which anyone interested can learn all he wants to know about these names.

For the modern museumgoer, the label Frans Hals under his group portraits is enough without any mention of the names of those painted. This was not the approach of earlier generations. About the middle of the eighteenth century, numbers were used to indicate the individual portraits. The only exceptions were the guards paintings of 1616 and 1637. These numbers correspond to the names which were put on plates under the paintings so that they "should forever be remembered by posterity." An engraving shows how the guards painting of 1633 was placed in the *doelenzaal* and how the plates were attached (fig. 40). The names of the guards of 1616 were published only in 1959 by C. C. van Valkenburg, after the discovery of an eighteenth-century manuscript. In the case of *The Meagre Company* of 1637 (colorplate 29), only the names of the captain and lieutenant are known.

Colonel Loo's sash is proudly marked No. 1. Apart from its informative purpose, the number also has symbolic significance, for Loo is here the dominant figure. So suggestively did Hals paint the cane and rapier into his arrangement that he has unforgettably confirmed the authority of this seventeenth-century magistrate. As with Banning Cocq in Rembrandt's *Night Watch*, the cane on which he is leaning with his right hand indicates his authority as colonel. The left hand is ostentatiously placed above the hilt of his rapier, which has around it the inimitably painted sash, ending in a wealth of gold lace. To us Johan Claesz. Loo not only convincingly reveals the authority of a powerful burgher, but the versatility of Hals's art.

112

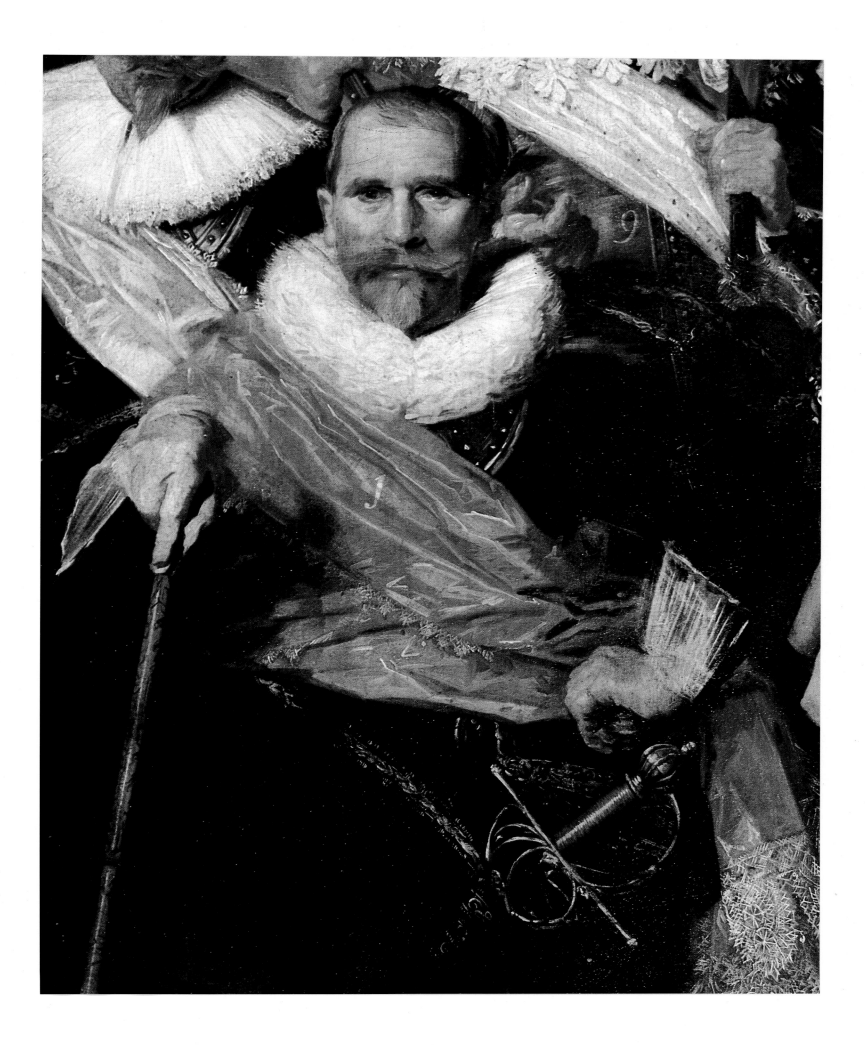

Colorplate 26
PIETER VAN DEN BROECKE
c. 1633
Oil on canvas, 28 × 24"
The Iveagh Bequest, Kenwood House, London

Pieter van den Broecke was born in Antwerp in 1585. He remained a bachelor and throughout his life was connected with the sea. He went on voyages to Cape Verde (1605–6), Angola, and the Congo (1607–12), and as a senior merchant between 1613 and 1629 established trade relations with ports on the Red Sea. During that time he led the defense of the fort of Djakarta against the British, who were allied with the Javanese (1618–19). In 1616 he was sent by Jan Pietersz. Coen, founder of the Netherlands dominions in the East, to Surat, where he remained as director of trade in Hindustan until 1629. After returning to Batavia, he became commandant of the fleet which returned to Holland in 1630, bringing back Coen's widow. On his return, the Dutch East India Company awarded him a gold chain, which can be seen in this portrait. Later he went back to the East Indies and was in command of the siege of Malacca, where he died before the town was captured in 1640.

In his diaries Pieter van den Broecke showed what kind of man he was: simple, unaffected, lively, and self-confident, just as Frans Hals painted him at the age of forty-eight.

It is a pity that neither Rembrandt nor Hals had the opportunity to paint more of the fleet commanders who rendered such invaluable services to the Dutch Commonwealth in the seventeenth century. Dutch seamen have been immortalized in many portraits, such as those by Ferdinand Bol, Jan Lievens, Bartholomeus van der Helst, Nicolaes Maes, and Hendrick Berckman, to name but a few. It was indeed a privilege for Van den Broecke to be painted by Hals, for apart from the sensitive portraits by Jan Lievens, such as the one of Maerten Harpertsz. Tromp in the Rijksmuseum, the paintings by the artists we have mentioned and others are in many cases sound representative portraits, but lack the psychological depth of Rembrandt's and Hals's subjects.

When we compare Hals's rendering of Van den Broecke's hand with the rendering by Ferdinand Bol of the hand of Holland's greatest fleet commander, Michiel Adriaensz. de Ruyter (figs. 41, 42), we realize that Bol's depiction fails, according to his first biographer, Gerard Brandt, to "keep tune with the harsh music of so many cartridges." While Bol was unsuccessful in trying to give expression to this important detail, he also failed to give De Ruyter's portrait anything more than a superficial, formal likeness, showing the hero not as he was, but as his admiring, idolizing contemporaries wished to see him.

It is typical of the greatness of Hals's vision that he was able to convey both humanity and authority in one portrait and, as always, the artist made the human element prevail.

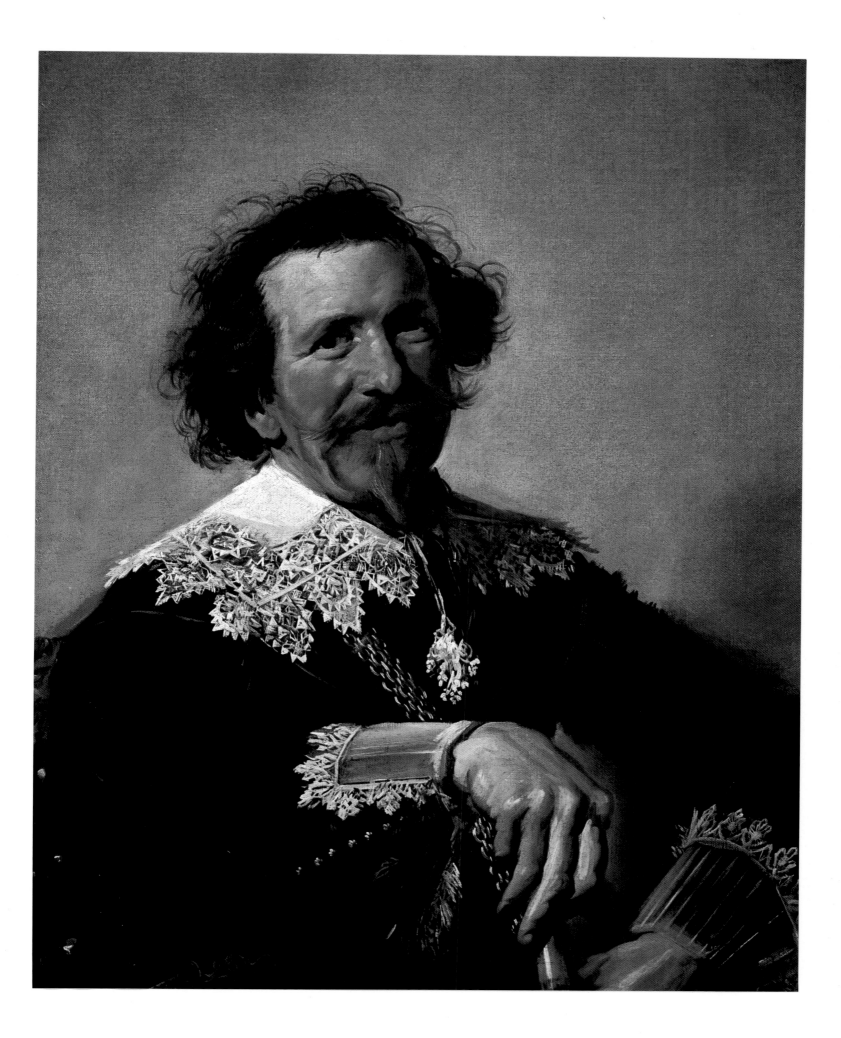

Colorplate 27
PIETER VAN DEN BROECKE (*detail*)

It has been said that Hals often held a dialogue with his sitters. However romantic this may seem, it is a fact that the way certain models are placed, for example, *Massa* (colorplate 16) or the *Man in a Slouch Hat* (colorplate 48), gives the impression of a contact that is more than mere posing. This is also true of the presentation of Pieter van den Broecke, where the aspect of a dialogue is a very strong one.

The pose of the sitter—his closeness to the viewer—has been assumed to reinforce the essence of the dialogue. The essence is in the face, which is so penetrating that we feel convinced that Van den Broecke is in direct contact with the person looking at him.

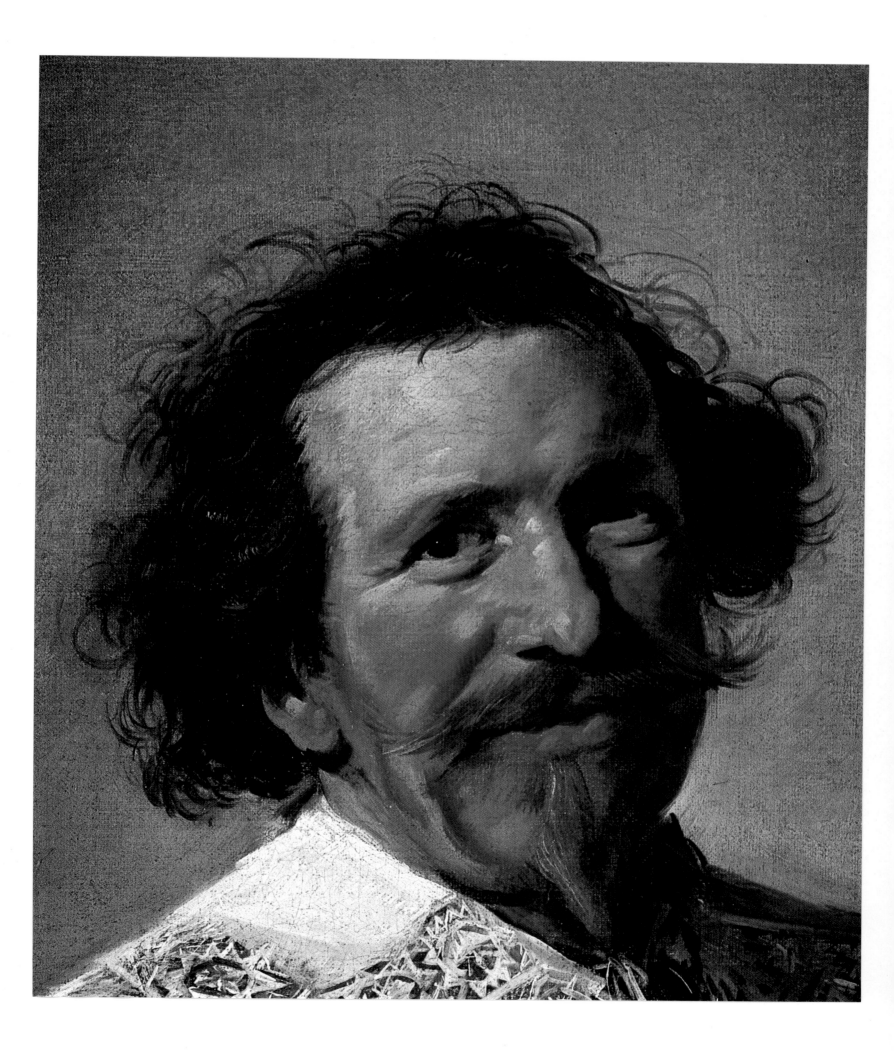

MALLE BABBE
c. 1635 or later
Oil on canvas, 29 1/2 × 25 1/4"
Staatliche Museen, Berlin-Dahlem

She was apparently generally known in Haarlem as Malle Babbe, with the accent on Malle (crazy), that is, if an inscription (eighteenth century?) found on a piece of the old framing and later put on the new frame is authentic. This inscription reads: "Malle Babbe of Haarlem . . . Fr(a)ns Hals."

Research has not yet yielded any results on the identity of this mythical woman. Like Verdonck, she must have been a character whose local popularity inspired Hals to paint her. It may be assumed that Malle Babbe was her nickname (or an insult?). Whether the inscription is authentic or not, Hals's rendering of the woman proves that the epithet "Malle" is appropriate.

His brushstrokes convey the confusion which must have filled the disordered brain of this street type. She seems to be pressed in between the wonderfully painted pewter beer mug and the owl haphazardly perched on her shoulder. She behaves like a hunted creature, pursued by her own delusions. She was created out of an entangled mass of brushstrokes, short and long touches, which combine to merge into the cacophony mentioned in the introductory text. The inner disorder is also manifest in the crumpled collar, the loose touches on the left of the bonnet, and her untidy hair protruding from it. The mouth, crude as that of an animal, is wide open, as if amplifying the shrill shout which will echo as long as this canvas holds its paint.

Our curiosity is aroused by the owl on the woman's shoulder. The symbolism of the owl varies remarkably. We find it as an inseparable attribute of Athena or Minerva, and in the deviltries of Hieronymus Bosch. In ancient Greece it was a symbol of wisdom, and in the Middle Ages a personification of evil. In accordance with medieval concepts, Hals's owl and Malle Babbe may well suggest demonic force, madness, coarseness, or drunkenness.

The painting has been copied several times, the one in the Metropolitan Museum of Art in New York being the closest to the original. Courbet, who said of the painting that "it was one of the greatest masterpieces," made a copy of it in 1869, which is in the Kunsthalle in Hamburg.

As with all replicas and copies, these show that it was beyond the ability of those who painted them to equal or approach Hals. With such revolutionary brushwork as this we become aware that Hals is intuitively moved by a discipline, an order, which guarantees a mutual relationship in the seemingly loose pattern of brushstrokes. Among his imitators this pattern deteriorates into chaos, and to the observant eye shows how wide is the gap between their efforts and the inimitable original.

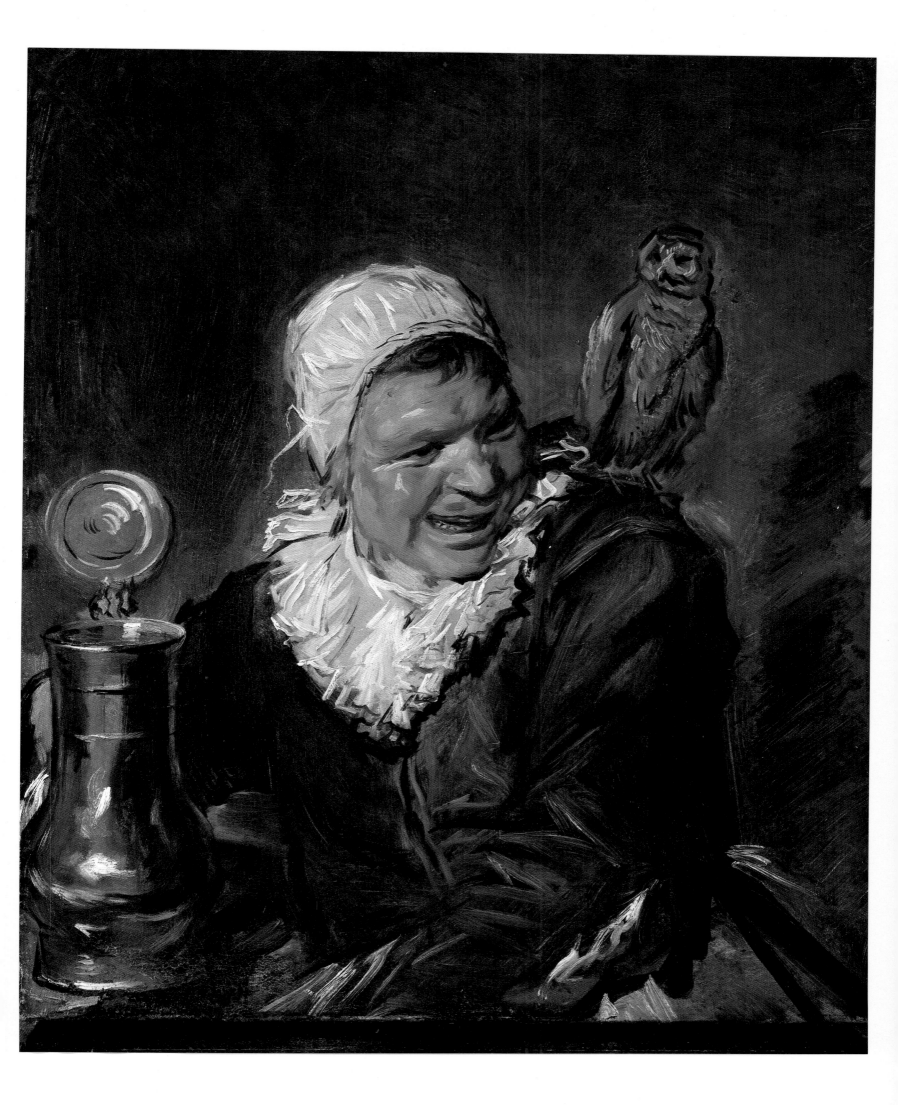

THE COMPANY OF CAPTAIN REYNIER REAEL
AND LIEUTENANT CORNELIS MICHIELSZ.
BLAEUW, *known as* THE MEAGRE COMPANY
(detail of standard-bearer)
Finished by Pieter Codde, 1637
Oil on canvas; size of entire painting, 6' 10 1/4" × 14' 1"
Rijksmuseum, Amsterdam

The Meagre Company, which was commissioned by the Amsterdam *Voetboog-doelen* in 1633, is the only guards painting which Hals was asked to do outside Haarlem (fig. 43). According to Amsterdam tradition, it shows the company full-length in contrast to the Haarlem three-quarter-length portrayals.

Due to a dispute between the painter and those who commissioned him, Hals did not finish the work, and the Amsterdam painter Pieter Codde (1599–1678) had to be called in to complete the picture in 1637. There is a distinct difference between the larger left half of the picture, painted by Hals, and the remaining figures done by Codde. Note, for example, how the crisply painted clothing and the foppishly displayed boots of Hals's standard-bearer (opposite) adorn a body that is vibrantly alive, whereas Codde's counterpart on the extreme right looks like a frigid, dutifully painted puppet in an officer's uniform.

In October, 1885, Vincent van Gogh visited the Rijksmuseum, which had opened on July 13 of that year, and he wrote enthusiastically about his encounter with Frans Hals in a letter to his brother Theo: "I do not know whether you remember the one to the left of the *Night Watch*, . . . there is a picture (unknown to me till now) by Frans Hals and P. Codde, about twenty officers full length. Did you ever notice that? that alone—that one picture—is worth the trip to Amsterdam—especially for a colorist. There is a figure in it, the figure of the flag-bearer, in the extreme left corner, right against the frame—that figure is in gray, from top to toe, I shall call it pearl-gray—of a peculiar neutral tone, probably the result of orange and blue mixed in such a way that they neutralize each other—by varying that keynote, making it somewhat lighter here, somewhat darker there, the whole figure is as if it were painted with one same gray. But the leather boots are of a different material than the leggings, which differ from the folds of the trousers, which differ from the waistcoat—expressing a different material, differing in relation to color—but all one family of gray. But wait a moment! Now into that gray he brings blue and orange—and some white; the waistcoat has satin bows of a divine soft blue, sash and flag orange—a white collar. Orange, white, blue, as the national colors were then—orange and blue, side by side, that most splendid color scale, against a background of a gray, cleverly mixed by uniting just those two, let me call them poles of electricity (speaking of colors though) so that they annihilate each other against that gray and white. Further, we find in that picture—other orange scales against another blue, further, the most beautiful blacks against the most beautiful whites; the heads—about twenty of them, sparkling with life and spirit, and a technique! a color! the figures of all those people superb and full size! But that orange white blue fellow in the left corner . . . I seldom saw a more divinely beautiful figure. It is unique. Delacroix would have raved about it—absolutely raved."

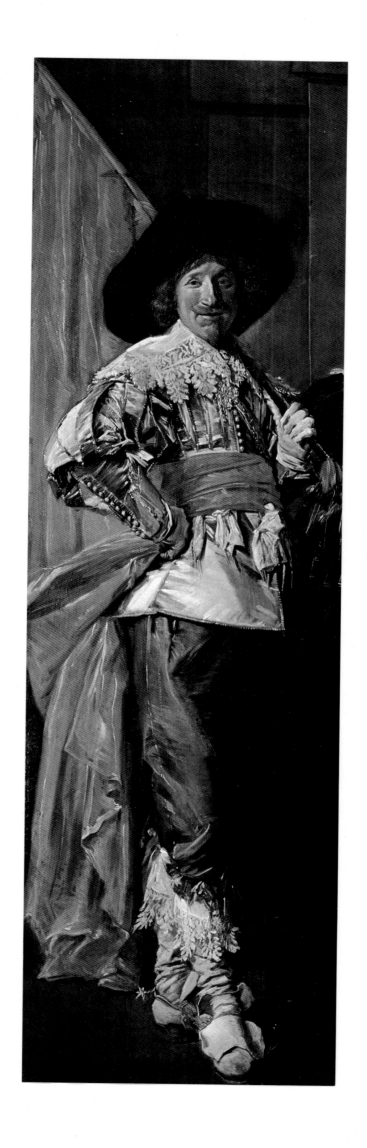

Colorplate 30
CLAES DUYST VAN VOORHOUT
c. 1638
Oil on canvas, 31 3/4 × 26"
The Metropolitan Museum of Art, New York City

This portrait seems to invite the viewer to challenge the sitter, Claes, either in a tavern or on his own territory, i.e., the Swan Brewery, of which he was the owner. His bearing, eyes, and mouth express this challenge. By providing space for the ample body in a three-quarter view and on a diagonal, while the two parts of the lace collar with their similar diagonal effect meet under the chin, Hals gave his model a sense of superiority over the viewer.

He emphasized the attitude by placing the arm akimbo, making the elbow push into the frame. The impression of superiority is also obtained by the fact that we look upward at the model, an optical effect that Hals tried to achieve with *The Laughing Cavalier* (colorplate 13) and with *Jasper Schade van Westrum* (colorplate 37). The illusion that Hals had tried to convey in his first guards painting of 1616, executed with three-dimensional effect, finds here its simplified two-dimensional equivalent.

A comparison of this masterpiece with the above-mentioned portraits leads to the surprising conclusion that the use of a means to achieve the same result never, in Hals's case, deteriorated into a cliché. Each in their own way, the three different elbows reveal a separate world, which informs us about the strictly individual attitudes toward life of these three subjects.

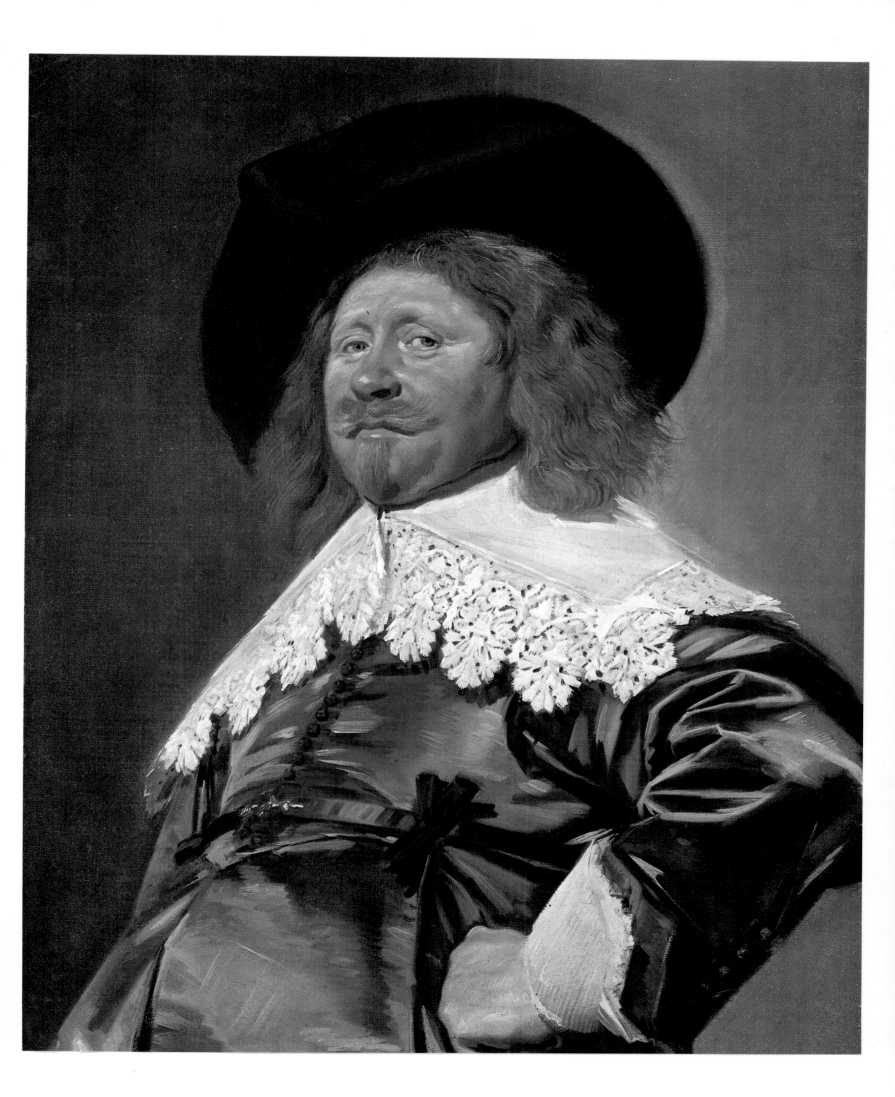

Colorplate 31
OFFICERS AND SERGEANTS OF THE
ST. GEORGE CIVIC GUARD COMPANY
(*detail of Captain Quirijn Jansz. Damast*)
1639
Oil on canvas; size of entire painting, 7' 2" × 13' 10"
Frans Hals Museum, Haarlem

The last commission Frans Hals received for a civic guards painting did not result in the compositional boldness that might have been expected (fig. 38). Probably the men who commissioned him wanted to be painted as economically as possible so that Hals was prevented from giving full rein to his imagination.

The elements of a banquet composition, evident in the group of 1633 (colorplate 24) and partly present in his unfinished composition of 1633–37 (fig. 43), have completely disappeared in this static display of lined-up guards. According to the Amsterdam formula, twelve officers are arranged in the foreground and shown only from the knees up. They form a horizontal frieze of heads, in between which some figures are turned, without much success, to break the monotony. Two standard-bearers close the ranks. In the second row the seven remaining figures are grouped in a somewhat heterogeneous order, and descending step by step, form a diagonal, ending in the middle of the first row.

The shaded background is badly painted and gives the impression of a tired stage backdrop. Possibly the artist was a weaker colleague of Hals, Cornelis Symonsz. van der Schalcke, shown in the second row, sixth figure from the left.

While the group may be disappointing as a whole, the portraits individually are not inferior to those of their Haarlem colleagues, which we can see in other guards paintings. First of all, Hals's self-portrait, in the back row, second figure from the left (fig. 1), claims our attention. In our introduction we referred to Hals's melancholy, which pervades this portrait. At first glance one would not suspect that in this somewhat shy man there is concealed the soul of an artist of genius, who could, with seeming ease, merge with this display of vanity.

We have already pointed out that Hals detached himself from the parade atmosphere, and that he was an observer and not a participant, in the strict sense of the word. On closer observation we are struck by the shrewd penetrating look with which he holds aloof from his surroundings. The touch of melancholy in his face explains the trend which becomes apparent in the 1640s: colors are toned down or disappear altogether, giving his models a more somber look.

One of the most powerful figures in this guards portrait is that of Captain Quirijn Jansz. Damast, a damask weaver who was burgomaster of Haarlem in 1642–43 (see opposite). The stubbornness which is evident from his countenance is confirmed by the rigidity of his hand, which keeps his sash firmly in place. Although the left hand is gloved, Hals reveals the man's strength of character in the grip and anatomy of the hand through the material of the glove.

In the masterly portrait we may detect the personification of that stern Calvinism which was the spiritual mainstay of seventeenth-century Holland. By contrast, the blue ornamental feather, by the brim of the hat, seems almost frivolous.

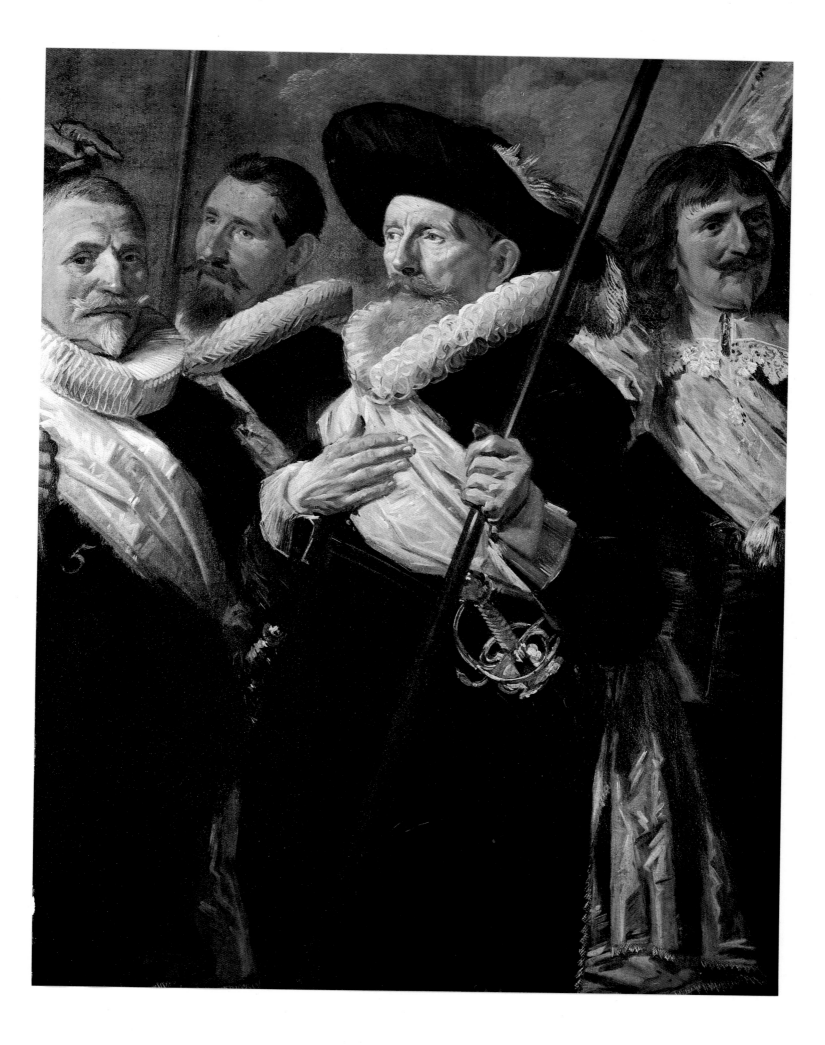

Colorplate 32
HENDRICK SWALMIUS
Inscribed on the right near the center: Aetat 60/1639
Oil on panel, 10 5/8 × 7 7/8"
The Detroit Institute of Arts. Joint Purchase, Founders Society and City Appropriation

The Detroit Institute of Arts may consider itself fortunate that the portrait of Hendrick Swalmius was rediscovered in 1934, for fifteen years later it purchased this remarkable work, one of Hals's liveliest portraits. Before 1934 this portrait was known only through an engraving, in reverse, done by Jonas Suyderhoef (c. 1613–1686). The engraving shows that the panel, which is otherwise in very good condition, was cut to some extent at the top and on the right side.

Hendrick Swalmius (c. 1579–1649), a Haarlem clergyman, was painted in such a lively way by Hals that Seymour Slive found reason enough to doubt the likeness: "It is a neat problem trying to decide whether the Haarlem preacher was really such a lively sixty-year-old man and had a Silenus-like twinkle in his eye, or whether Hals endowed him with these personality traits." Rembrandt's portrait of Hendrick's brother, the Amsterdam preacher Eleazar Swalmius, painted in 1637 and now in the Antwerp museum (fig. 44), displays such a striking likeness, that the two were confused. Despite a family resemblance (see fig. 45), we think it worth noting that Hendrick tended to be an extrovert and Eleazar an introvert, and that these two characteristics were emphasized by the two artists, each in his own way, which does not mean that the resemblance suffered as a result.

In this book we have three preachers, each holding a Bible as a symbol of his spiritual calling. Hendrick Swalmius, painted about 1639, Johannes Hoornbeek, 1645 (colorplate 39), and Herman Langelius, 1660 (colorplate 44). It is interesting to compare the three portraits on two counts. First, because we observe the growing trend toward abstraction in the development of Hals's brushstroke over a period of twenty years, and second, because of the information we obtain about the characters of three colleagues sharing the same religious beliefs and environment, but each completely different in the exercise of his office. It is indeed remarkable how the various Bibles look entirely different in the hands of these three men! The differences are reminiscent of Donald Judd's statement that "things are not what they are; they are what they are in their situation," an apt statement in this case. We can imagine that the mere human warmth radiating from Hendrick Swalmius must have brought consolation to a group of believers entrusted to his spiritual care. He impresses us as a man administering God's word and exercising his high calling far more as a guide than as a teacher. The function which Hals gives to this little Bible is fitting for the image of the man (fig. 46), the book which inspired him on his way and from which he drew the strength that he cheerfully passed on to those around him. Because of the small format of the Bible, the spiritual emphasis lies far more on the man and teacher, fortified by his Bible, than on the holy book itself, which seems to point only incidentally to his priestly office.

In discussing the portraits of the two other preachers, we shall again see confirmation of Judd's statement and observe how the Bibles, in their shapes, sizes, and appearances, fit their subjects' personalities.

The panel is signed below the inscription with the joined initials FH.

126

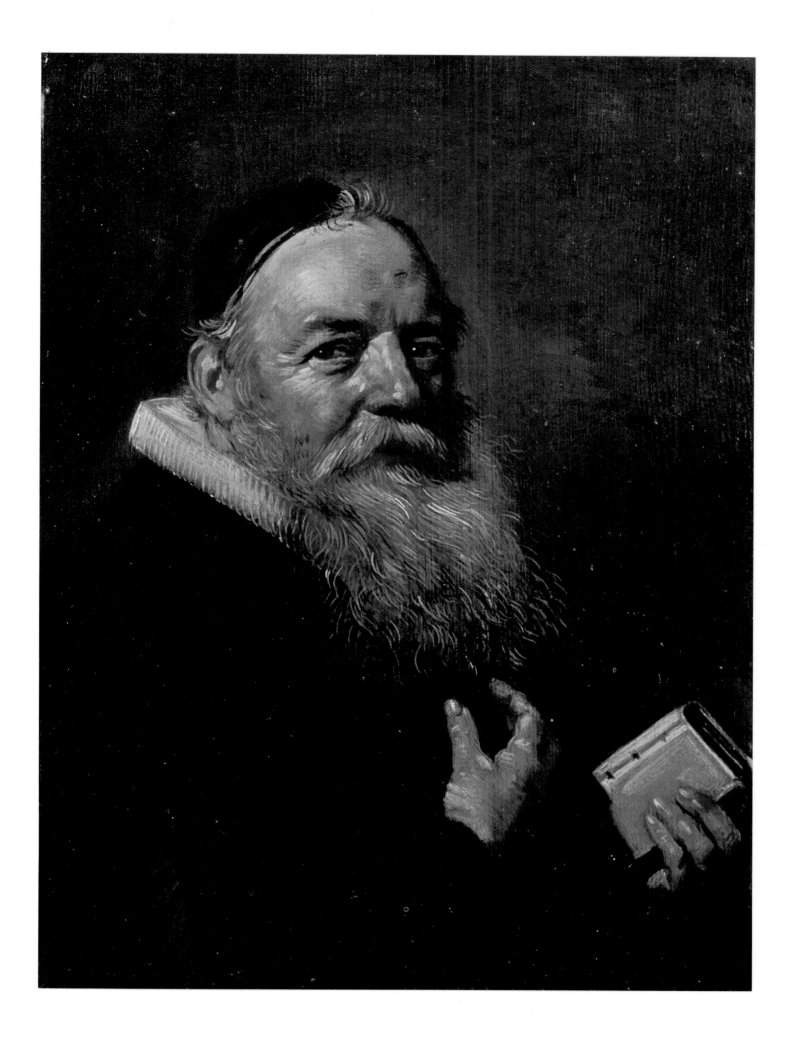

REGENTS OF THE ST. ELIZABETH HOSPITAL OF HAARLEM
1641
Oil on canvas, 60 1/4 × 99 1/4"
Frans Hals Museum, Haarlem

Like the guards pieces, the regents portraits had a tradition when Frans Hals carried
out his commission to portray the regents of the St. Elizabeth Hospital in Haarlem
in 1641. This tradition did not, however, originate in that city, but in Amsterdam,
where similar group portraits had been popular since the end of the sixteenth cen-
tury. As far as is known, this portrait of the regents was the first of its kind to be
done in Haarlem. Regents portraits demanded greater imagination than guards
paintings because of the lack of that element of movement which gave the artist
the opportunity to depict some action in progress.

The Amsterdam ladies and gentlemen dutifully posing behind their tables
faced outward, mostly full face, without seeming to be members of a group. They
are, in fact, individually painted persons, who want to project themselves as
favorably as possible to their contemporaries and to future generations. Hals was
the first to breathe life into this rather prosaic type of scene by making the
canvas the place of action for the interplay of the characters.

Dominating everyone and everything is the chairman, Dirk Dirksz. Del, who
sits on this side of the table. The ease with which he plays his role is apparent not
only in his face and bearing, but in the way in which his little finger slides off the
edge of the table. His weighty presence is accentuated by the light projected on
him from the invisible open shutters of the window above. In addition, the hand
dominates the space in the center of the composition.

A great psychiatrist once said that the hands are the visible part of the brain and
in this respect Hals never neglected his portraits. The shape and structure of the
hands and the gestures of his sitters always complete and confirm the portrayal of
character, which he expresses in the faces.

Even in his brushwork Hals adapts himself to his model, as is evident in this
picture. We have already pointed out the difference in the style of painting when
we compared the strong hand of Dirk Del with that of Sivert Sem Warmond, the
somewhat disinterested figure at the left (figs. 2, 3). Here one hand belongs to the
dominant figure, while the other hangs limply and, like the man himself, is not
taking an active part in what is going on.

Hals has caught the heads of Salomon Cousaert and Johan van Clarenbeek
(second and third from the left) in the diagonal light, directed toward Del.
These two are in closest contact with him as he addresses them; they are drawn
into the compelling orbit of their chairman, whose authority refutes all their
arguments.

The whole presentation invites an analysis of the interplay of face and gesture.
Van Clarenbeek seems to agree with Del's views, a fact confirmed by the position
of his left hand against his chest, while the right hand, resting on the book, seems
to have lost all power of assertion behind Del's dominating hand in the center of
the composition. Van Clarenbeek's face shows benevolence. Cousaert tries to in-
tervene, but the hesitation on his face is borne out by his right hand, which defers
to the powerful hand of Del.

128

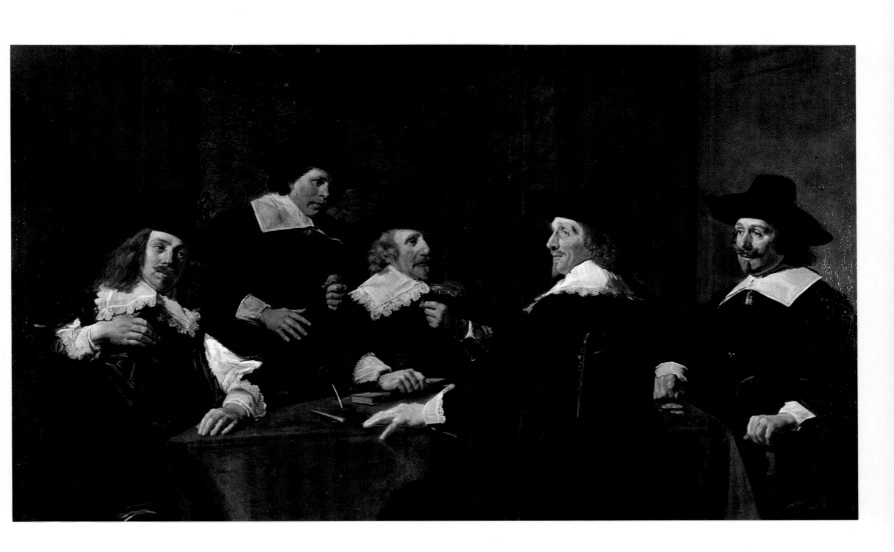

Colorplate 34
REGENTS OF THE ST. ELIZABETH HOSPITAL OF HAARLEM
(*detail of Dirk Dirksz. Del*)

On the extreme left, Sivert Sem Warmond leans somewhat nonchalantly against the table and seems to push Salomon Cousaert and Johan van Clarenbeek in Del's direction. Lost in thought, he takes no active part in the discussion.

On the extreme right sits the treasurer, François Wouters, the coins in front of him on the table indicating his function. We find him as a lieutenant in the guards painting of 1639, the fourth figure from the left in the front row (fig. 38). An imperturbable face and a pair of firm hands reassure us about his financial management. From the point of view of composition his presence is essential; not only does he round off the group on the right as a counterpart to Warmond on the left, but he serves as an essential supporting figure for his colleague Del's authority.

Hals's regents form a collective group. They are taking part in a meeting, and their attitudes and reactions reveal mutual contact without detracting from the individual portraits. As in the guards pieces painted after 1616, the artist avoids all three-dimensional and illusionistic effects. As a perfect organism the group is painted two-dimensionally with harmonious rhythmic effects for the bodies, heads, hands, and hats. The muted green of the table covering, the gray map on the wall, and the red accents of the books and chair seats introduce discrete notes of color in the sober but richly differentiated combination of blacks and whites.

Thus Frans Hals has elevated the men who commissioned him above the level of manners and customs and has given his creation a dimension which would only find its equivalent in *The Syndics of the Draper's Guild*, which Rembrandt was to paint twenty-one years later (Rijksmuseum, Amsterdam).

Dirk Dirksz. Del's head, reproduced on the opposite page, is placed so as to form the center of the centrifugal force which emanates from this masterly composition. One should have the same command of words as Hals had of matter to express so much so well with so little, but the impact of this phenomenal painting cannot be expressed in words.

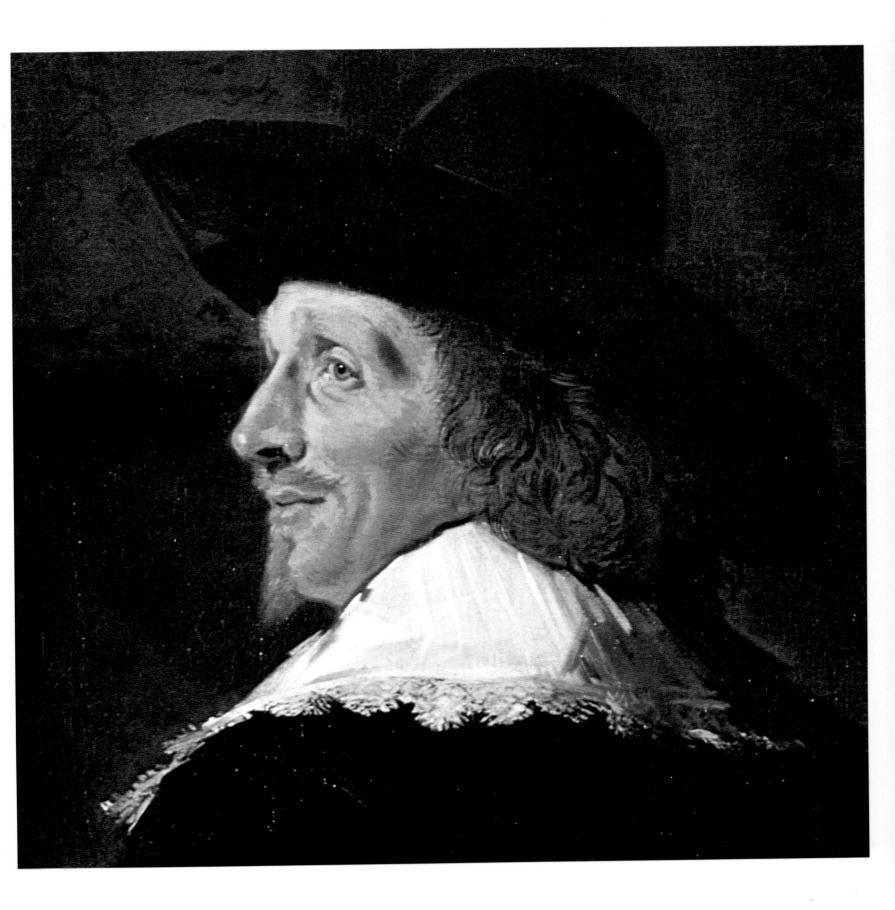

Colorplate 35

PORTRAIT OF A WOMAN (so-called Mevrouw Bodolphe)
Inscribed to the left of the sitter's head: Aetat Svae 72/ An° 1643
Oil on canvas, 48 1/4 × 38 3/8''
Yale University Art Gallery, New Haven, Conn. Bequest of Stephen C. Clark

One of the most monumental portraits of the 1640s is that of this elderly lady, identified as Mevrouw Bodolphe on the basis of a lost inscription on the back. It is possible that when the painting was transferred to a new canvas the name, which may have appeared on the old canvas, disappeared. This is only an assumption, which must be treated with reservation.

The painting of Mevrouw Bodolphe is a pendant to Heer Bodolphe, also painted in 1643, who was a year older than his wife (fig. 56). Both portraits are at the Yale University Art Gallery. We could describe this impressive portrait as a monument to the bourgeois class. When we approach this self-possessed woman, we feel we must be duly on our guard, for with her strong will and domineering personality she will obviously not suffer anything that conflicts with her rigid principles. Here, too, the expressive hands add to the face, while the gloves, hanging down from the right hand in an indefinable way, emphasize the authoritative impression which Hals gives to this creation.

By seventeenth-century standards we should speak of a woman in advanced old age, rather than an elderly woman. Her well-preserved condition when she posed for Hals at the age of seventy-two is all the more remarkable when we realize that the average life-span in the seventeenth century was half of what it is today. We have only to look at the painters of that time: Isaac van Ostade died at the age of twenty-eight; Adriaen Brouwer and Willem Buytewech when they were about thirty-two; Adriaen van de Velde at thirty-six; Gabriel Metsu, thirty-eight; Esaias van de Velde, about forty; Johannes Vermeer, forty-three; Cornelis Dusart, forty-four; and Govert Flinck and Caspar Netscher, forty-five. Many artists died between the ages of fifty and sixty, including Pieter de Hooch, fifty-four; Jacob van Ruisdael and Jan Steen, fifty-three; Bartholomeus van der Helst, fifty-seven; Judith Leyster, fifty-one; and Simon de Vlieger, fifty-three.

Compared with the above, Rembrandt lived to the respectable age of sixty-three, while Hals died in 1666 at an exceptionally advanced age—between eighty-two and eighty-five. We should note here that his artistic potential not only remained unaffected, but reached a climax in the last group portraits, which he completed two years before his death.

The portrait of Mevrouw Bodolphe is signed below the inscription with the joined initials FH.

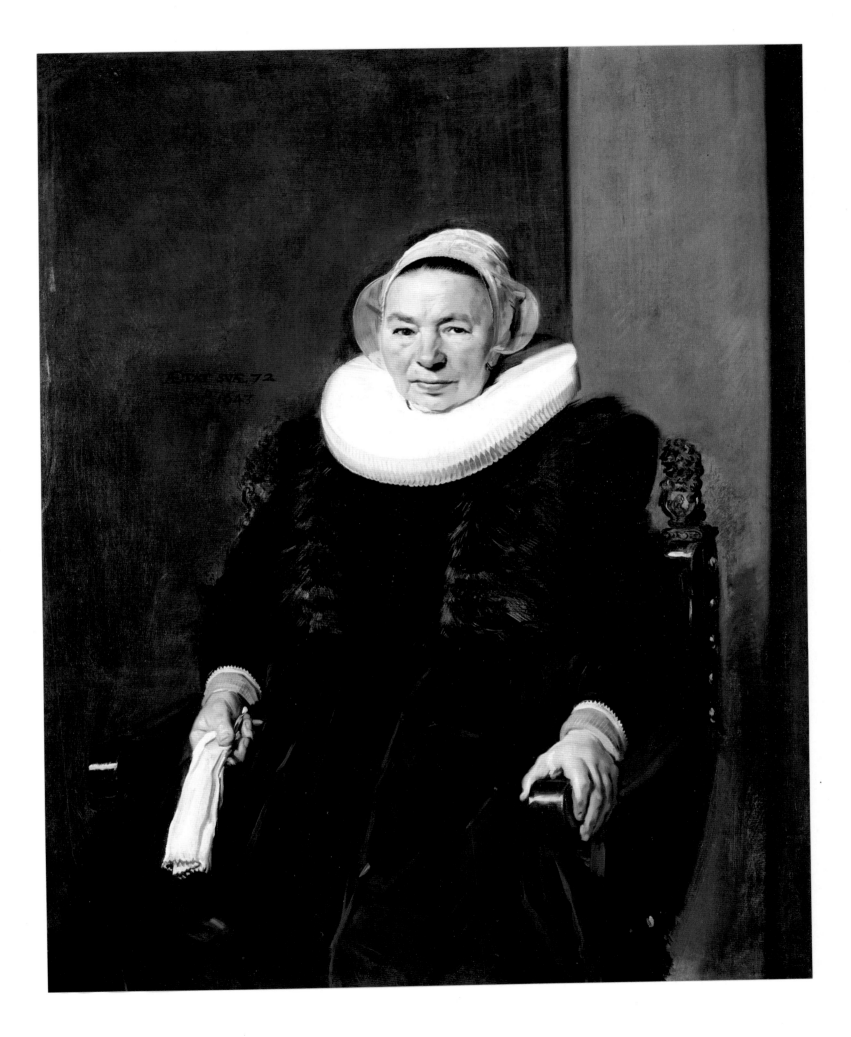

Colorplate 36
PORTRAIT OF A WOMAN
(so-called Mevrouw Bodolphe) (*detail*)

Mevrouw Bodolphe would certainly not have thought it permissible to come as near to her as this close-up. And we wonder whether she herself could ever have suspected that Hals, in his interpretation of her outward appearance, was able to penetrate into her inner being to the extent that amazes the spectator of today.

Her forceful character is just as discernible in the details of the head as in the portrait as a whole. The painting loses none of its original force through photographic enlargement or even through an outsize film projection. This was confirmed by the excellent film about Hals made in 1962 by the Dutch film maker Frans Dupont. In this film, as an experiment, the camera closed in on the face of Mevrouw Bodolphe all the way to her right eye. Projected on the wide screen the close-up of this eye not only stood up pictorially to the enlargement, but provided, in a disquieting way, "a window on the soul," an insight into the character of Hals's model. Such was the result of an experiment in one of the most surprising highlights of the film.

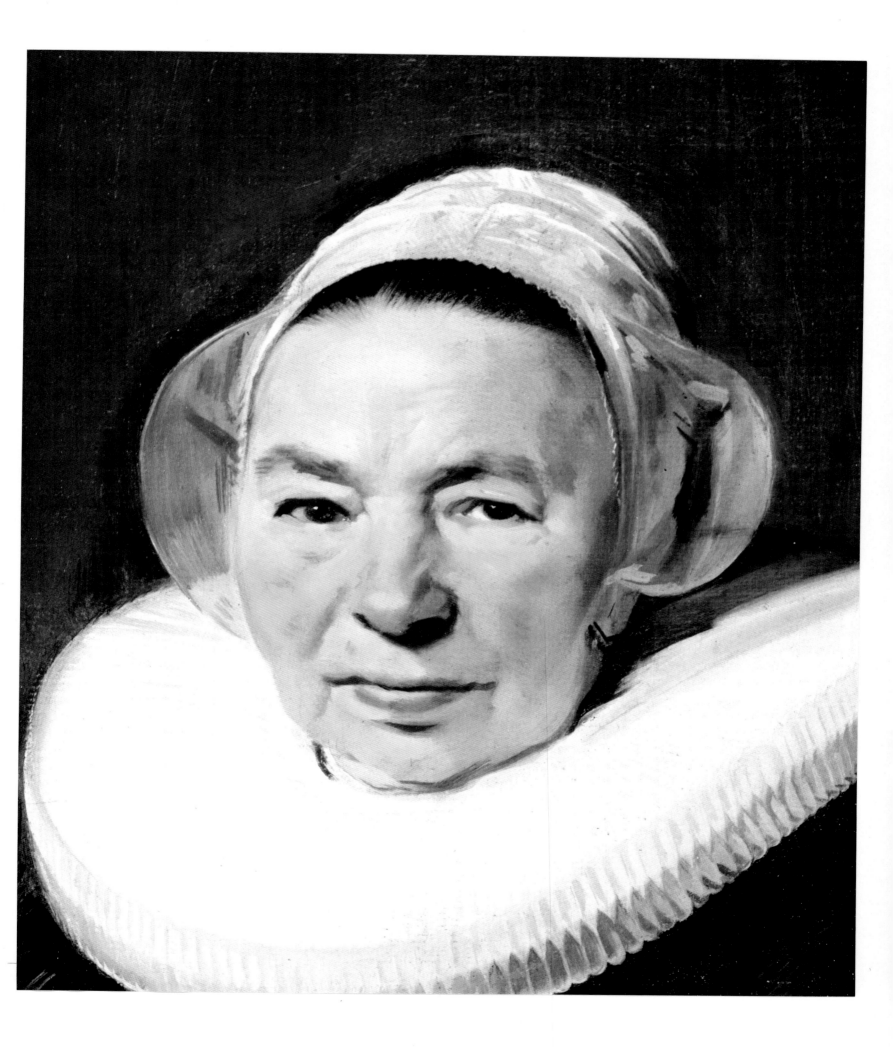

Colorplate 37
JASPER SCHADE VAN WESTRUM
c. 1645
Oil on canvas, 31 1/2 × 26 5/8"
Collection of Old European Art, National Gallery, Prague

The scion of an old patrician family, Jasper was born in 1623 and died in 1692. Lord of Tull and 't Waal, he served as deacon of the chapter of Oudmunster at Utrecht. The finery in which Hals has decked him agrees with contemporary information about his liking for fine clothes. C. P. L. van Kinschot informs us about this in his *Genealogy of the Van Schooten Family*. In a letter dated August 7, 1645, Louis van Kinschot warns his son Kasper, who was at that time in Paris, not to spend so much money on his tailors as his nephew Jasper had done!

Further information about the trend toward the French way of life, in which a man like Jasper flourished, was provided by Sir William Temple, who was British ambassador in The Hague from 1668 on. In his *Observations upon the United Provinces of the Netherlands*, he says: "The nobles, . . . in the province of Holland, are very few, most of the families having been extinguished in the long wars with Spain. But those that remain are in a manner all employed in the military or civil charges of the province or state. . . . They strive to imitate the French in their mien, their clothes, their way of talk, of eating, of gallantry or debauchery . . ."

After the many aspects of the *Comédie humaine* which Hals has presented to us so far, he personifies Pride in Jasper. Here, too, he shows himself a restrained observer who never speaks out in black and white, but in shades, according to the complex pattern of characteristics which makes every human being a unique phenomenon. While the artist placed the vain Schade van Westrum on a high pedestal from which he looks down on us, his vanity is tempered for the better by his unmistakable bearing, which is the privilege only of the born aristocrat.

It is this positive side of his personality which the noble Jasper himself probably regarded as his dominant feature, without being aware of the inborn defects which Hals has so clearly shown in this painting. Hals made Jasper, to quote Max Liebermann, "more like himself than he was," but the fact that the painting still exists shows that this must have escaped the man who commissioned it!

The sleeve of the upper arm is painted in a new and original way, guiding the eye upward along the abundance of flowing locks to the haughty face (fig. 47). And so he presides, the Lord of Tull and 't Waal, in the National Gallery in Prague, at the height of his grandeur!

Inherent in his personality is his liking for finery, which culminates in the fashionable bow that sets off his hat, an accent that, from the point of view of composition, gives the finishing touch to the diagonal effect of the arm and hairdo. If we view him against the background of the fashions of his time, the vain Jasper is the emblem of gilded youth, whose clothes were a challenge to the sober regents' dress of the conservative bourgeoisie.

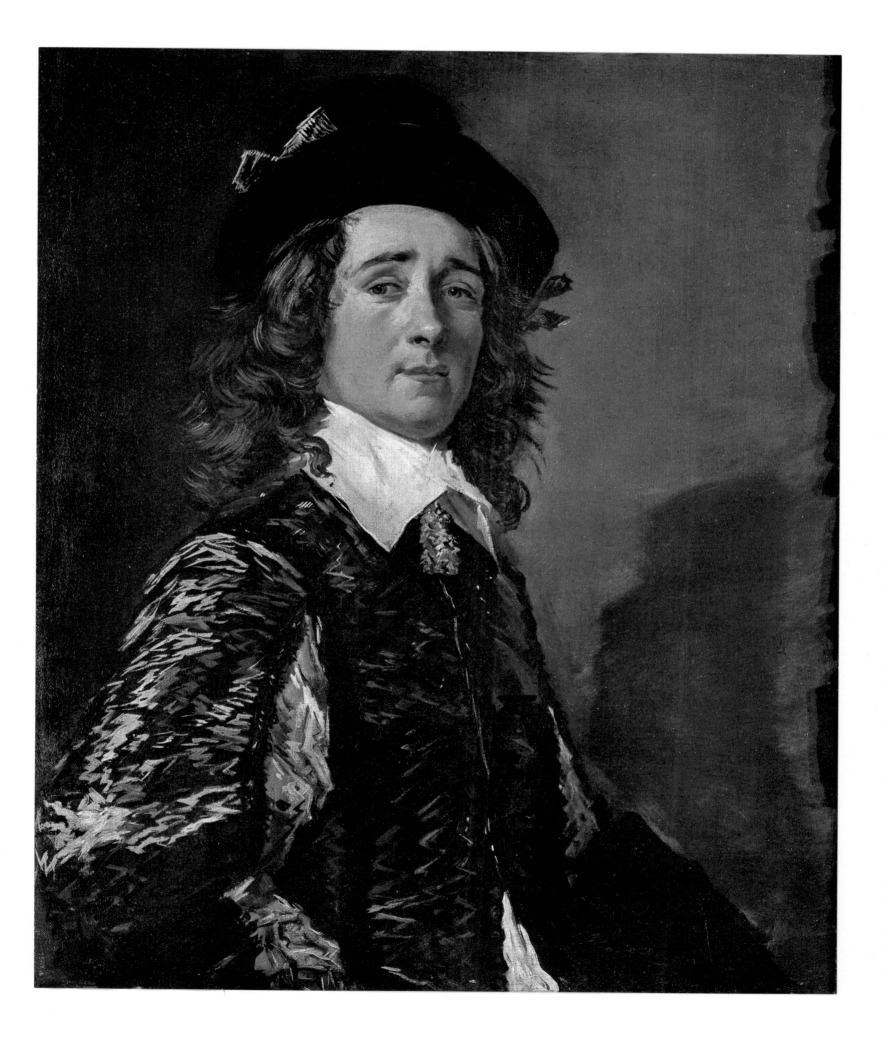

Colorplate 38
SEATED MAN HOLDING A BRANCH
c. 1645
Oil on panel, 16 3/4 × 13"
National Gallery of Canada, Ottawa

The identify of the sitter and the authenticity of this impressive portrait have been questioned. With regard to the identity, we quote the convincing answer of Seymour Slive in his catalogue, which is part of his three-volume work on Frans Hals. "The sitter has been erroneously identified as the Haarlem painter Frans Post more than once. Hals did indeed paint a portrait of Post (Collection Mrs. David Corbett, Evanston, Illinois), which can be securely identified upon the basis of Jonas Suyderhoef's contemporary engraving of it. Hals's portrait of Post is also a small panel and he too is portrayed with long hair, wearing a hat, and seated with his right arm resting on the back of a chair. But not much more than a glance is needed to show that the sitters are not identical."

The authenticity of the portrait began to be questioned because of its attribution to Frans Hals II. It is difficult to imagine how a work that is signed (unsuspectedly) at the lower right with the joined initials FH and clearly betrays the hand of the master in the smallest detail could suddenly be attributed to such a vague figure as Frans Hals's son. Frans Hals II may have been his father's offspring, but the paintings that are attributed to him show that he was a successor in name only and not in spirit.

Finally it has been shown that this portrait strongly resembles that of 1650–52 in the National Gallery of Art (Mellon Collection) in Washington, D. C., which is considered to be the portrait of Adriaen van Ostade. So striking is the resemblance that we might feel tempted to confirm this identity. However, a close analysis of the two faces disproves this assumption. What is probably the most convincing factor is the entirely different expression of the eyes, as well as the fact that the model in Washington seems much younger than that in Ottawa, notwithstanding a time difference of about five years between the two works.

We must thus conclude that the sitter is unknown, although he has an overwhelming presence. The outstanding effect of Hals's brushwork here foretells the later portraits.

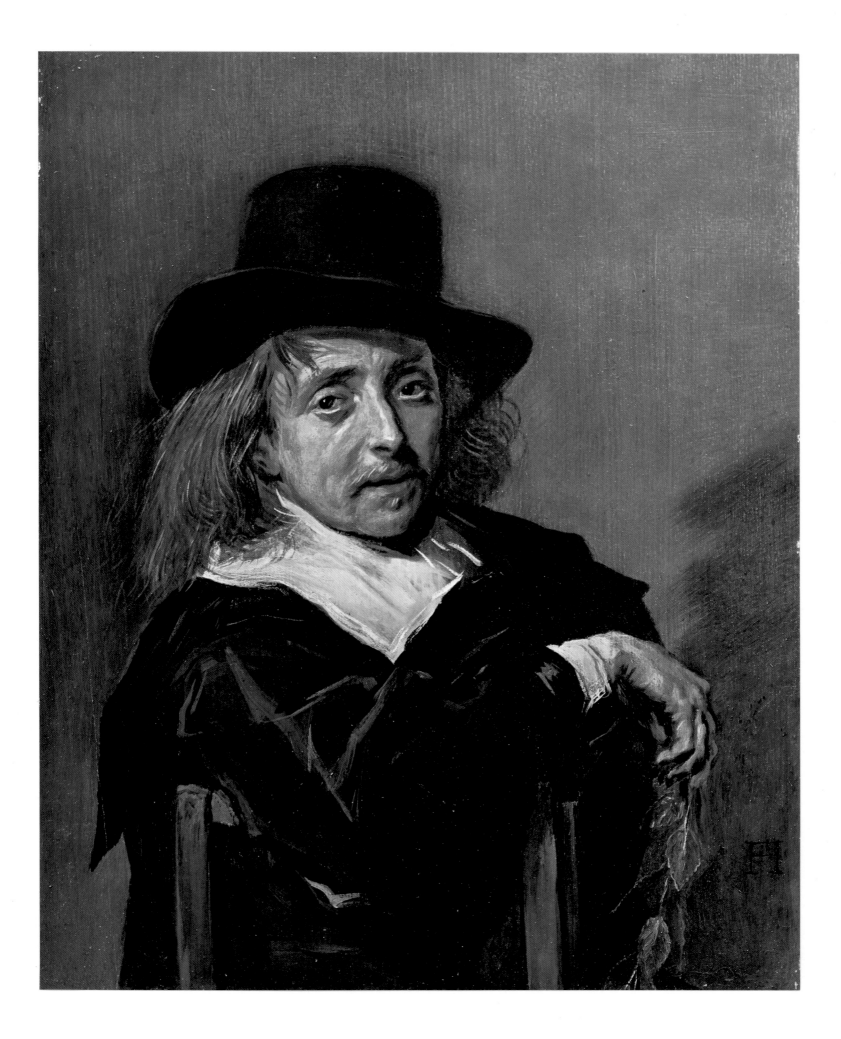

JOHANNES HOORNBEEK
Inscribed at the lower right: Aet. Svae/27./1645
Oil on canvas, 31 1/4 × 26 3/4"
Musées Royaux des Beaux-Arts, Brussels

Johannes Hoornbee(c)k (or Horenbeek) was born in Haarlem in 1617 and died
in Leiden in 1666. He studied theology in Leiden and Utrecht. From 1639 to 1643
he was a minister in Mülheim (near Cologne) after which he taught theology at
Utrecht University (1644), where he became a minister a year later. In 1654 he
gave his inaugural address at the University of Leiden.

Hoornbeek was a typical intellectual theologian, actively involved in the the-
ological controversies of his time. He had a command of no less than thirteen
languages. Like many other outstanding personalities, his portrait was re-
produced by Jonas Suyderhoef, who made an engraving, in reverse, of Hals's
painting.

It is an exciting experience to place Hoornbeek's portrait between those of his
colleagues Swalmius (colorplate 32) and Langelius (colorplate 44), exciting be-
cause Hals makes us see how differently they practiced their calling.

Hals dressed his Utrecht professor in the discreet luster of his black professorial
gown, sounding a sonorous note in his adagio composition. The serious features
reflect intellect and peace of mind with a tinge of melancholy.

Hoornbeek seems to have momentarily interrupted a lecture in order to pose:
the left hand, whose delicate structure betrays spirituality and nobility of mind,
holds the Bible, kept open by the thumb at the passage which is the subject of his
lecture (fig. 48). The way in which Hals shows the Bible as a clear piece of evidence
reminds us of a portrait of Luther by Lucas Cranach, done more than a century
earlier, on which the words "Ich habs Verbum" ("I have the Word") are inscribed.
While Cranach places Luther's thumb demonstratively on a Biblical text, Hals
offers a far more natural presentation. In his servant of God, Hals reveals an im-
pulse to bear witness which springs more from the spirit and reason than from a
desire to convert: a true representation of the inspired teacher and intellectual.

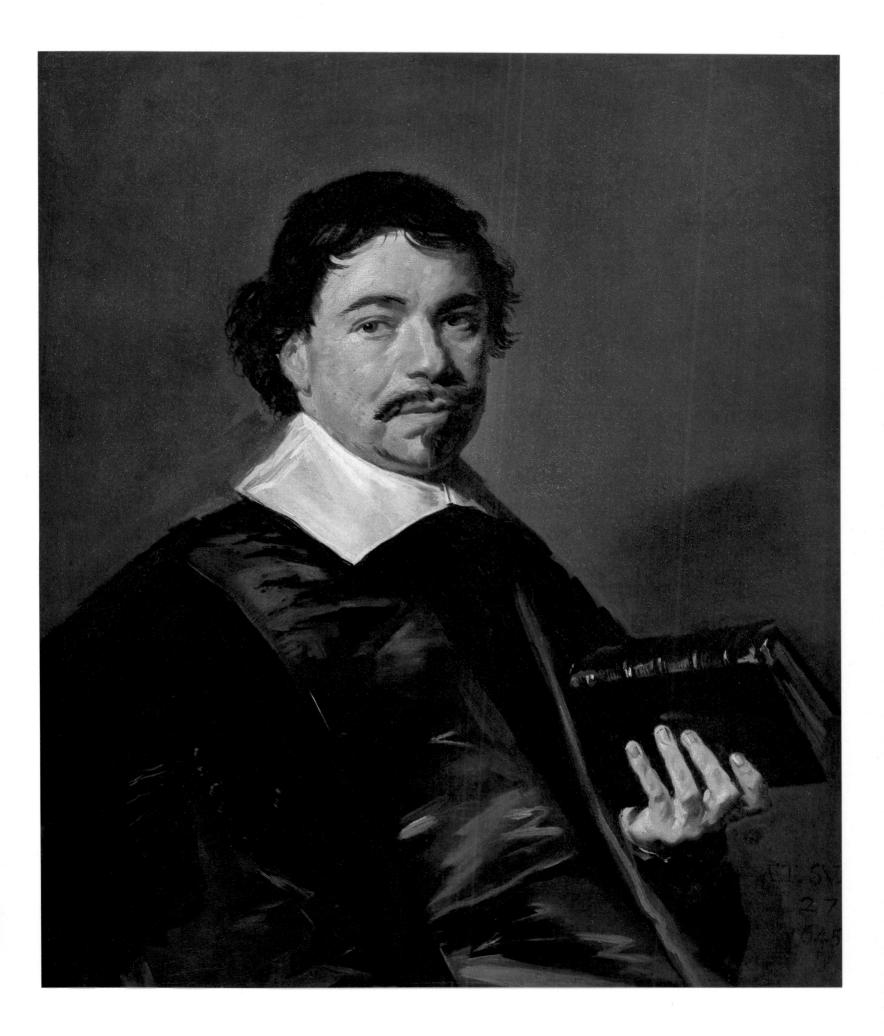

Colorplate 40
FAMILY GROUP IN A LANDSCAPE
c. 1648
Oil on canvas, 6' 7 1/2" × 9' 4 1/4"
Thyssen-Bornemisza Collection, Lugano-Castagnola

Of the three family groups Hals painted, this lifesize one is the most imposing. The parents are between their son and his somewhat older sister and the black boy, who seems to have been lovingly accepted into the family. Though standing between mother and daughter, he has modestly moved back a step. As evidence of his master's hobby, he is displaying a fishing pole with a fish in his right hand. It is a pity that, because of the merging of his black skin with the background, the boy's face lacks the clarifying light which would have done more justice to Hals's acute characterization (fig. 49). If we use the word "lovingly," it is because a free human being is portrayed here, whereas the word Negro in Hals's day (and, alas, long after) was synonymous with slavery. The presence of a Negro boy in a Dutch family reminds us of a statement made in 1631 by Descartes (whom Hals also painted) about Holland's hospitality and tolerance, from which he himself benefited for more than twenty years: "In what other country could one enjoy such full freedom?"

More than ten years later Rembrandt painted his unforgettable *Two Negroes* (fig. 50). Conceived as studies of heads, they undoubtedly impressed Rembrandt by their exotic beauty.

Compared with this masterly interpretation by Rembrandt, Hals's boy is a complementary element. He is not singled out as someone special, but as a family page, allowed into the intimacy of the Dutch family. We have here a characteristic contrast in the concepts of the two masters. Rembrandt wove his Negroes into the chiaroscuro of his contemplative mind, while Hals, more objectively, was able to breathe life into what was going on by his brilliant interplay of eye and hand. What is so striking in Hals is the respect with which he has observed and interpreted the Negro boy as a servant.

We need hardly draw attention to the meticulously analyzed faces of parents and children and the free brushwork of the clothes, particularly of the brilliantly painted boots of the father. The portrayal of the boy is remarkable for its charm, which is tinged with melancholy; the girl moves us by her latent femininity, the fan in her hand contrasting with the stick her younger brother is toying with.

In literature on Hals it has rightly been pointed out that he has symbolized love's fidelity in the emblematic tradition in the joined hands we see in the center of the group. We do not know whether the dog at the end of the group is supposed to symbolize marital fidelity, as in Jan van Eyck's *Giovanni Arnolfini and His Bride*, painted in 1434 and exhibited in the National Gallery in London. His casual presence seems to suggest far more his awareness of being an inseparable and dear part of the family than some kind of lofty symbol.

Although the background vegetation and the landscape are generally attributed to Pieter Molyn, the plant at the left of the boy's foot looks as if it has grown out of Hals's brush. By handing over the painting of the background to someone else, Hals has deprived his group of the powerful sounding board which would have guaranteed a more harmonious consonance between man and nature.

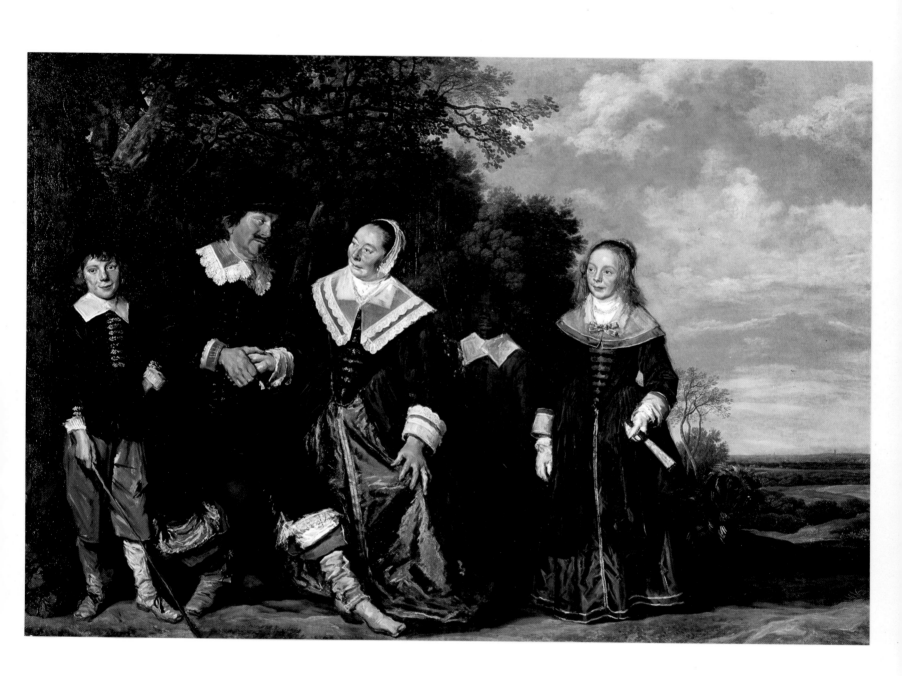

Colorplate 41
STEPHANUS GERAERDTS (*detail*)
c. 1650–52
Oil on canvas, 45 1/2 × 34 1/2"
Royal Museum of Fine Arts, Antwerp

When surveying Hals's work, we note the deplorable separation to which many of his portrait couples were posthumously subjected. Deplorable because the couples in their portrayals, as in life itself, regarded themselves as a double entity. These are works of art which complement one another, like the two panels of a diptych, and, when separated, suffer from imbalance, both spiritually and compositionally. Hals showed the relationship existing between these couples either by drawing them together, or by setting off one against the other, so that when we look at them our eyes move involuntarily from one to the other.

In 1886 one of the cruelest separations occurred in the case of Stephanus Geraerdts and Isabella Coymans (colorplate 42). At one time they were probably placed on either side of the fireplace in a Haarlem home. After this close proximity they were separated by an immeasurable gap between them, one being moved to Antwerp and the other to Paris.

No separation has harmed a composition by Hals more than this one, for the sprightly Isabella, no longer beside her husband, finds no response to her gestures. Her rose is now offered to no one, and Stephanus, with his somewhat heavy countenance and demeanor, is not accepting anything from anyone.

It gives us a sense of satisfaction if we can at least make this pair a part of our portrait gallery: by reuniting them, we can see how imaginatively Hals was able to carry out his composition. The costumes have been beautifully rendered and are almost Rembrandtesque in their richness. We are reminded of one of Rembrandt's finest paintings, the portrait of Burgomaster Jan Six, painted at about the same time (Six Collection, Amsterdam). But what a contrast there is in vision and style of painting, comparable to the contrast in mood between Beethoven and Mozart. Rembrandt emphasizes while Hals evokes. It is as if Rembrandt's models share with him the burden of the artist's powerful thought-laden world, permeated as they are with his own being. Hals's models are caught in their daily activities, in contrast to a frozen photographic shot, and all the rest is dispelled in that irretrievable moment, fixed forever in time. Rembrandt projects himself forcibly upon us, while Hals withdraws and succeeds in seizing the essence of life without any noticeable participation and as objectively as possible. Could that be the reason why the powerful Six portrait, looming out of the past, commands our reverence, while Stephanus and Isabella are somehow closer to us?

Stephanus Geraerdts was born in Amsterdam and married Isabella Coymans in 1644 in Haarlem, where he served as councillor and alderman of the town and where he died in 1671. His family crest and that of his wife hang to the left and right of their respective portraits.

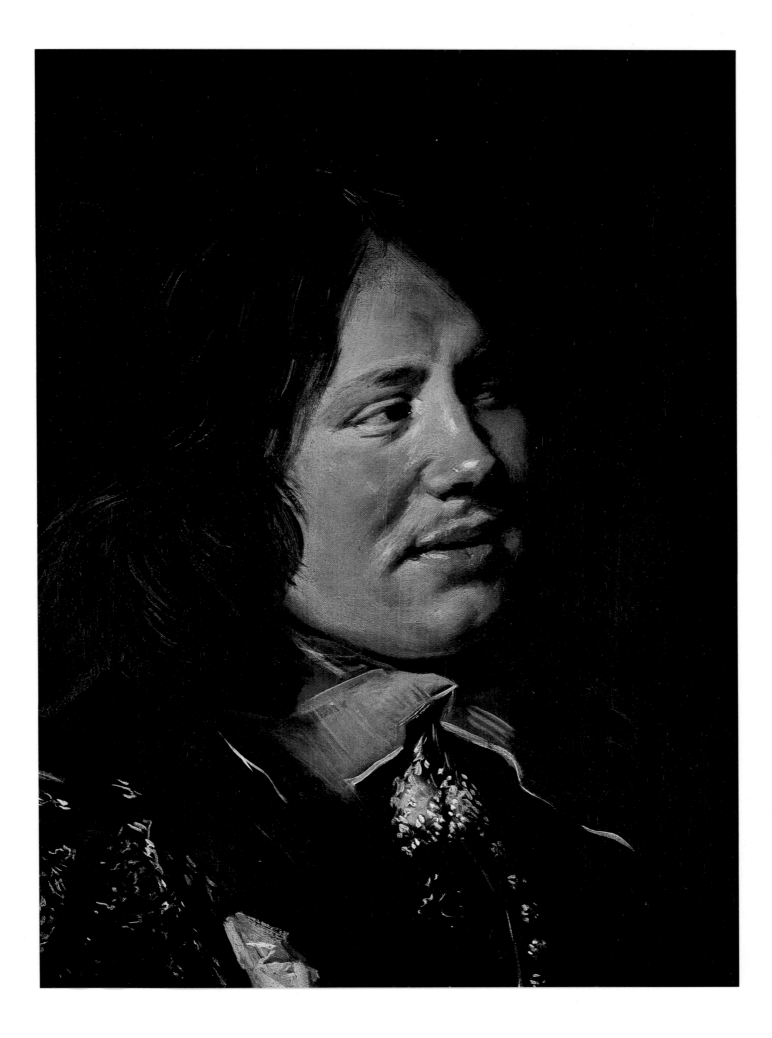

Colorplate 42
ISABELLA COYMANS, WIFE OF STEPHANUS GERAERDTS
c. 1650–52
Oil on canvas, 45 5/8 × 33 7/8"
Private collection, Paris

Isabella Coymans was born in Haarlem. She was the daughter of Joseph Coymans and Dorothea Berck, who were painted by Hals in 1644 (figs. 64, 65). The portrait of the father hangs in the Wadsworth Atheneum in Hartford, Connecticut, and that of the mother in the Baltimore Museum of Art.

Isabella married Stephanus Geraerdts in 1644 in her native city. Two years after the death of her husband in 1671, she married Samuel Gruterus. She died on October 7, 1689, in Haarlem.

In no other woman's portrait has Hals put so much action as in that of Isabella. After her death and that of her first husband, the two portraits were separated, which made this portrait of the opulently dressed woman appear top-heavy, as she was no longer balanced by her counterpart—a literally disturbed balance indeed!

Seymour Slive is right in his comments on these portraits when he criticizes the ungainly bearing of the self-satisfied Stephanus: "It was difficult for this fat Haarlem alderman to rise even when his wife approached him bearing a token of her love." But let us not forget that it was Hals, the *metteur-en-scène*, who made him act this way! Could it be that the artist composed this scene to get the greatest possible contrast between the smug bourgeois and his wife's disarming feminine charm, much to the discredit of the bovine Stephanus?

146

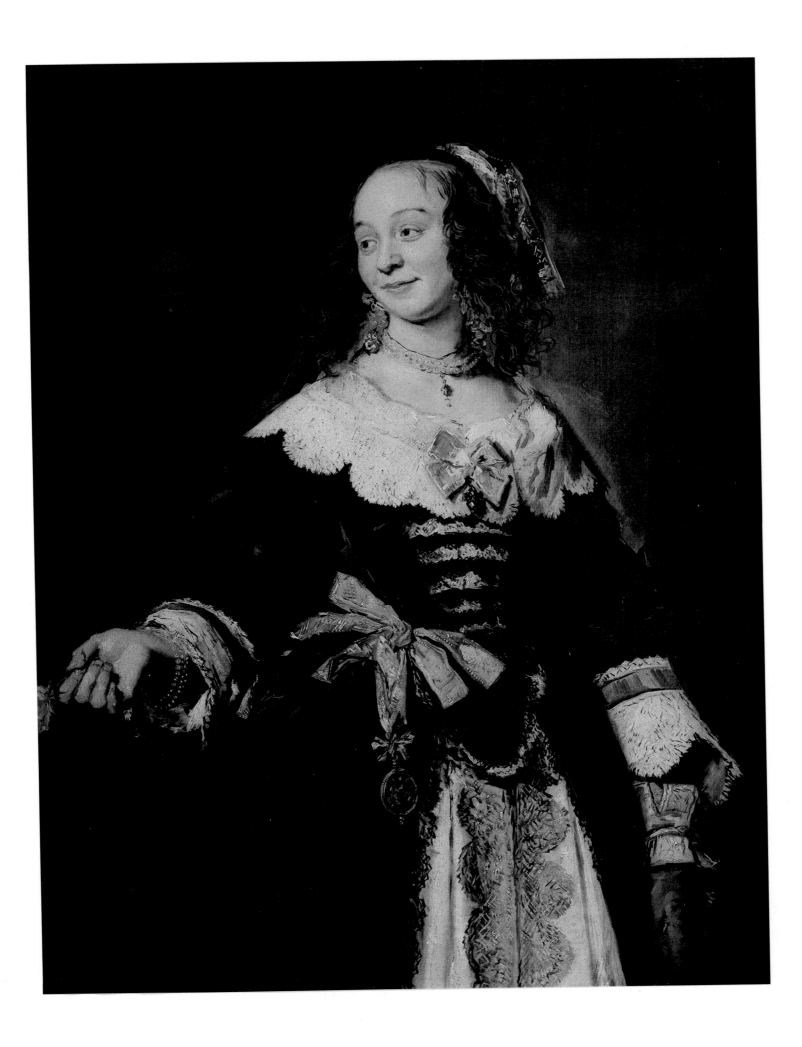

Colorplate 43
PORTRAIT OF A MAN
c. 1650–52
Oil on canvas, 33 1/4 × 26 3/8"
The Hermitage, Leningrad

This magisterial portrait, which can be traced back to its purchase by Catherine the Great of Russia (1729–1796), is one of Hals's finest achievements of the 1650s. We have already referred to the drawing relating to this portrait in the introduction, where we also discussed the doubtful authenticity of the drawings attributed to Hals. The drawing in question is a copy of the portrait in its original form (fig. 7), from which it would seem that the unknown man wore a hat tilted to the right, the angle of which is of compositional importance, as we shall see.

The dull paint above the man's head could not possibly have been applied by Hals. Whoever made the unfortunate decision to have the hat removed was equally unfortunate in his choice of the unskilled hand to carry it out. The drawing proves convincingly how such interference can impair the essence of a composition, as we saw in the Verdonck portrait (colorplate 17).

If we look at the drawing made from the painting before the hat was removed, we see how Hals literally topped the diagonal formed by the upper arm, collar, hair, and face with the indispensable cylinder of the hat. This served to counterbalance the diagonal formed by the upper part of the body, which also ends in the face, but now misses the brim of the hat, which would have set off the other diagonal. As a result the compositional balance between the left side and the heavy body has been disturbed, upsetting the intended triangular effect.

We see similarly balanced compositions in the portraits of two other hat-wearing models, painted in Hals's last period: *Man in a Slouch Hat* (colorplate 48) and the *Portrait of a Man* in the Fitzwilliam Museum in Cambridge, England, whose hat, too, was removed but restored in 1949 (fig. 70). "What makes the hat is the way one wears it," and yet, none of the numerous hats topping as many heads in the art production of the seventeenth century have the flourish of Hals's hats. They are expressive and in keeping with his characters, represent no particular fashion, and do not comply with the demands of decorum; they are part of the lives of his subjects, executed in a bold and original style by a nonconforming genius.

The portrait is signed on the right with the joined initials FH.

148

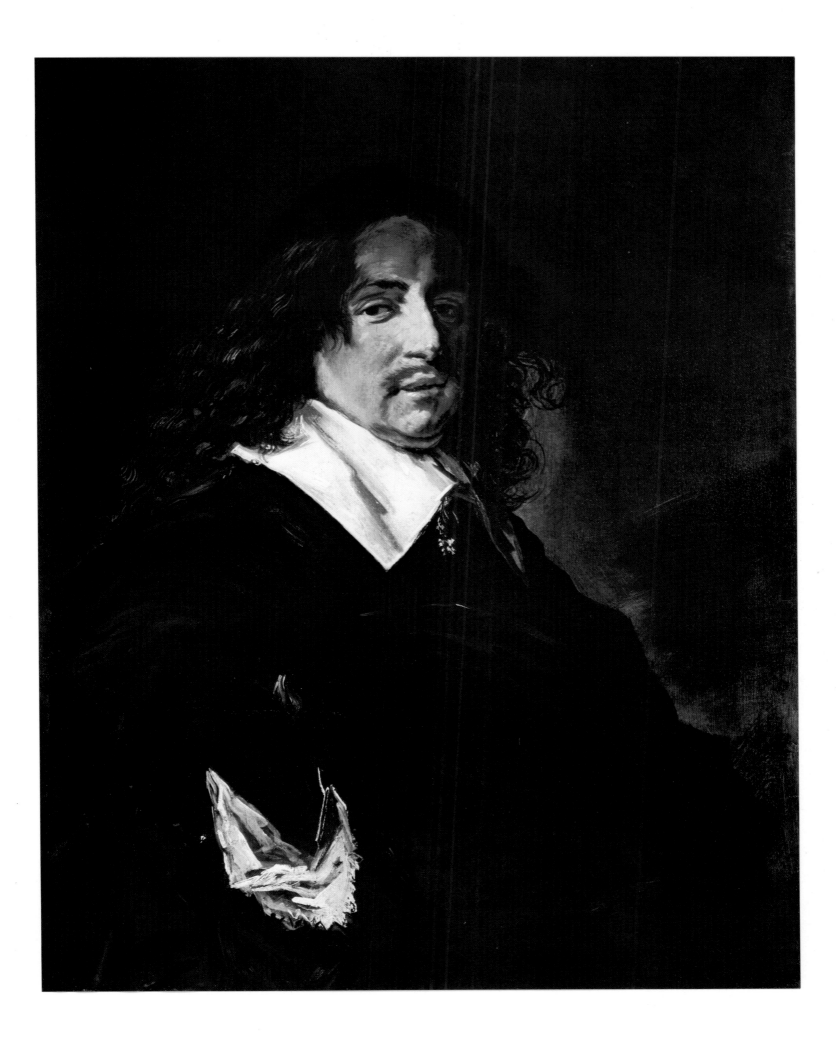

Colorplate 44
HERMAN LANGELIUS
c. 1660
Oil on canvas, 30 × 24 3/4"
Musée de Picardie, Amiens

About six years before his death in 1666, Frans Hals painted the minister Herman Langelius (1614–1666), who also died that year. According to historical sources the Amsterdam preacher was an active opponent of atheism, passionately attacking conditions which, in his eyes, were wrong. But even without this historical information, Hals would have enlightened us about the intensity of this man's zeal. Hals mirrors him as a fanatical protagonist of God's kingdom, a man filled with God's power, an inspired missionary passionately drawing strength from Holy Writ. How passionately he does this Hals shows us in the way the hand grips the Bible (fig. 51), a grip so intense that we would not be surprised if he used that Bible as a weapon to make the force of his convictions physically felt!

It is fascinating to observe in the three ministers portraits we have discussed the different ways in which they bear witness to the word of God. In the three separate paintings, each Bible acquires the character befitting the minister holding it. And it is all the more fascinating because we can also follow the development of Hals's work in these three portraits.

In the case of Swalmius (colorplate 32), we see the beginning of the simplification of style which began in the 1640s, with a pictorial balance of warm and cool tones in the composition. With Hoornbeek (colorplate 39) this process went further, as we can see from the even more economical technique, both in respect to form and the contrast of black-and-white shading. The final stage of Hals's life culminates in the portrait of Langelius, in which the artist had the ability to give the greatest possible expression to the spirit with a minimum of means.

The fact that Abraham Blooteling engraved the portrait of Langelius shows that it enjoyed a certain amount of popularity. Nonetheless, many of Hals's contemporaries must have been nonplussed by such a revolutionary approach, which is understandable in light of the times. It was only with the rise of Expressionism, more than two centuries later, that its affinity with his vision would reveal what heights old Hals had reached.

A poem by a certain Herman Waterloos in 1660 indicates how Hals's contemporaries failed to appreciate his greatness:

> *Old Hals, why do you try to paint Langelius?*
> *Your eyes are too weak for his learned rays,*
> *and your stiff hand too rough and artless*
> *to express the superhuman, peerless mind of this man and teacher.*
> *Although Haarlem boasts of your art and your masterpieces,*
> *We here in Amsterdam will now witness that*
> *You did not understand the essence of his light by half.*

In our commentary on Hals's portrait of the regentesses of 1664 (colorplate 46) we clearly show how wrong Waterloos's criticism is. For even at a more advanced age, Hals was not handicapped by weak eyes or a stiff hand.

The portrait is signed at the right, at shoulder level, with the joined initials FH.

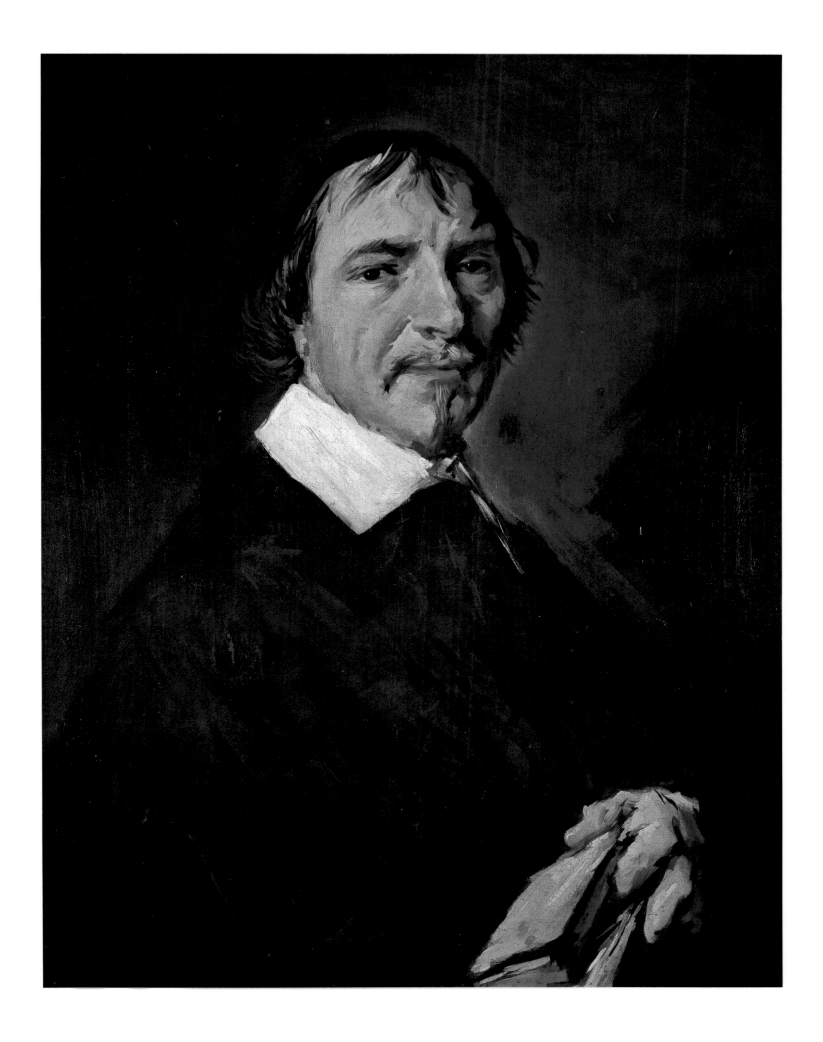

Colorplate 45
PORTRAIT OF A GIRL
c. 1660
Oil on canvas, 23 5/8 × 21 7/8''
Ferens Art Gallery, Hull, Yorkshire

The style of painting and the costume show that this heartwarming portrait must have been painted shortly before the group portraits of the regents and regentesses of 1664 (colorplates 46, 47), which makes the date of about 1660 plausible. This disarming portrait does not attract us so much by its outward beauty as by its appeal to a higher order—the innocence of unspoiled youth. Her inner being, which, here too, is penetrated more deeply than in his earlier children's portraits, is caught in the tinge of melancholy which is characteristic of the atmosphere generally pervading Hals's later portraits.

The approach and execution already predict the qualities which we find so striking in the portraits of the regents and regentesses. In the case of the girl, the sparing use of paint and the utterly sober forms leave it to the viewer to complete the picture in his mind's eye.

The forms are entirely expressionistic; for example, the bow of the collar could have been drawn by one of the Fauve painters. It is amazing how the artist, with a few touches of his brush, can evoke the pearl on the pin which decorates the bonnet. It is indeed a miracle if we compare it with a delicate jewel of this kind painstakingly depicted by Vermeer or Terborch! Hals's life's work was drawing to its close in a mood tinged with sadness, but brightened by the charm of youth, which thirty years earlier he had painted in brighter colors.

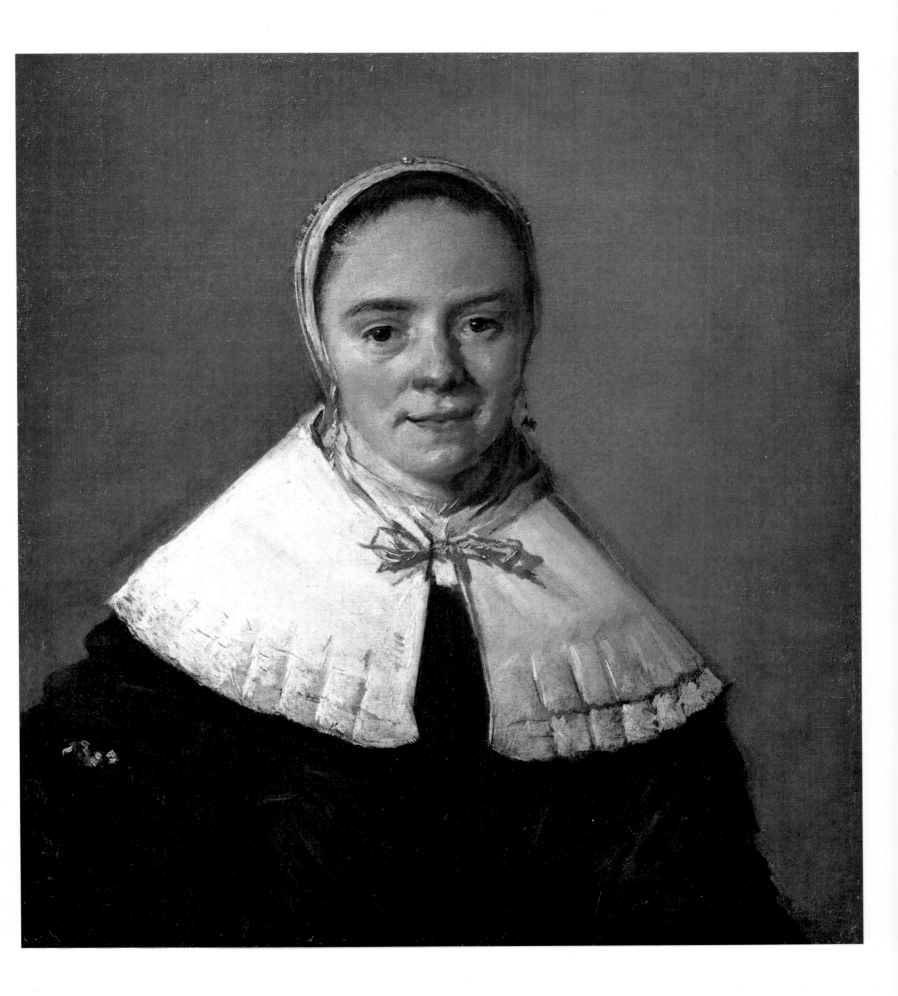

When we look at regentess paintings, which in the seventeenth century were commissioned for the purpose of adorning halls and for the sake of posterity, we become aware of what makes this particular group portrait so fascinating. While such paintings usually retain their authority when seen in the context in which they were painted, they often lose their impact when transplanted to a museum. As examples of old manners and customs, of transitory fashion and past glories, they are often observed by museumgoers with a smile of amusement as "vanity of vanities." In such a neutral museum room we realize that painters answered the wishes of their commissioners to make status and appearance the leitmotiv of the paintings, thus maintaining a tradition. They were carefully confined to their time and environment and immortalized as variations on the regentess theme.

Hals's regentesses, too, were removed from their original surroundings, but they have escaped the downgrading which befell their colleagues, because Hals did not merely paint variations on the theme but gave unique interpretations of human beings. The saying "vanity of vanities" applies here, too, but because of Hals's emphasis, the work assumes tragic overtones. Hals did not deprive his subjects of their illusion of self-importance—the importance of the regentesses on the one hand and the readiness to serve of the housemother (the standing figure at the extreme right) on the other, contrasts which accentuate one another.

Hals's work moved, after a gradual transition, from an impressionistic to an expressionistic approach (figs. 52, 20). The expressionism in Hals's later works brings with it an even deeper probing into the human being. In the immaterialization that accompanies this, some critics detected signs of old age. We have already pointed out this misunderstanding in the adverse comments of Waterloos on Hals's portrait of the fanatic Langelius (colorplate 44). Fromentin, who otherwise admired Hals, also contributed to this misunderstanding when, in his *Maitres d'autrefois* (1876), he made such comments as: "He is losing his touch," "he daubs rather than paints," "the strokes are applied in a slapdash manner," and "declining genius." If Hals's painting ability was indeed in such a sad state of decline, then how could he have placed the subtle accent of a white dot in the pupil of an eye in exactly the right place to achieve the desired effect? This surety of touch is also evident in his application of broader strokes which have their allotted places, thus showing that they are guided by an unerring discipline.

While in similar paintings by other artists the models were isolated within their own confines, in Hals's work the freely flowing brush allows his sitters to be a part of the indefinable atmosphere best described by Goya as the "magic of the surroundings." Witness the presentation of the second regentess on the left: her bonnet reflects what Hals has made so grippingly visible in her face. Compare this with the entirely different atmosphere of the bonnet of the housemother.

Goethe has said: "Everything that lives creates an atmosphere around itself." With the regentesses, whom Hals's brush made so alive, we sense not only Goya's "magic" within the magnetic field of this group, but also Goethe's "atmosphere."

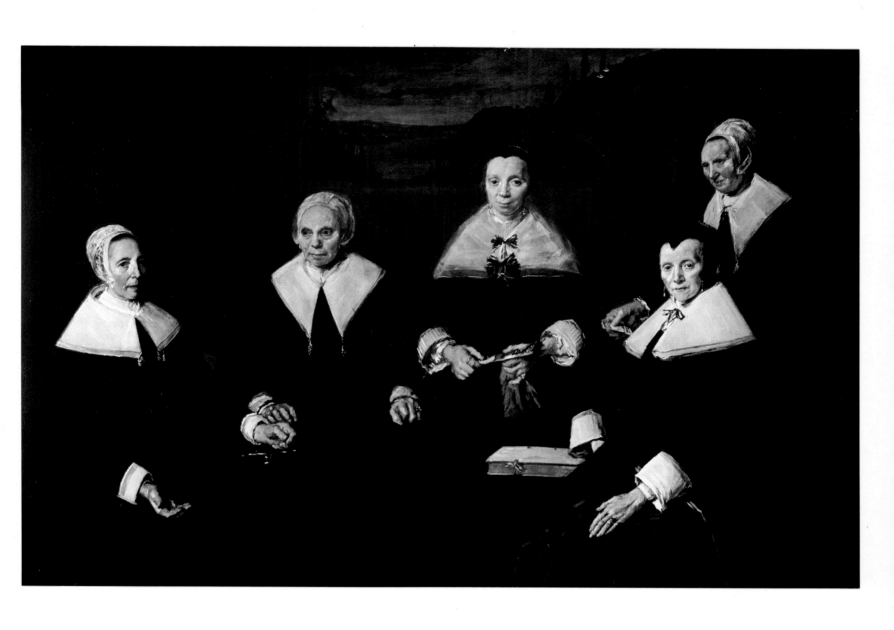

REGENTS OF THE OLD MEN'S ALMSHOUSE
(*detail of Johannes Walles*)
c. 1664
Oil on canvas; size of entire painting, 67 7/8 × 98 3/4″
Frans Hals Museum, Haarlem

A note by Pieter Langendijk (1683–1756) in the Haarlem Municipal Archives
mentions that about 1750 the group portraits of the regents and regentesses (color-
plates 46, 47) hung in separate halls. This may or may not have been the case in
the seventeenth century, but in any event the portraits together complement one
another. The regents have a somewhat milder air about them than the regentesses.
The bold details around the regents' table surpass the free brushwork of the
regentesses portrait. Take, for example, the rendering of the gloves and linen
of Johannes Walles (shown on the opposite page), a representative of the regents
who, between 1662 and 1665 was supervisor of the Haarlem Old Men's Alms-
house. Walles's face bears unmistakable traces of loneliness, which are so striking
that it is hard to forget his look and demeanor. Here the face and the heavy color-
ing play an important part. The "shorthand" that Hals uses here, hardly imagin-
able in the seventeenth century, would not be generally acceptable until two cen-
turies later, when it was thought to be akin to certain aspects of modern art.

Eugène Fromentin (1820–1876), who was conservative as an artist and was
delighted with the sharpness of contours against the light, could not accept the
forward march of Impressionism and consequently of Hals's forms in his final
years. But being a sensitive observer, he praised the positive elements. His was the
most objective form of appreciation of Hals's timeless craftsmanship. "It is im-
possible," he said, "to imagine finer blacks or finer gray-whites. The regent on
the right with his red stocking, that is seen above the garter, is for a painter a price-
less morsel." Elsewhere he observed quite rightly: "The perceptions of his eye are
still vivid and just, the colors entirely pure. Perhaps in their first composition they
have a simple and masculine quality, which betrays the last effort of an admirable
eye, and says the last word of a consummate education." And *summa summarum*:
"If I were to choose between the painting of 1616 [colorplate 6] and that of 1664,
I should not hesitate and would certainly choose the latter."

When Henri Focillon in his *Life of Forms* observed, "the artist lives in a region
of time which is not necessarily his own," he expressed precisely how Frans Hals
in his regents pieces was able to depict abstract values which do away with place,
time, outward form, and studio conventions, and to evoke reminiscences of equiv-
alent concepts in the art of all time.

Many artists have explained what drove them in their creative work. Where
their statements were relevant we have quoted them. In the case of Hals, we know
nothing of his motives, and any analysis of what he saw must be based exclusively
on what the works of art themselves convey. Furthermore, we do not know to
what extent Hals was aware or unaware of what made him paint.

Just as we may be surprised by a handwriting expert's analysis of hidden qualities
in our handwriting, so Hals might very well have been surprised by unsuspected
characteristics revealed in the analysis of his work. But would this not have been
typical of the intuitive, spontaneous, and improvising character of his work?

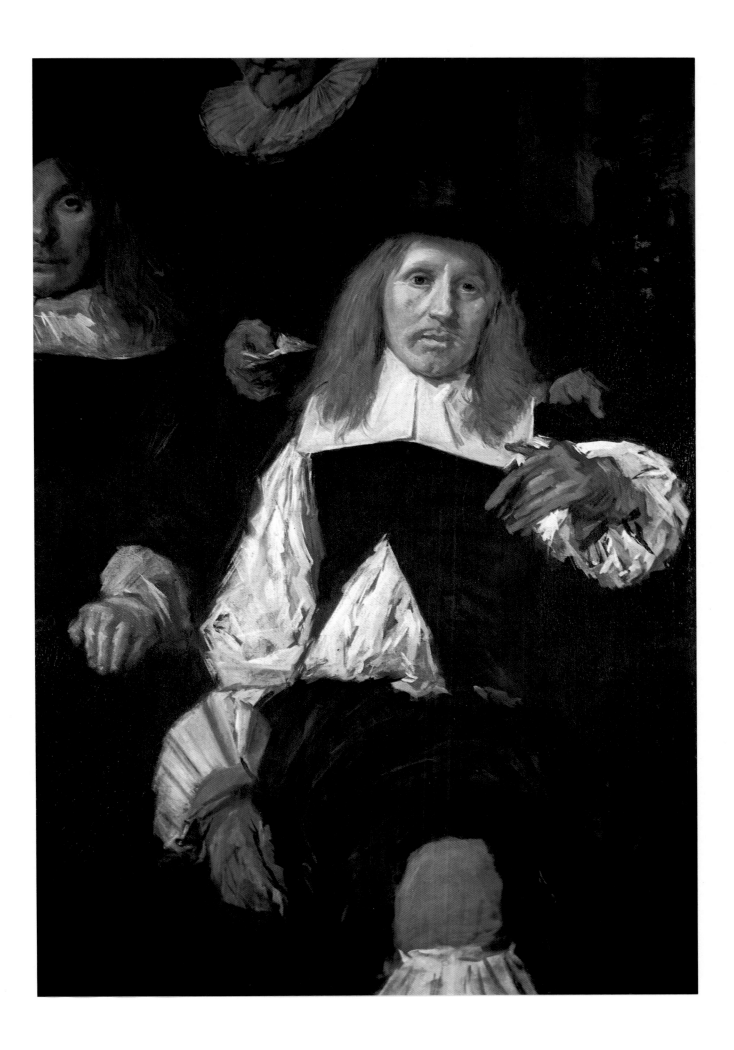

Colorplate 48

PORTRAIT OF A MAN IN A SLOUCH HAT

c. 1660–66

Oil on canvas, 31 1/4 × 26 1/4"

Staatliche Kunstsammlungen, Kassel

In the unlikely event that, after this wealth of Hals's portraits, one is still not entirely convinced of his genius, this work, one of Hals's last, should finally convince him. This most abstractly painted of Hals's portraits is an even bolder challenge to the fixity of the "snapshot" than that of his earlier portraits and will thus remain undeniably contemporary through the ages.

Hals's contact with this unknown sitter resulted in an orchestration that acquired a grandiose rhythm; his model's relaxed air struck a responsive chord in the much-criticized freedom of Hals's brushstrokes. In retrospect we could speak of an historic meeting, since the complete harmony between the artist and his model resulted in one of the most brilliant portraits in the history of pictorial art. "Every portrait painted with feeling is a portrait of the artist, not of the sitter," said Oscar Wilde. Applied to Hals, Wilde's statement can be interpreted to mean that all his portraits are self-portraits. This paradox is very convincing when we look at this slice of life in which Hals himself is, like his model, above criticism.

The freedom we observe on both sides of the easel is evident in the composition and in the brushwork. The latter is so revolutionary that, with the possible exception of Goya, it can only be related to the concepts of the Fauves, who, in the early 1900s, brought exuberant life to the art of their period under the guidance of Matisse.

The zigzagging of the diagonals, which we had earlier observed in the portrait of Isaac Massa (colorplate 16), dominates here and is strengthened by the economy of Hals's touch. The angle of the hat gives it an extra accent; traces of an originally smaller brim show that the artist consciously enlarged it to lay greater emphasis on the diagonal effect.

We have already deplored the insipid title of this vivid portrait. Slouch hats were generally worn in the 1660s, but this hat is unique in the forceful way in which Hals presents it. Under Hals's direction this hat is not a statement on fashion but reflects an attitude of life, that of a friendly man who does not take life too seriously. The wearer of this hat must have been a witty and friendly conversationalist, whose company must have had the same cheering effect as his picture.

The open window hints at a view with a strong suggestion of space and perspective. The abstract treatment of the space gives the impression that it is unlimited; a similar evocation of atmosphere is seen in the unforgettable *Gypsy Girl* (colorplate 21).

Typical of Hals's work is the way in which the mood of the model is conveyed in the hand. Here Hals disregards anatomy for the sake of greater expression. The sitter's dangling hand expresses natural relaxation and reflects his outlook on life.

Thus the man with his magnificent hat effortlessly braves the lifeless museum atmosphere. His form becomes evanescent in the perfect freedom in which he is immortalized.

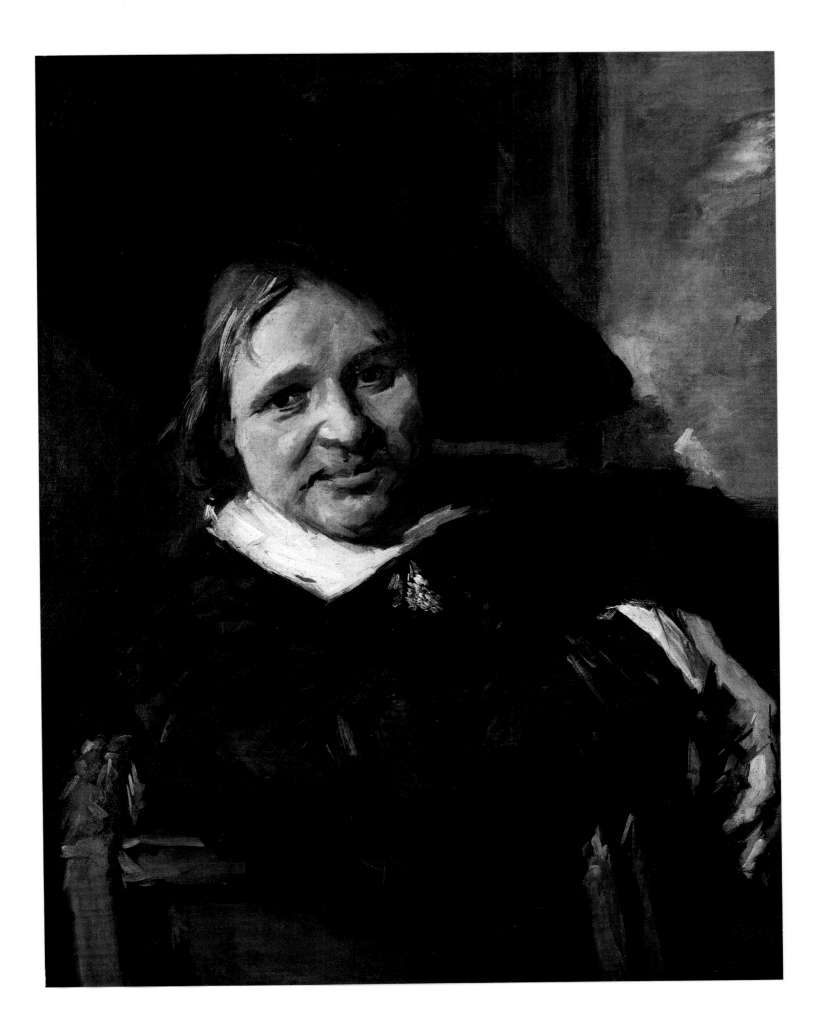

Colorplate 49

PORTRAIT OF A MAN IN A SLOUCH HAT (*detail*)

If we look at a close-up of the man under the sweep of his hat, we find yet another reason for the refreshing effect of his appearance than what was discussed in our previous commentary. We are speaking of the entirely different attitude of the man of today when compared with the life-style of more than three centuries ago.

The alienation from nature and religion, the creation of a computerized society with its devaluation of the individual, the penetration of mass media into daily life are only some of the factors affecting society today. These are reflected in abstract painting, which was, to some extent, synonymous with these developments and became, in part, one of society's natural components.

Nonfigurative art broke drastically with cherished traditions which had directed the pictorial arts for thousands of years. The French poet Pierre Reverdy succinctly described the drastic change in course brought about by Wassily Kandinsky (1866–1944) and his colleagues when he said: "Reality is not the motive for a work of art: life is the starting point for achieving another reality." In other words, the visible world is no longer our aim in creating a work of art, but the artist makes life the point of departure to attain some other reality. The abstract artist is no longer the prisoner of substance and visible form and takes over an unlimited domain beyond our world.

Thus an unbridgeable gap was created between this completely new concept of the world and the sources of inspiration of Frans Hals and his colleagues, who found their creative impulses in the visible world. This historical break with the past has been admirably expressed by Professor Hans Jaffé, who said that the beginning of our century was the starting point of a "spiritual dispute with the problem of reality." One of the negative results of this complex development is the alienation of natural characteristics, both in the case of peoples and individuals—alienation, insecurity, and isolation.

The consequent loss of what were considered unassailable standards at all levels of society fills an ever-increasing number of people with nostalgia. A nostalgia, not so much for the past as such, with its doubtful blessings, but with its familiar values of artistic and cultural monuments, of which tributes to what can be seen and to human involvement are the central elements. The nostalgia of today for art, fashion, and other expressions of the society of the distant past is symptomatic in this connection.

And this brings us back to our portrait. Without denying the right of abstract art to exist, we can understand Kokoschka's complaint that "there will be no portrait left of modern man, because he has lost his face and is turning toward the jungle." We breathe a sigh of relief when we meet a man who, under Hals's brush, remained so alive that he has, by his uncomplicated attitude to life, a rejuvenating effect on the troubled man of today.

And so, unwittingly, this unknown man bears a message for the weary among us, a message reminiscent of a saying by Blaise Cendrars (1887–1961) which could have been the motto of Frans Hals: "Just to exist is true joy."

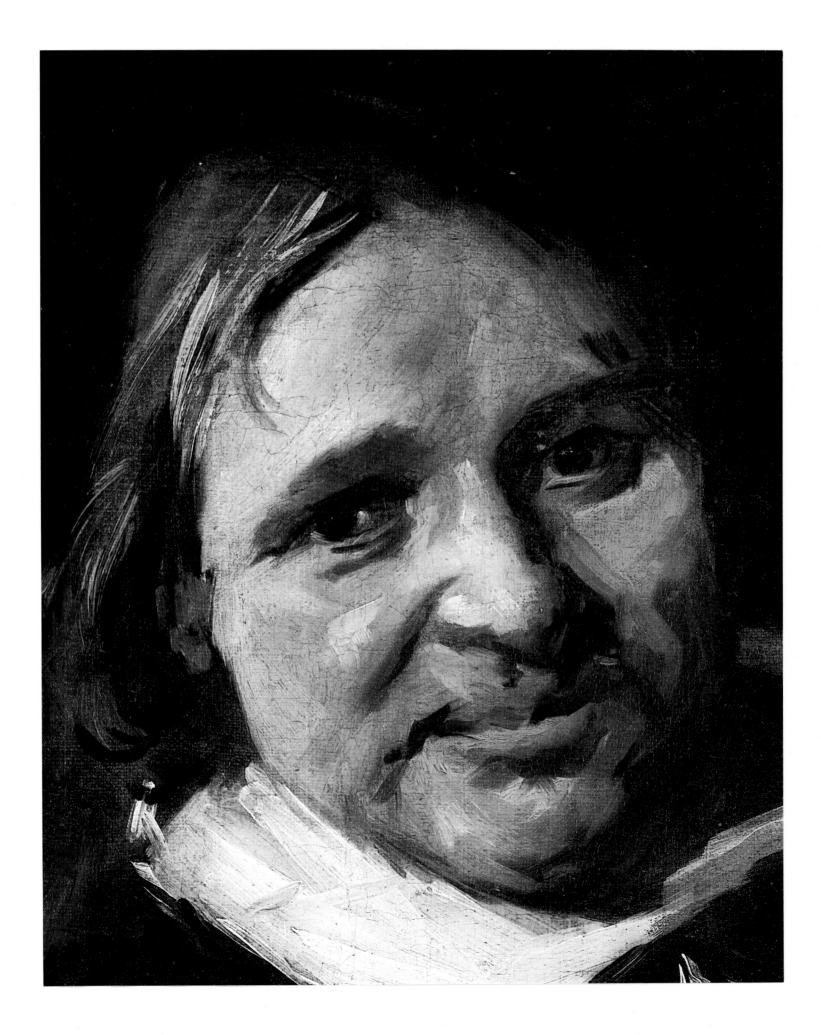

1581/1585	Frans Hals born in Antwerp as son of the "clothworker and weaver" Franchoys Hals and Adriaentgen van Geertenrijck, who were from Malines (Mechelen).
1591	MARCH 19: Frans's brother Dirck is baptized in Haarlem. This is the earliest known reference to the Hals family in Haarlem.
c. 1600/1603	Pupil of Karel van Mander.
1610	Member of the Guild of St. Luke in Haarlem.
1611	Year of the earliest dated portrait known: *Jacobus Zaffius* (colorplate 4). Harmen, the son of Frans Hals and his first wife Annetje Harmansdr., is baptized on September 2.
1615	JUNE: Annetje Harmansdr. dies, leaving behind two children.
1616	The first of the six civic guards paintings is done, the *Banquet of the Officers of the St. George Civic Guard Company* (colorplate 6). Mention is made on August 6 of this year that Hals is residing in Antwerp. Member of the chamber of rhetoricians, *De Wijngaertranken* (The Vine Tendril), until 1625. Earliest known archival record relating to unpaid debts.
1617	FEBRUARY 12: Marriage to Lysbeth Reyniers in Spaarndam, near Haarlem. The birth dates of eight children from this marriage are known.
1629	Payment of fees to Hals for the "cleaning and changing" of paintings in the Brotherhood of St. John in Haarlem. It is possible that Hals also did restoration work on paintings by Geertgen tot Sint Jans.
1633	Commission for the painting of *The Company of Captain Reynier Reael and Lieutenant Cornelis Michielsz. Blaeuw* (fig. 43 and colorplate 29). Hals refuses to complete the work in Amsterdam; it is finished by Pieter Codde in 1637.
1641	The first commission for a painting of regents in Haarlem is given to Hals: *The Regents of the St. Elizabeth Hospital of Haarlem* (colorplate 33).
1644	Officer of the Guild of St. Luke in Haarlem.
1654	The baker Jan Ykesz., to whom Hals owes a debt of two hundred guilders, levies an attachment on Hals's household goods and five of his paintings.
1661	The Guild of St. Luke exempts Hals from paying the annual contribution because of his advanced age.
1662	At his request, Hals receives support in the amount of fifty guilders from the burgomasters of Haarlem, followed by an additional sum of one hundred and fifty guilders for one year.

1663	The support is increased to an annual sum of two hundred guilders, pledged to him for life.
1664	Paintings of the group portraits of the regents and regentesses of the Old Men's Almshouse (colorplates 46, 47). The Haarlem magistrate assigns three wheelbarrows of peat to the artist.
1665	Hals is guarantor for his son-in-law Abraham Hendricksz. Hulst for a sum of 458 guilders and 11 stuivers. The fees he received for painting the group portraits of the regents and regentesses the previous year may explain how he could afford to do this.
1666	SEPTEMBER 1: A grave for Hals is opened in the choir of St. Bavo's Church (no. 56).
1675	Lysbeth Reyniers, Hals's widow, having become poverty-stricken, is provisionally allowed to receive fourteen stuivers each week.

SELECTED BIBLIOGRAPHY

Baard, H. P. *The Civic Guard Portrait Groups.* Amsterdam: Elsevier, 1950; New York: Macmillan, 1950.

Beeren, Willem A. *Frans Hals.* Translated by Albert J. Fransella. London: Blanford Press, 1963.

Bode, Wilhelm von. *Frans Hals und seine Schule.* Leipzig: E. A. Seemann, 1871.

Descargues, Pierre. *Hals.* Translated by James Emmons. Geneva: Skira, 1968.

Dülberg, Franz. *Frans Hals: ein Leben und ein Werk.* Stuttgart: P. Neff, 1930.

An Exhibition of Fifty Paintings by Frans Hals. Detroit Institute of Arts, January 10–February 28, 1935. Introduction and catalogue by Wilhelm R. Valentiner.

Fontainas, André. *Frans Hals.* Paris: H. Laurens, 1909.

Frans Hals: Exhibition on the Occasion of the Centenary of the Municipal Museum at Haarlem. Frans Hals Museum, Haarlem, June 16–September 30, 1962. Introduction by H. P. Baard; catalogue by Seymour Slive.

Fromentin, Eugène. *The Old Masters of Belgium and Holland.* Translated by Mary C. Robbins. New York: Schocken Books, 1963.

Gratama, Gerrit D. *Frans Hals.* The Hague: Oceanus, 1943; 2nd ed., 1946.

Höhne, Erich. *Frans Hals.* Leipzig: E. A. Seemann, 1957.

Luns, Th. M. H. *Frans Hals.* Amsterdam: H. J. W. Becht, 1946.

Martin, Willem. *De Hollandsche Schilderkunst in de Zeventiende Eeuw.* 2 vols. Amsterdam: Meulenhoff, 1935–36; 2nd ed., 1942.

Moes, Ernst W. *Frans Hals: Sa vie et son oeuvre.* Brussels: G. van Oest, 1909.

Péladan, Joséphin. *Frans Hals.* Paris: Goupil, 1912.

Schmidt-Degener, Frederik. *Frans Hals.* Amsterdam: H. J. Paris, 1924.

Slive, Seymour. *Frans Hals.* 3 vols. London: Phaidon, 1970–74.

Trivas, Numa S. *The Paintings of Frans Hals.* New York: Oxford University Press, 1942.

Valentiner, Wilhelm R. *Frans Hals Paintings in America.* Westport, Conn.: F. F. Sherman, 1936.

Veldherr, J. G.; Gonnet, Cornelius J.; and Schmidt-Degener, Frederik. *Frans Hals in Haarlem.* Amsterdam: S. L. Van Looy, 1908.

DATE DUE	